RUSSIA
IN ORIGINAL
PHOTOGRAPHS 1860-1920

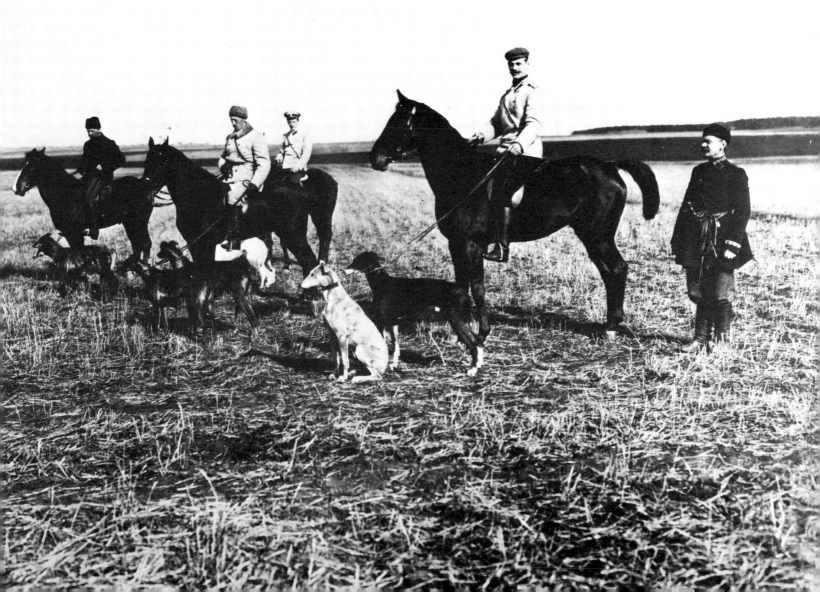

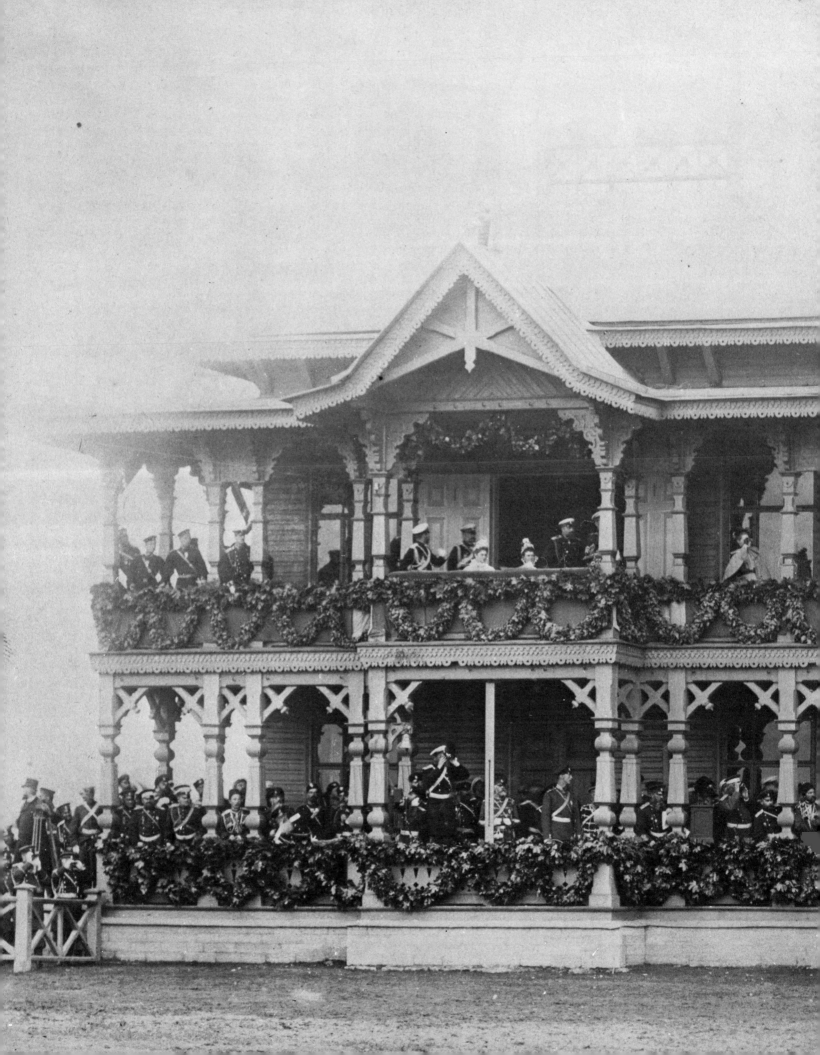

RUSSIA
IN ORIGINAL
PHOTOGRAPHS 1860-1920

MARVIN LYONS

EDITED BY ANDREW WHEATCROFT

ROUTLEDGE & KEGAN PAUL
LONDON AND HENLEY

First published in 1977
by Routledge & Kegan Paul Ltd
39 Store Street,
London WC1E 7DD and
Broadway House,
Newtown Road,
Henley-on-Thames,
Oxon RG9 1EN
Set in Monophoto Bembo
and printed in Great Britain by
BAS Printers Limited, Over Wallop, Hampshire

British Library Cataloguing in Publication Data

Russia in original photographs, 1860–1920.
1. Russia—Social life and customs—Pictorial works
I. Lyons, Marvin II. Wheatcroft, Andrew
947.08'022'2 DK32

ISBN 0 7100 8653 9

To
J.M.
A small and long overdue token of my appreciation for all your kindness, and particularly for your interest and most welcome assistance.

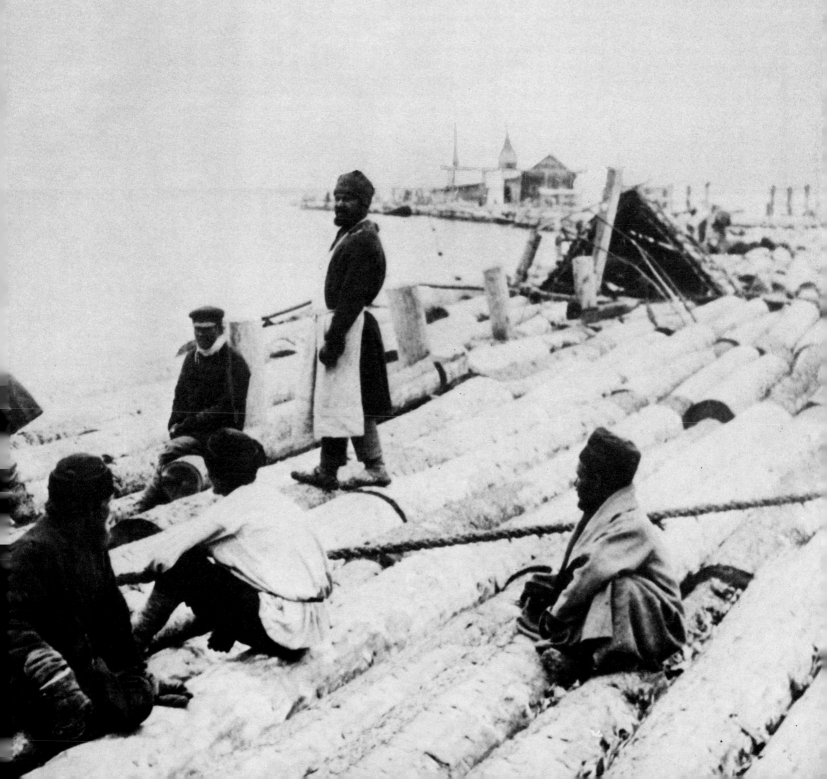

CONTENTS

INTRODUCTION

To attempt within the covers of one volume to convey to the reader an impression of life in a nation that no longer exists is almost an impossible task. The variety and interest of the various aspects of life in that state demand many volumes for each. One can only hope that by devoting some time and space to some of the areas of importance, one can begin to appreciate what it was all about, what it was like.

Similarly, to attempt to select from tens of thousands of photographs a few hundred that will convey to the reader a rounded impression is almost impossible. Each person looking at the same photograph will see very different things.

The Russian Empire was a complex society. There were great iniquities and inequalities to be certain but men were actively trying to overcome them—legally and not through the bullet or the bomb. Slowly but surely the changes that men desired were taking place, restrictions were being removed, rights were being legislated into law. Certainly there was abject poverty, certainly the Jews were harassed, the Poles deprived of their language, the Finns of their army, but just as certainly Russia's fellows in the community of nations were at one time or another guilty of the same or similar sins.

This is not a brief in favour of the Imperial Russian State. It is a partial and very inadequate pictorial chronicle of a country that for a long time has exerted a great influence on the world, has exported literature and music and great men. It is a nation that has an emotional and intellectual hold on those born there (and many of those who lived there only for a time) unlike any other country. Even after sixty years of exile, the post–revolutionary Russian émigrés still feel they have only one home. Would that I could make it possible for them to return to that home. Perhaps this book will soothe a little of that yearning.

M.L.

ACKNOWLEDGMENTS

To the so very many who through the provision of materials or information, advice or other forms of assistance, have made this book possible, my gratitude and appreciation:

Her Majesty The Queen, Ex-King Umberto of Italy;

HRH Princess Eugénie of Greece, TRH Prince and Princess Paul of Yugoslavia;

HH Prince Dimitri of Russia, the late Prince Nikita of Russia, HH Prince Vasili of Russia, the late Prince Vsevolod of Russia;

Mrs George W. Allan, the late General Serge Andolenko, Miss Louisette Andrews, Metropolitan Anthony of Sourozh, Captain Vladimir Apoukhtine, Miss Felicity Ashbee;

Michael Bakhroushin, Mme S. Bakounine, Mrs I. Baranowska, Mrs A. Baring, Prince Serge Belosselsky, Miss Alex Benckendorff, Mme Catherine Bibikoff, Miss Helen Bibikov, Baroness Tatiana Bilderling, Boris Blumowicz, Mme Maria von Bock, Colonel Borkovsky, Mme Tatiana Botkin, Mrs Marina Bowater, Mrs E. L. Brasol, Colonel and Mrs Jacob von Bretzel, Mrs Elisabeth Brunn;

Miss Mary Chamot, Nicolas Chatelain, Princess Marina Chavchavadze, Colonel Peter Chilovsky, Mrs Sonia Churchward, Mrs Marina Corby, M. and Mme Nicolas Crown;

Alexander von Daehn, Mrs R. Dawe, George Dekonsky, the late Baron Nicolas and Baroness Marie Dellingshausen, the late Colonel Serge Dirine, Colonel Gabriel Dolenga-Kovalensky;

Mrs Helen Edmonds, the late Princess Vera Eristoff, Princess Mary Eristow, Mr and Mrs George Evnine;

Prince Nicolas Gagarine, Prince Emmanuel Galitzine, the late Colonel Nicholas Galushkin, the late M. Frederic Gilliard, Baron Patrick Gmeline, Mrs Michael Golovine, Paul Goudime, Mrs Tamara Gough, the late Captain Alexander Gramotine, M. Leon Grinberg, Colonel Baron Gaston de Grotthuss, Dimitri de Grunwald, Prince Alexis Guedroitz, M. Alexis Guering;

Mrs Irina Haley, Mme Dimitri Hall, Mrs Elisabeth Hartman, Major George Hartman, Mrs Olga Hartman, Countess Irene de Heiden, Countess Olga Hendrikoff, Vladimir Heroys, Mrs Natalia Heseltine, the late Countess Marina Heyden, Mme Olga Hitrovo, Colonel Alexander Hoerschelmann, Commander Basil Hwoschinsky;

Mrs Vera Iakovleva, Miss Olga Illashevitch, Iakov Isakoff;

the late Captain Vladimir Kamensky, Professor George Katkov, Mme Helen Khlebnikoff, Count and Countess Kleinmichel, Count and Countess Nicholas Konownitzine, Mme L. Kostritsky-de-Proce, Miss Alexandra Koulomzine, Count Alexander Kreutz, Tihon Kulikovsky;

Mrs Wladimir von der Launitz, the late Duke Serge von Leuchtenberg, Captain Reinhold von Liphart, Colonel and Mrs Dimitri Loutchaninoff;

Prince Alexandre Makinsky, Theodore de Malama, Colonel Vsevold de Martinoff, Baroness Nadejda Meller-Zakomelsky, Marquise Anna de Merindol, Mme Marie Miklachevsky, Paul Miklachewsky, Michael Moukhanoff, Earl Mountbatten of Burma;

Captain Cyril Narischkine, Countess Catherine Nieroth;

the late Colonel Theo Olferieff;

Marquis Nicholas Paulucci, the late Daniel Perret de Villeneuve, the late Mme Barbara Podcherkoff, Mlle Elisabeth Poretzky, Prince Ivan Poutiatine, Mme Nina Prejbiano;

Miss Lydia Ragosin, Mrs Helen Rapp, Michael de Rauch, Mrs Olga Rayner, Countess Marie Rehbinder, German von Rennenkampf, Captain Serge Rodzianko, the late Captain Victor Rodzianko, Colonel Alexander Romanenko, M. and Mme Igor Roop, Marvin C. Ross, Señora N. Roudneff;

the late Roman Sagovsky, John Screen, Colonel Constantine Semchevsky, Alexandre Serebriakoff, the late Captain Cyril Shirkoff, Mr and Mrs Dimitri Shvetzoff, the late Count Alexander Sollohub, Count Nicholas Sollohub, Colonel Serge Somoff, Countess Natalia Soumarokoff-Elston, Mrs Nina Spiridovitch, Alex Stacevich, Baron Constantine Stackelberg, Captain Ivan Starosselsky, Count and Countess Ivan Stenbock-Fermor, the late Lieutenant-General Michael Swetchine;

Mme Daria Tatistcheff, Baron George Taube, the late Colonel Prince Igor Tcherkassky, Countess Marie Tchernycheff-Bezobrazow, the late Colonel Dimitri Tikhobrasoff, Captain and Mme Timtchenko-Rouban, the late Countess Maya Tolstoy, Mrs Helene Tolstoy-Miloslavsky;

the late Commander George Vesselago, Mrs Olga Villiers, Nicholas van der Vliet, Mme Anna Voeikoff, Jack and Jennifer Voevodsky;

Colonel Valery Walter, Sergei Waltz, HG The Duke of Wellington, Lady Zia Wernher, Princess Nina Wiazemsky, the late Brigadier H. N. H. Williamson, Alexander Wolcough, Edith Baroness von Wolff, Mark Wolff, Serge Wolff, Mrs D. Wonlar-Larsky, Mrs Olga Woronoff, Mme Nina Wrangel-Ball, Mlle Irene Wyrouboff;

the late Prince Felix Youssoupoff;

Dr Hubert Zawadski, Mrs Elisabeth Zinovieff, Michael Zvegintzov, the late Colonel Wladimir Zweguintzow;

the ladies and gentlemen employed in the various repositories in which I was fortunate enough to work and particularly Sir Robert Mackworth-Young, the Librarian at Windsor Castle, and Miss Frances Dimond in charge of the photographic collections in the Royal Archives, for whom I'm afraid I made a great deal of extra and perhaps unnecessary work; and also Mr Roy Castle of the Victoria and Albert Museum, who found such interesting material for my use; and three gentlemen at my publishers who advised and assisted and contrived in the end to make what was difficult easy and otherwise widened my horizons— Andrew Wheatcroft, Tony Orme and Jo Hart; but most particularly to that small circle of close friends who provided advice and criticism and information and have created this book as much as I—Merica and Volodia, Dimitri, Eugenie, Evelyn, Arthur and Michael, Jack and Dickie.

RUSSIA
IN ORIGINAL
PHOTOGRAPHS 1860-1920

FACES OF AN EMPIRE

A western traveller in Russia was invariably struck by the immense variety of peoples and types that the empire contained; some 110 different nationalities and an infinity of languages and dialects made any generalisation both facile and inaccurate. Nor was the racial multiplicity restricted to the lower orders of society, for the upper echelons contained a *pot-pourri* of different nationalities. Even the Imperial Court contained Poles, Finns, Germans, Tartars, Georgians, even Armenians, as well as 'Russians'. This multiplicity made for a state in which minorities (excepting some religious dissenters) were better treated than in many western societies. Only the Jews, the universal scapegoats, were appallingly and deliberately maltreated over the centuries, restricted to living, in large measure, in the Pale of Settlement, and maintained in a state of abject subjugation. It is therefore often hard to discover any great unifying forces within the vast empire, save for a common loyalty to the Tsar and the state. The Russian Orthodox Church, the established church and supposedly the great uniting force in society, had all the trappings of power, and a substantial voice in determining censorship and suppression. But much of their authority was illusory, for the number of active believers was declining, especially since (in stark contrast to the Catholic churches in western Europe), they had neglected to control elementary education until late in the 1860s. As one bitter critic noted: 'The majority of the parish clergy have always been distinguished for their fat bellies, scholastic pedantry and savage ignorance.' No lead was to come from the church, save backwards into a reactionary past.

A great secular creed exploded into the vacuum left by religion; if not to replace it, to provide a moral purpose and justification for Russia's burgeoning imperialism. As the poet Tyutchev wrote, Russia's destiny knew no limits:

Seven inland seas and seven mighty rivers
From the Nile to the Neva
From the Elbe to China
From the Volga to the Euphrates
From the Ganges to the Danube
Such is our Empire to be.

A new creed, of Panslavism, uniting religion with political opportunism, gripped the leaders of Russian society. The government, fearing any demonstrative political movement, however benign its objectives, failed to suppress it. Panslavism gave a radical tinge to Russian policy, raising hopes once again that the age-old objective of Russian policy, that the Tsar should attend mass in the Hagia Sophia in Constantinople, Tsargrad to the Russians, might be fulfilled. And beyond, that all Slavs might one day be united in one holy Slav state, under the sceptre of the Tsar. In Russia such dreams were dangerous, for in a state composed of so many disparate elements, inertia rather than enthusiasm had to be the sole governing principle. Nicholas I himself saw, as he explained to the poet Pushkin, that the massive solidity of Russia, one of the faces she presented to the world, could be but an illusion:

> Russia does not yet stand as a whole: the elements composing her are not yet harmonised. . . . Take away the limitless all-powerful will of the monarch and at the least shock she would crumble.

By the three hundredth anniversary of the foundation of the Romanov dynasty in 1913, Russia had not crumbled, but to prevent it, a police state had been created, in response to the terrorist atrocities of the enemies of autocracy. The facets which she presented to the world now became even more confused: was the violence of the revolutionaries the true Russia? Or the outspoken pacifist anarchism of Tolstoy? Or the fumbling attempts at reform and economic change by some of the Tsars' ministers? Or the wooden determination of Nicholas II to preserve his autocratic patrimony intact for his descendants? War and revolution served to resolve the dilemmas.

1 Vladimir Ivanovich Ershov (1847 + 1899). Taken in 1855 or 1856, this portrait of a young Russian nobleman is the finest early photograph I have seen. An officer of His Majesty's Hussar Guards, Ershov was a Fligel-Adjutant and friend of Alexander II.

2 The Emperor Alexander II in the service cap and winter cloak of the Chevalier Gardes or Horse Guards.

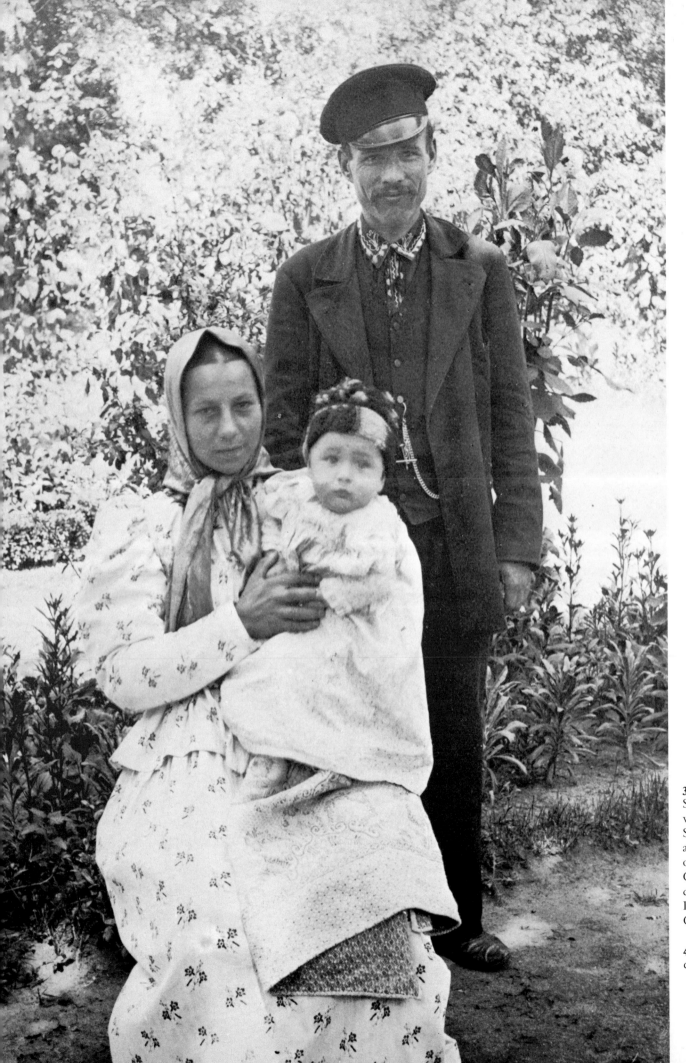

3 The butler Kuzma Shinkerenko with his wife Marusia and son Step in Sunday dress at Dolzhik, the estate of Princess M.A. Golitsyn and her children in Kharkov District, Kharkov Government.

4 *right* Father and child.

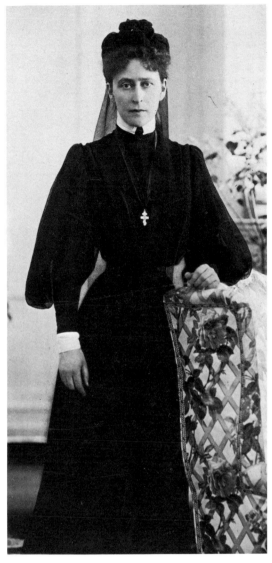

5 *left* The Tsarevich and Grand Duke Alexander Alexandrovich and his consort the Tsarevna and Grand Duchess Maria Feodorovna, *c.* 1870.

6 *above* Empress Maria Alexandrovna (27 July 1824 + 22 May 1880). Born Princess Maximiliana Wilhelmine Augusta Sophie Maria of Hesse and the Rhine, she married in 1841 the future Emperor Alexander II.

7 The Grand Duchess Elisaveta Feodorovna, in mourning for her murdered husband, 1906.

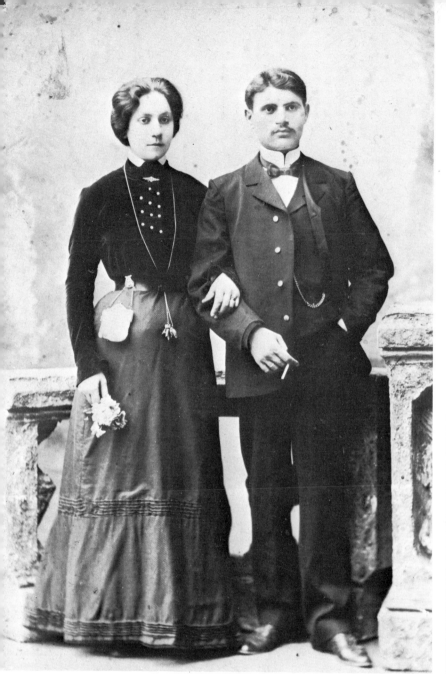

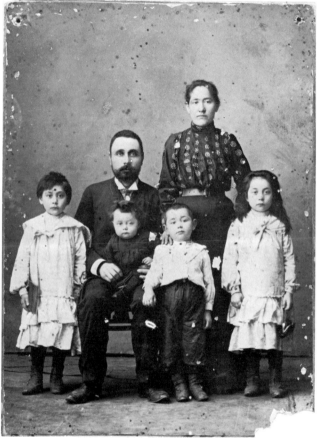

8 Jewish families in Ekaterinoslav province, *c.* 1910, within the Jewish Pale of Settlement, where all Jews were, in theory, forced to live.

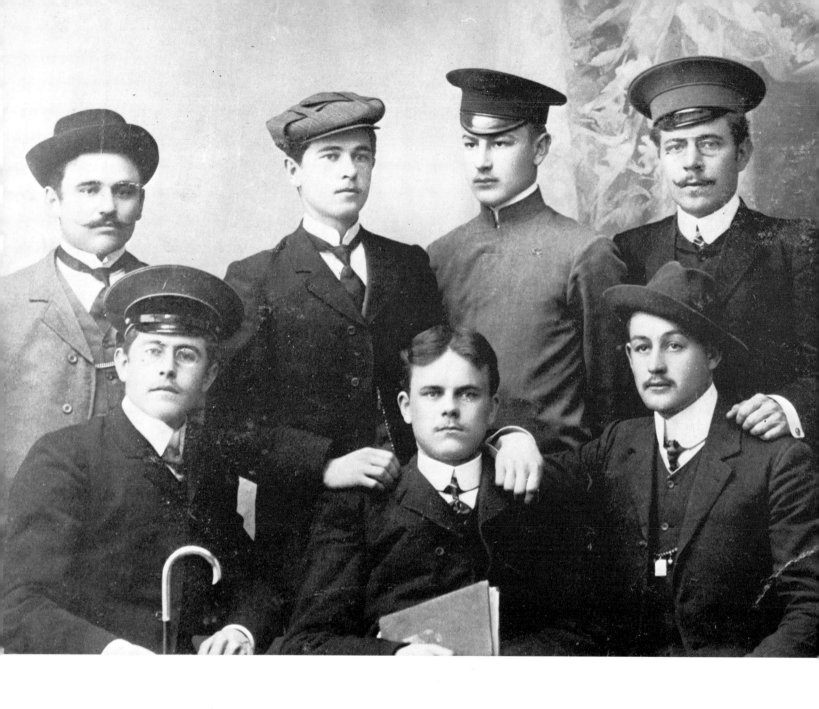

9 A group of young Mennonites at the Tiegerweide Colony in Tauride Province, *c. 1916*.

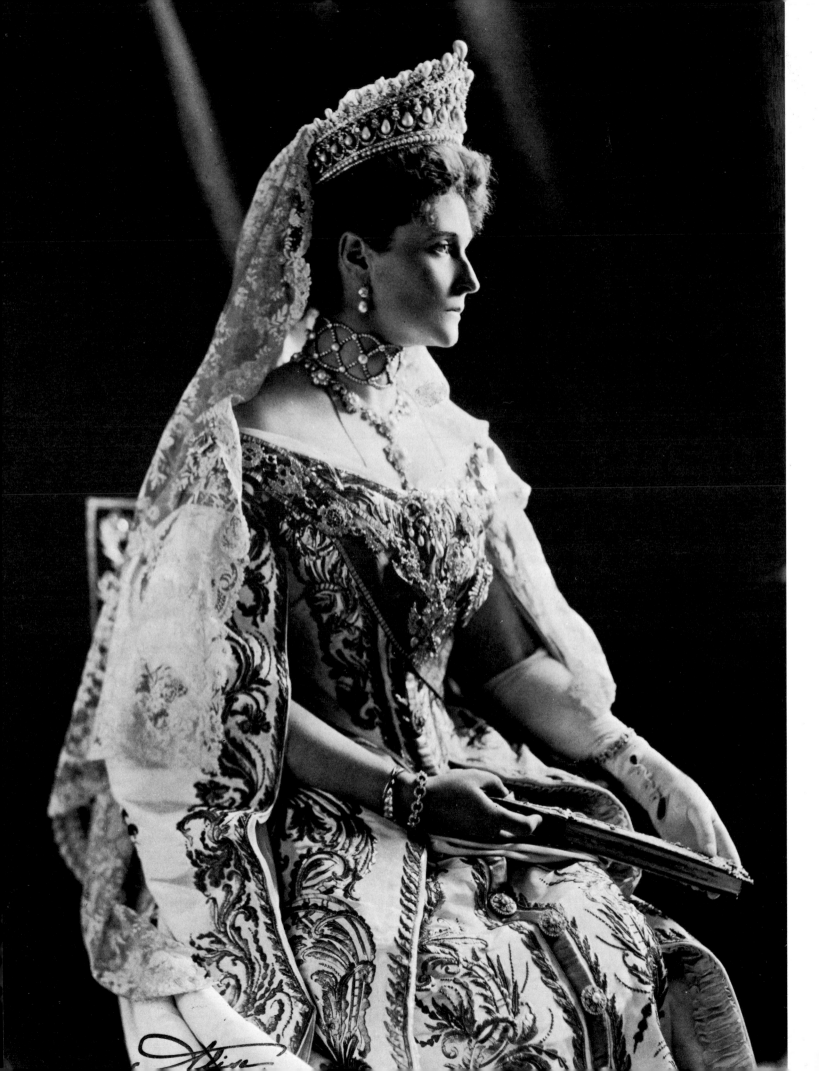

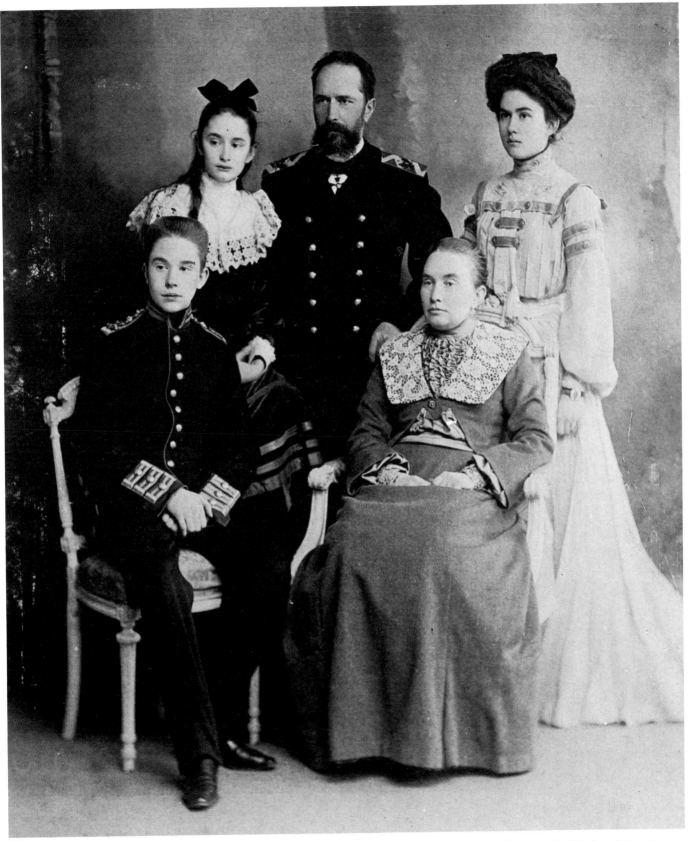

10　The Empress Alexandra in full Court Dress and wearing the Chain of the Order of St Andrew, 1908.

11　Rear-Admiral Sergei Nikolaevich Chirikov (1844 + 1920) with his wife Lubov Alexandrovna née Zelenoi (+1913) and their children Nikolai, then at the Corps of Pages, Sonia, and Ekaterina, c. 1902.

13

12 *left* Count Alexander Vladimirovich Armfelt (1862 + 1941) and his children (L to R) Ksenia, Kiril (in the uniform of the Imperial Law School), Vladimir (in the uniform of the Corps of Pages) and Tatiana.

13 *above left* Count Ivan Davidovich Delianov. St Petersburg, 29 December 1898. Delianov was created a count in 1888 by Emperor Alexander III for his services to the state, most particularly for his role as Minister of Education. He was a man of limited intellect and an extreme reactionary; education in general and the universities in particular during his tenure (1882–97) suffered greatly from narrow minded and dictatorial administration.

14 *above right* Mme Anna Khristoforovna Delianov, née Lazarev, with her pug 'Gubish', St Petersburg, 1886. Mme Delianov (after 1888, Countess) was quite the opposite of her husband and was famous for her small and select musical parties, to which all the most interesting artists and musicians came.

15 *above* Count Felix Nikolaevich Sumarokov-Elston (1820 + 1877). Born and brought to Russia at the age of seven with the name Felix Elston, he was the natural son of Prince Wilhelm of Prussia and a Hungarian Countess. Raised by Princess Kutusov-Smolenski, he married the last Countess Sumarokov and was given her name and title. His eldest son married the last Princess Yusupov and was given her name and title. Their son, the last Prince Yusupov, was the assassin of Rasputin.

16 *right* Baron Feofil Egorovich Meyendorff (1838 + 1919). One of the great and beloved 'characters' of St Petersburg and Court Society, 'Uncle Feofil' (as he was later always known

to all and sundry) was educated in the Corps of Pages and promoted into the Horse Guards in 1856. After serving in the Polish Campaign in the early 1860s, he commanded the 15th Dragoons and then His Majesty's Hussar Guards. One of seven children, his marriage to Countess Elena Pavlovna Shuvalov (1857 + 1943) produced twelve children. Not at all well-to-do, the expense of raising this huge family was beyond his means and the Emperor himself was disconcerted to see his General-Adjutant, attached to His Own Person, walking across the Palace Square during a blizzard and to then be informed that 'Baron Meyendorff walks because he does not own and cannot afford a carriage.' From that day a Court carriage waited outside his door each morning.

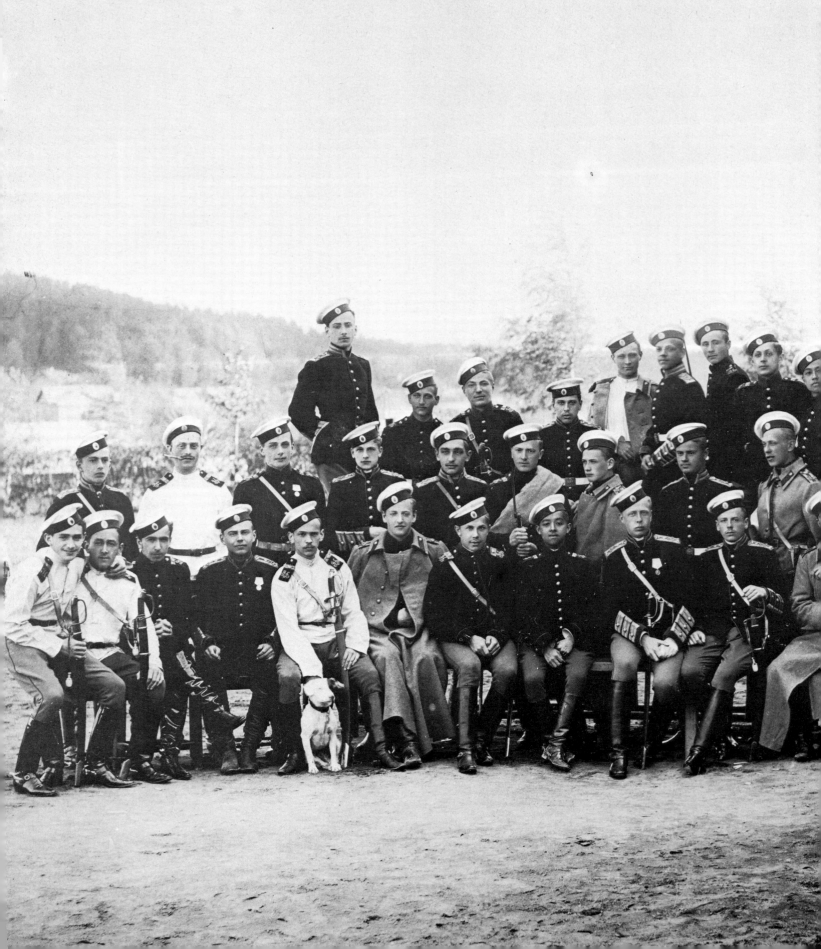

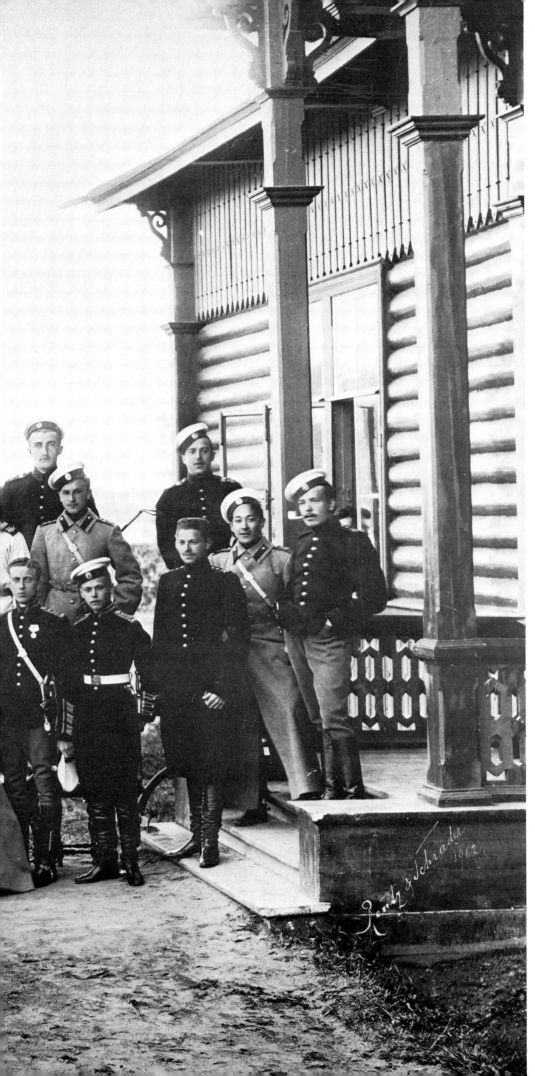

17 The members of the 10 August 1902 Promotion (Graduating Class) of the Corps of Pages—Krasnoe Selo, May 1902. The 1902 Promotion was average in size (40—the Sergeant-Major of the Class Count Keller was 'under arrest' for some minor indiscretion and is missing from the photo) and make-up. There were two foreigners—HRH Prince Chakrabon of Siam and his companion Nai-Pum, one Prince, three Counts, two Barons, twelve bore names of German or Swedish origin, twenty were not the first members of their families to graduate from the Corps (undoubtedly many of the others had connections with the Corps through their mothers' families), one went into the civil service, two went into Line regiments, and the remaining thirty-seven entered the Imperial Guard.

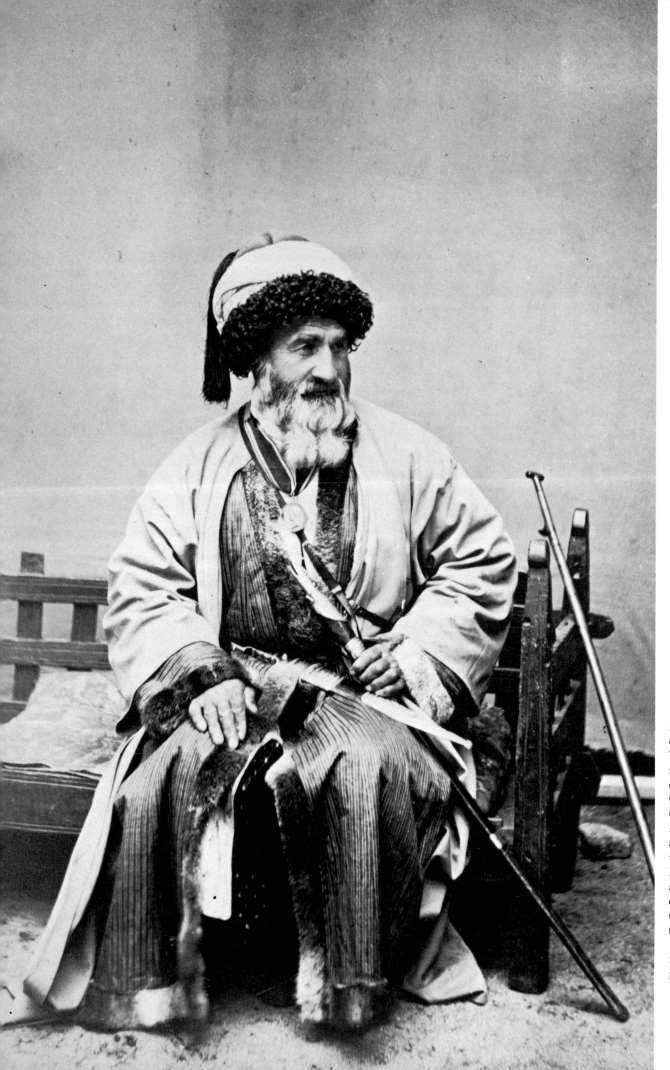

18 Abkhazian chieftain, *c.* 1890. The Abkhazians, a relatively small tribe of the Central Caucasus, part Christian and part Moslem, had long and intimate ties with the Georgians. Many revolted against the Russian occupation and fled to Turkey when their efforts failed.

19 Abkhazian girls, *c.* 1890.

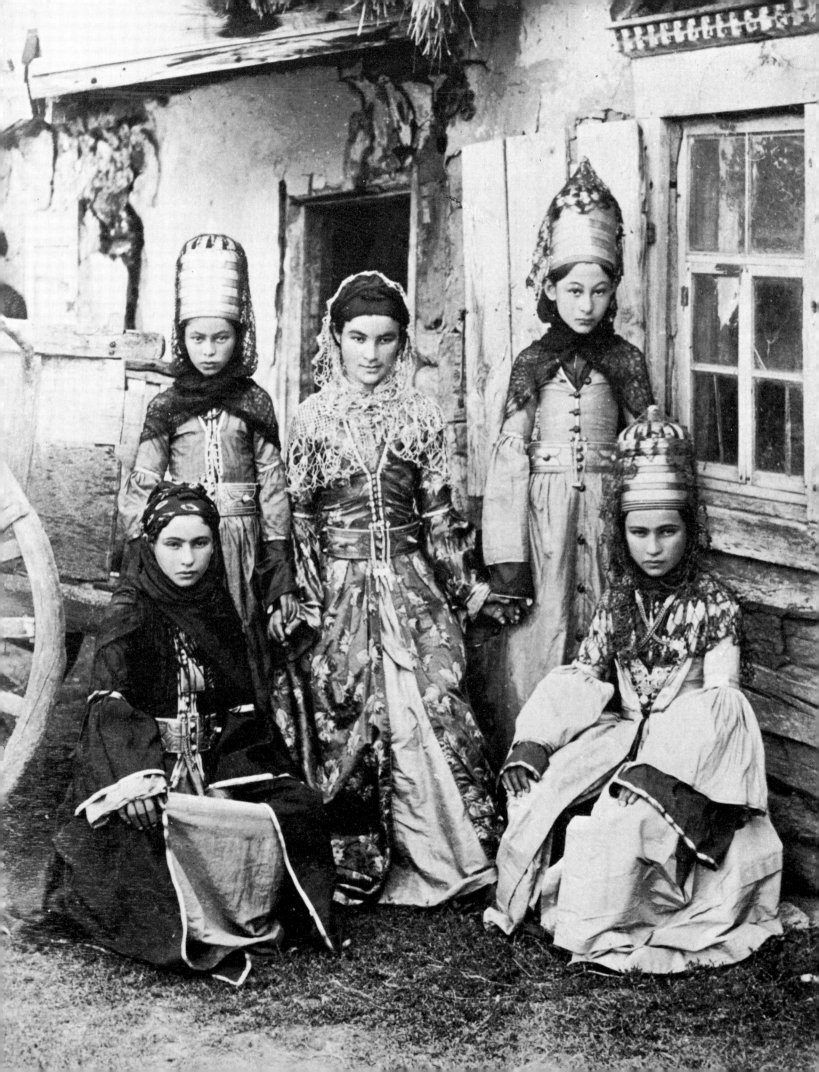

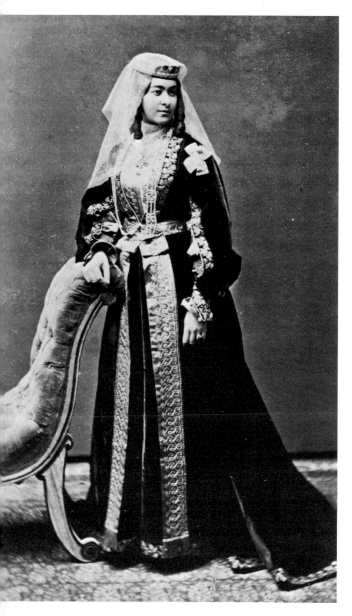

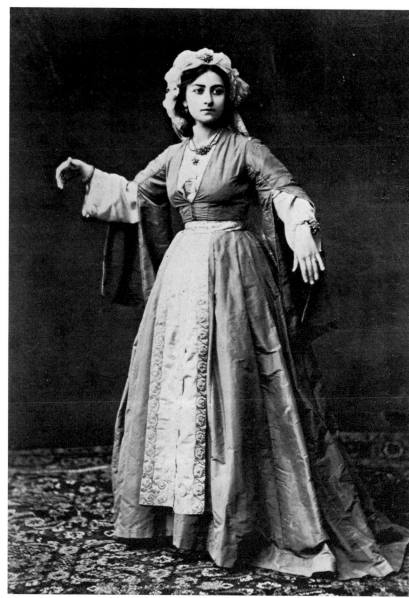

20 Georgian lady, Tiflis, *c.* 1890.

21 Mingrelian lady from the Western Caucasus, *c.* 1892.

22 Kabardin. The native costume of the Kabardin, one of largest Caucasian tribes, was adopted in due course by most of its neighbours and the Kuban and Terek Cossacks, because of its simplicity and elegance.

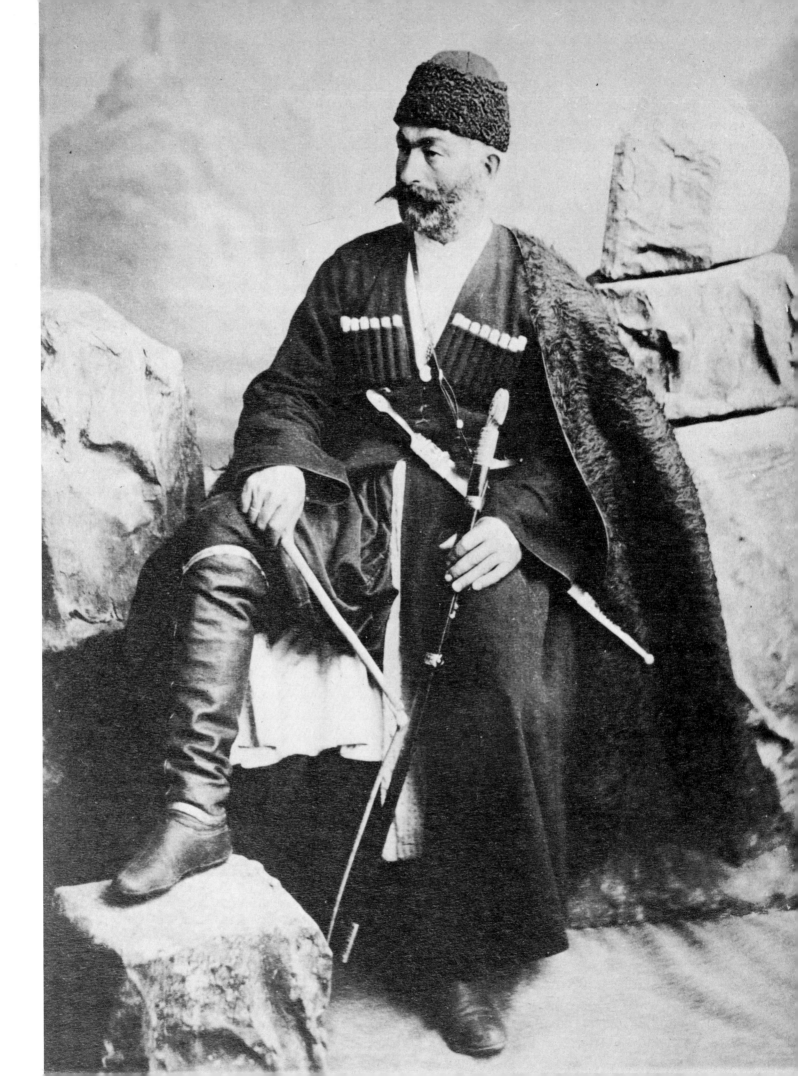

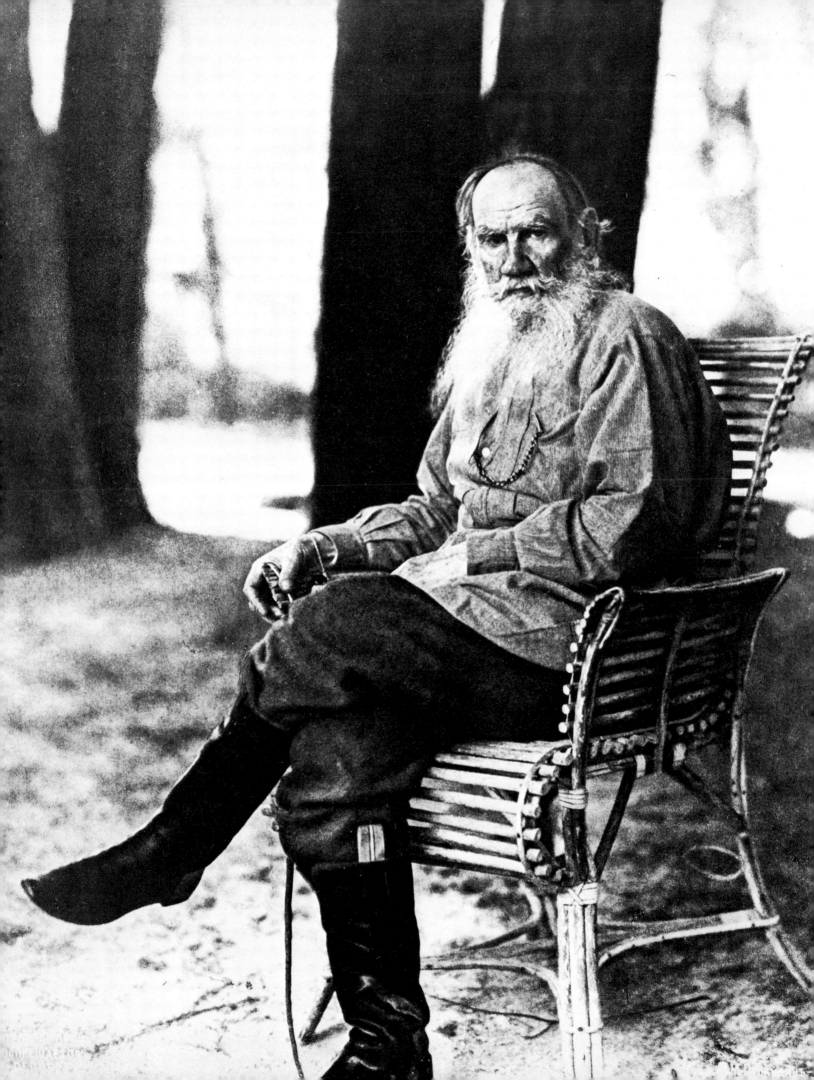

23 *left* Count Lev Nikolaevich Tolstoi (28 August 1828 + 7 November 1910).

24 *right* Tolstoi and his 'young' friend Anton Pavlovich Chekov (17 January 1860 + 2 July 1904) at Gaspra in the Crimea, 1901.

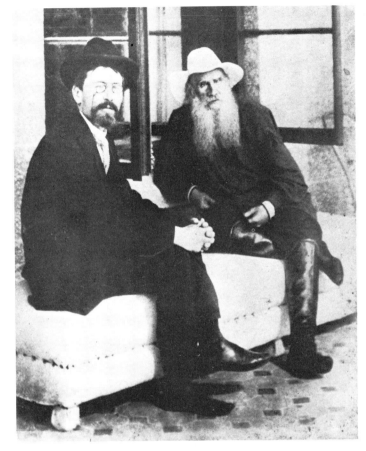

25 *below* Count Tolstoi at work in his study at Iasnaia Poliana. His friend and confidant, disciple and secretary, Vladimir Grigorovich Chertkov (1.October 1854 + November 1936) takes dictation. A former officer of the Horse Guards, a man of great wealth and position in society, Chertkov's views were akin to those of Tolstoi but carried to an extreme.

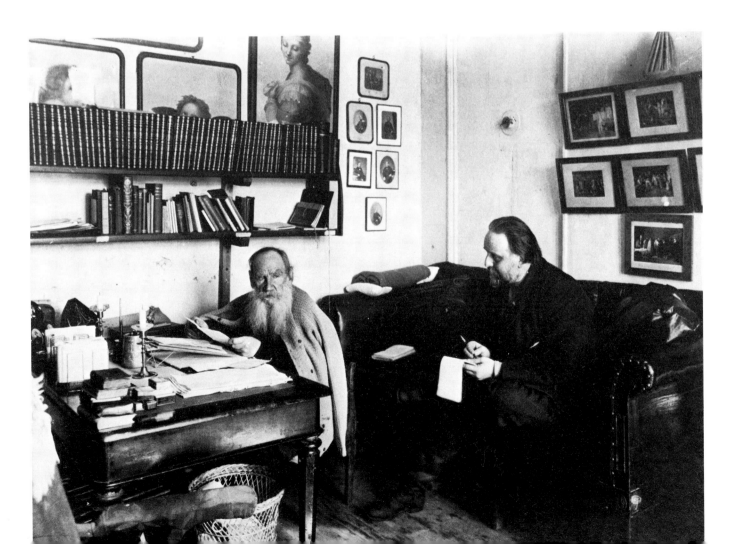

26 The Pashkov sisters, *c.* 1900. Children of Lieutenant-General Mikhail Vasilevich Pashkov (+1863) and his wife Marie Trofimovna née Baranov (+1887).

(L to R) (1) Princess Marie Mikhailovna Golitsyn (13 August 1836 + 8 April 1910). Senior Mistress of Ceremonies of the Imperial Court and Lady-in-Waiting in attendance on the Empress Alexandra Feodorovna. Her husband SH Prince Vladimir Dmitrievich Golitsyn (+1888) was a General of Cavalry and General-Adjutant of the Emperor. (2) Mme Olga Mikhailovna Buturlin (3 October 1843 + 16 September 1908). Directress of the Pavlovski Institute for young girls. Her husband was Lieutenant-General Nikolai Nikolaevich Buturlin (+1894). (3) Mme Alexandra Mikhailovna Apraksin (2 November 1829 + 18 January 1916). 'Dame a portrait' of the Court, Mistress of the Court of the Grand Duchess Ekaterina Mikhailovna. Her husband was Grand Marshal of the Nobility of Orel, Master of the Court Viktor Vladimirovich Apraksin (+1898). (4) Mme Ekaterina Mikhailov Ozerov (2 November 1832 + 9 January 1910). Her husband was Russian Minister in Darmstadt, Master of the Court Petr Ivanovich Ozerov (+1901).

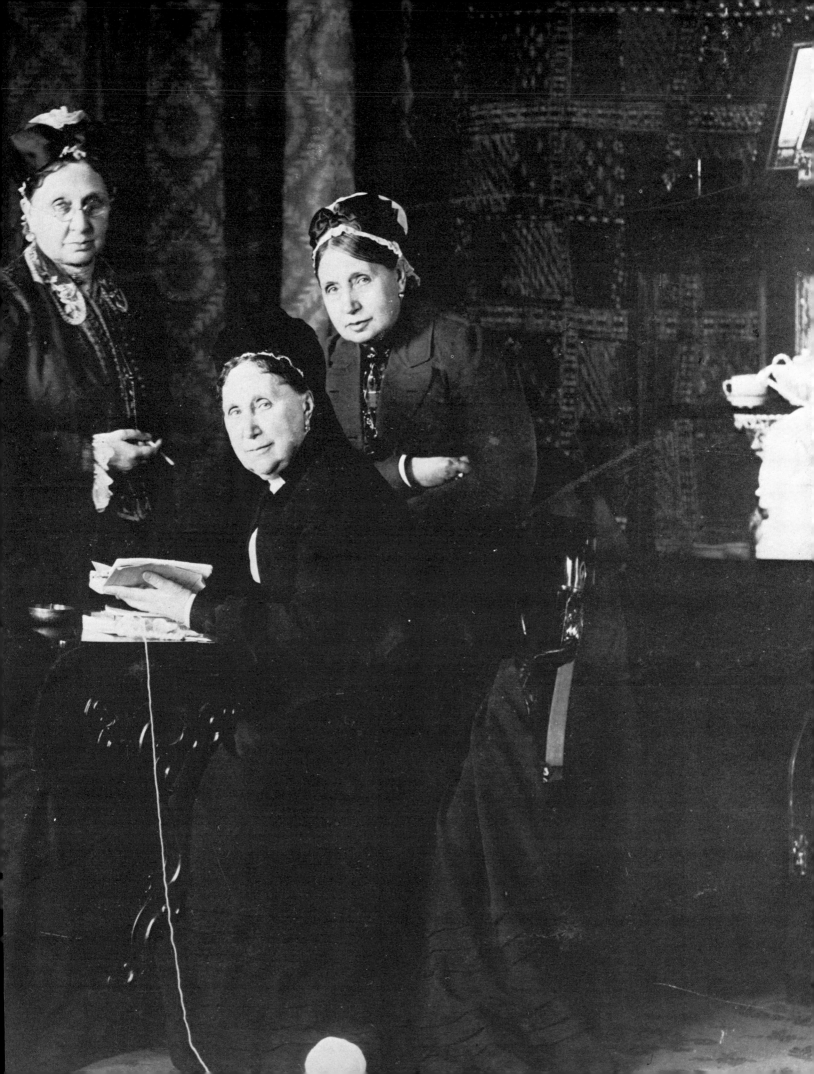

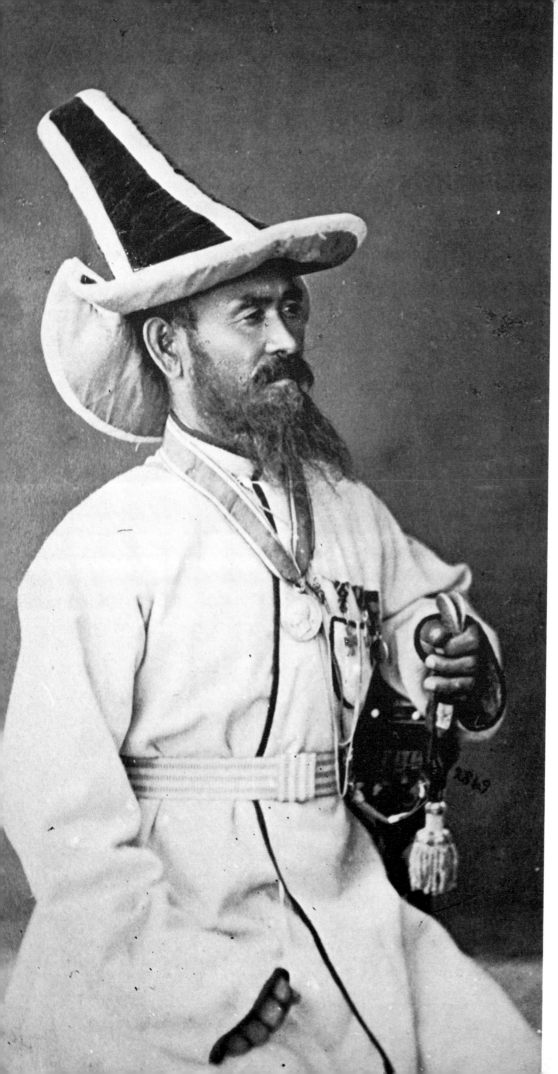

27 A Nogai of some prominence. Although the costume is typical in style of his tribe, he wears a Russian officer's belt around his waist and decorations on his breast, showing that he is or was in Russian military service. The medal hung from his neck was given by Alexander II to tribal chieftains throughout the Empire. The medal hangs from a ribbon of the Order of St Stanislas. The Nogai were part of the Golden Horde. Converted to Islam, they submitted voluntarily to the Russian state between the sixteenth and eighteenth centuries.

28 A Kirgiz, *c.* 1890. This descendant of the warriors of Genghis Khan, of a tribe that roamed Central Asia from China to the Volga and beyond, appears exactly as did his ancestors of the time of the Mongol Conquest.

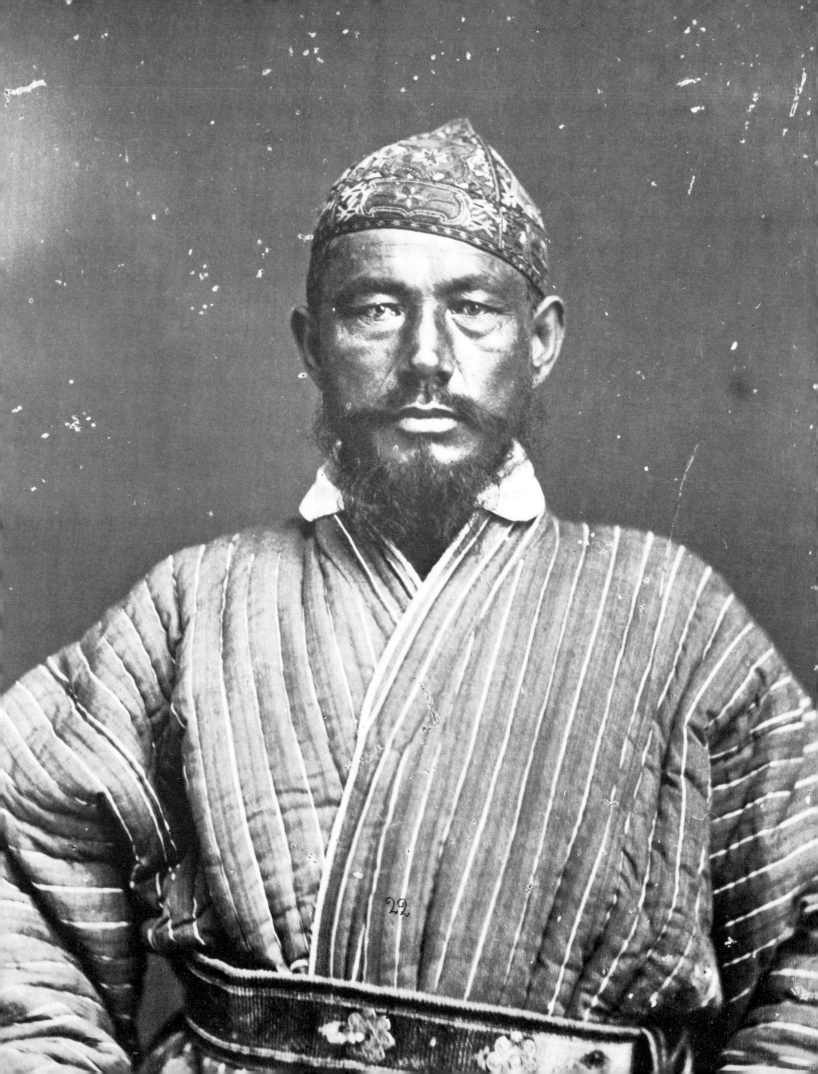

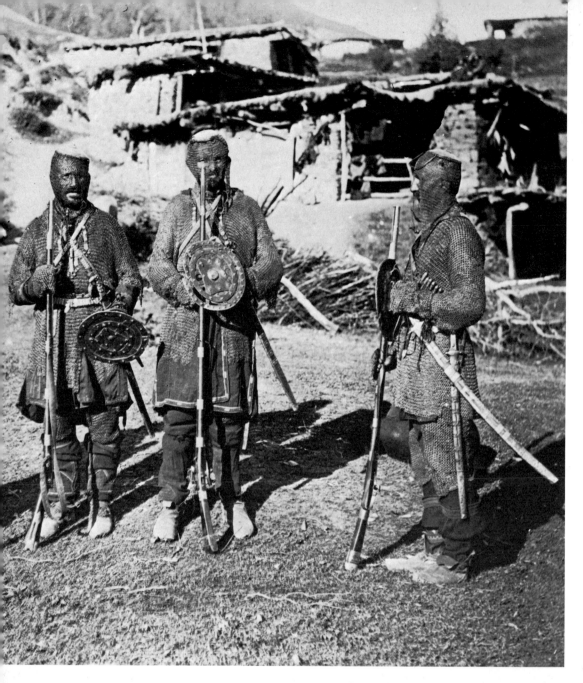

29 *left* Khevsurs, clad in the chain mail of the Crusaders they claimed as ancestors.

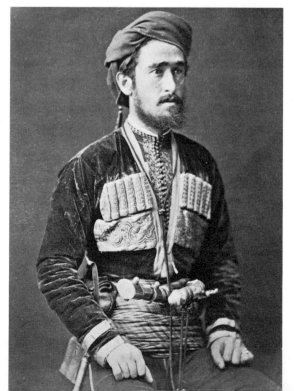

30 *left* Gurien. The Guriens were another of the Caucasian tribes.

31 Tushin woman of the village of Tushet, near Mount Kazbek along the Georgian Military Road, *c.* 1890.

30

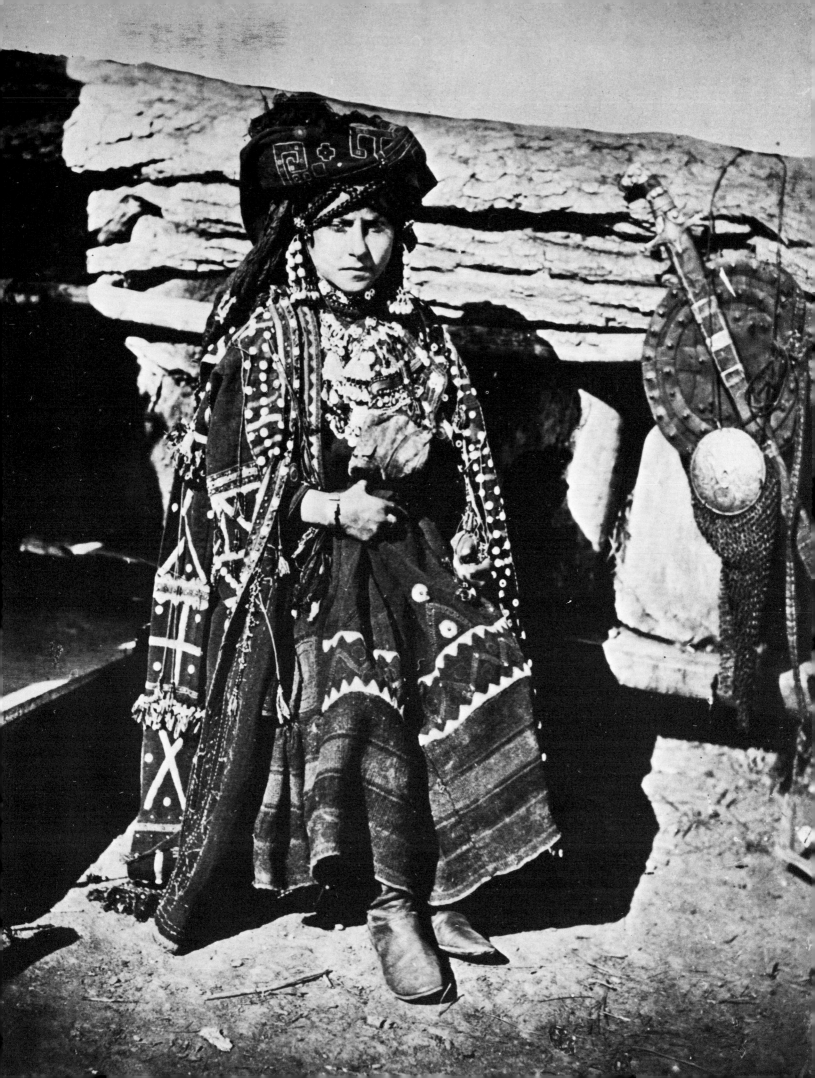

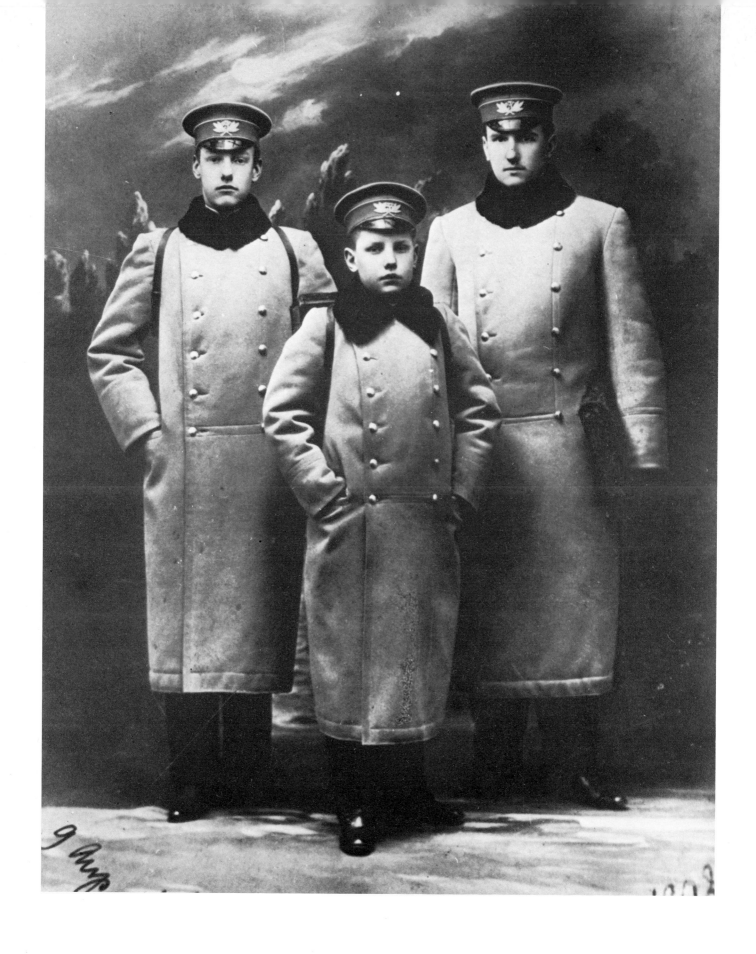

32 The brothers Princes Dmitri, Vladimir and Boris Leonidovich Viazemski, as students, 9 April 1902. Boris was murdered by the peasantry, Dmitri was shot in 1917, and Vladimir died in exile in Paris in 1960.

ST PETERSBURG

> I had pictured St. Petersburg to myself as a second Paris, a city glittering with light and colour, but conceived on an infinitely more grandiose scale than the French capital. The atrociously uneven pavements, the general untidiness, the broad thoroughfares empty except for a lumbering cart or two, the absence of foot passengers and the low cotton-wool sky, all this gave the effect of unutterable dreariness. And this was the golden city of my dreams! This place of leprous fronted houses, of vast open spaces full of drifting snow flakes, and of vast emptiness. I was never more disappointed in my life.

So wrote a British diplomat, Lord Frederick Hamilton, of the pre-revolutionary Russian capital, the great city founded by Peter the Great to provide a 'window on the west', and to present Russia's European face to the rest of the world. But if the gloom and intense cold of a St Petersburg winter robbed the city of the metropolitan bustle of Paris or London, few could deny that it was their equal in scale and grandeur. Nor was it surprising that it had the power to capture the imagination, for, even by the nineteenth century, St Petersburg was still inextricably linked with the strange and compelling personality of its creator, Peter the Great. Only he could have brushed aside so many practical considerations to realise his vision on the low-lying and unhealthy marshland of the Neva estuary, threatened until 1708 by the Swedes, to whom the whole of Livonia had belonged, and every autumn thereafter by the insurmountable danger of floods; in a bad year, and there were many, scores of lives would be lost.

St Petersburg is a city dominated by water, by the vast River Neva, frozen from the middle of November until the beginning of April, by its great canals, constructed by Peter the Great who was fascinated by all things maritime, by its docks, and its innumerable quays. Because of the swampy nature of the ground, most of the buildings had to be constructed on piles, and no doubt it was the expense of building as well as the notorious climate that made so many Russians

reluctant to move to the nascent city. But Peter refused to admit any obstacle, and what could not be achieved by persuasion, or even incentive, was achieved by compulsion. The size and style of private housing was strictly prescribed, and this overall unity of design, the great public buildings, churches and palaces erected by Peter and his successors; and the vast streets, often up to 100 feet wide, and many squares, make St Petersburg a city of incomparable dignity and grandeur. Lady Londonderry remarked that so monumental was the scale of the streets and buildings that carriages were reduced to nutshells and people to insects.

By the First World War, 'Piter', as it was colloquially known, was the greatest city in Russia, the leading commercial centre, the seat of government, and the centre of fashionable and intellectual life. It covered an area of 35 square miles, and its population, as Peter the Great would

33 View from the corner of 4th Line and University Quay on Vasilevski Island towards the Admiralty. On the left, the corner of the Academy of Art, and in front of it two Egyptian Sphinxes brought from Thebes in 1832. The ends of the two wings of the Admiralty can be seen and the construction of buildings in the space between the wings is in progress, c. 1880.

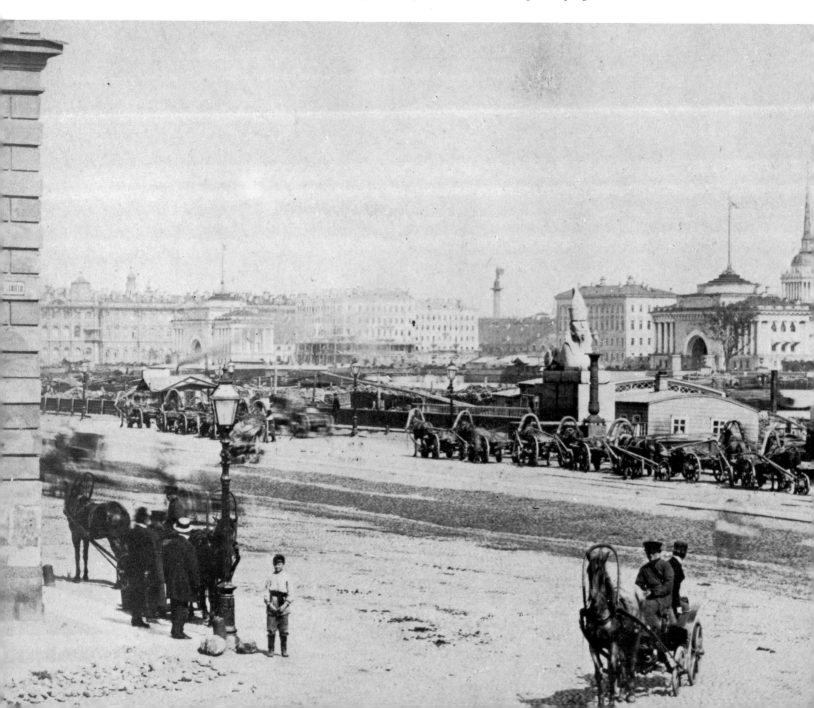

have been glad to note, was cosmopolitan. But, as Lord Frederick Hamilton and many other travellers noted, there was a sombre and essentially Russian side to its character.

The focus of the city and its life was the Imperial court, and the elaborate formality which surrounded it. The Tsar, either in the Winter Palace within the city, or at Tsarskoe Selo, a short train ride away, set the tone for the whole of Society. Under Nicholas II, a faster and more libidinous set developed as a counterpoise to the strait-laced court circle. But St Petersburg was a city designed to display an Emperor in the most resplendent fashion, and nothing could detract from his glory. Thus, if the streets were dull and empty, the great palaces set a standard of incomparable splendour behind doors closed except to the select and invited few.

34 *above* River steamers and barges tied up along Vasilevski Island, *c.* 1880.

35 *below* Prince P. Trubetskoi's bronze statue of the Emperor Alexander III on Znamenskaia Square, facing the Nikolaevski Railroad Station. Behind, the Great Northern Hotel, *c.* 1910.

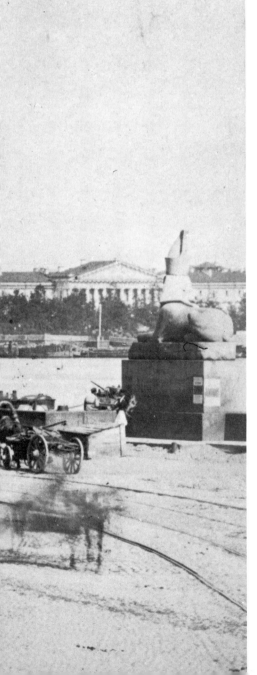

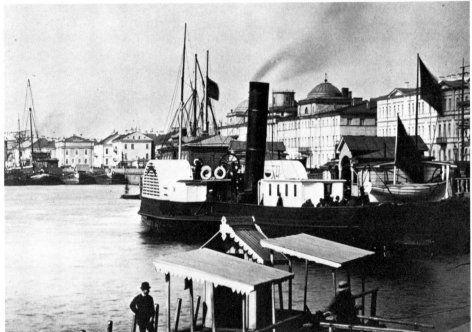

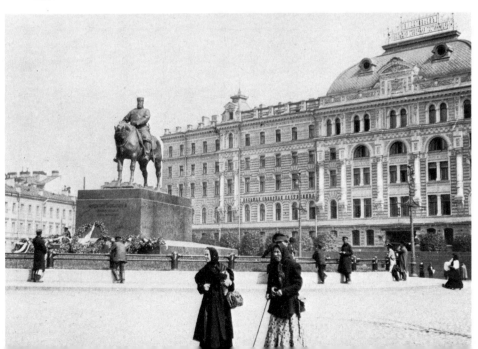

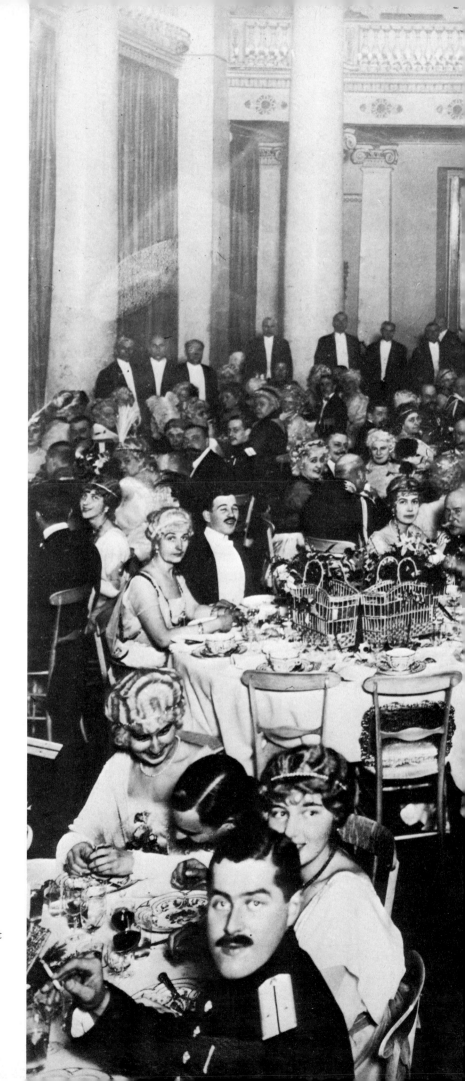

36 Dinner at a ball given by Countess 'Betsy' Shuvalov at the beginning of 1914, the famous 'bal blanc et noir' in her palace on the Fontanka in St Petersburg. Countess Shuvalov was one of the most prominent hostesses in St Petersburg in the years before the War and her guests were the most prominent of St Petersburg and Court Society.

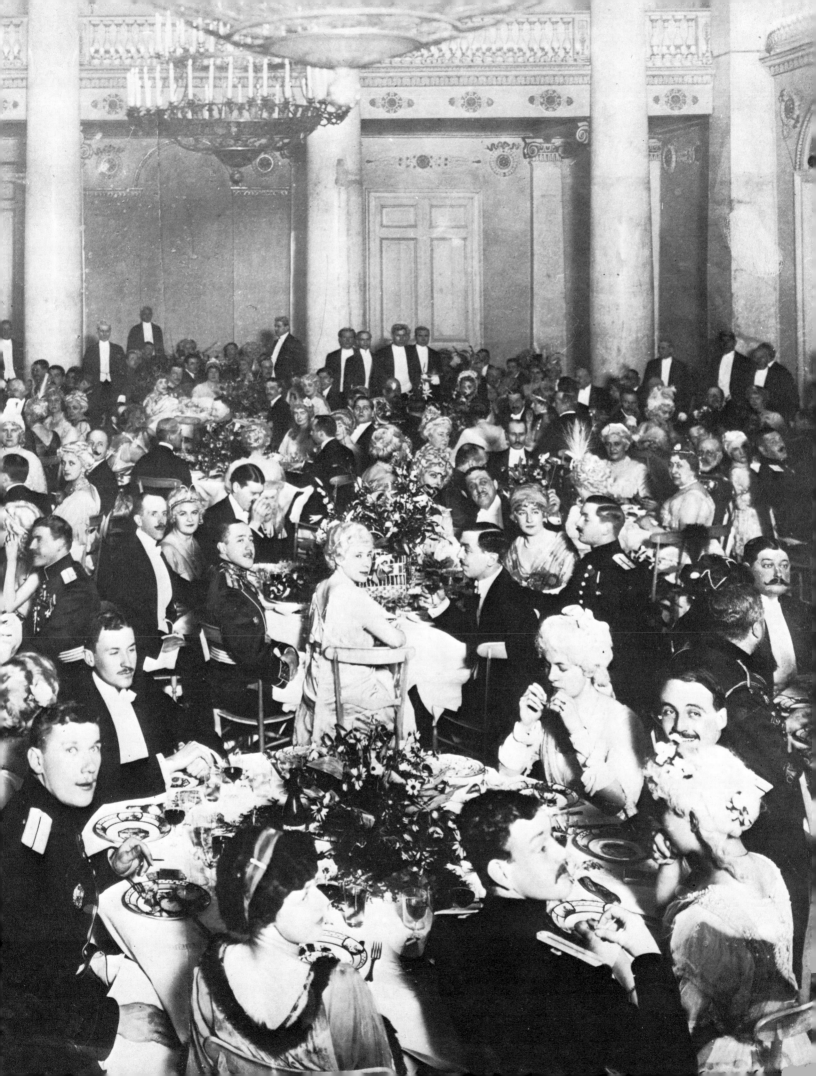

 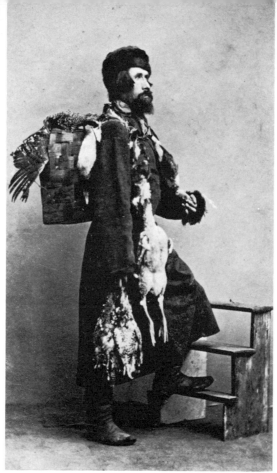 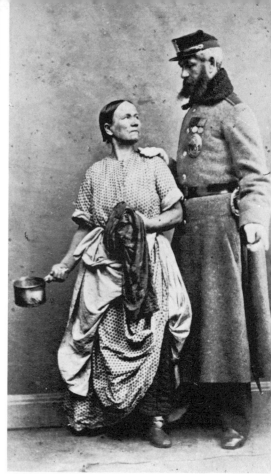

37 Old woman. 38 Hawker of fowl and game. 39 Policeman with a washerwoman.

37–48 'Types' found and photographed on the streets of St Petersburg by the photographer William Carrick, early 1860s. Carrick's 'types' form a remarkable record and deserve a book unto themselves.

43 A veteran of the militia. 44 Gamekeeper. 45 Street musicians.

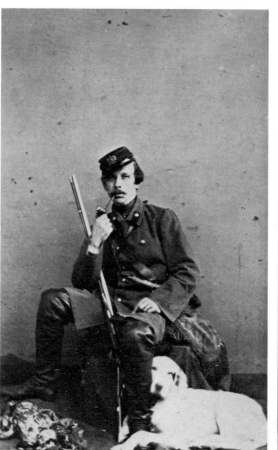 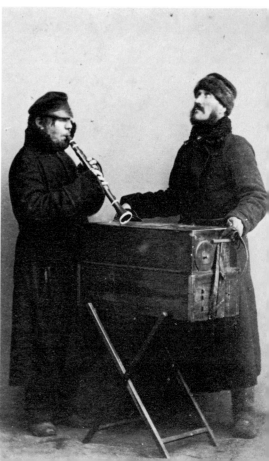

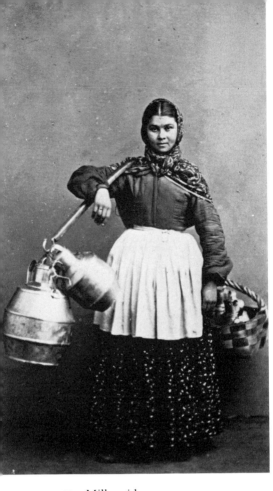

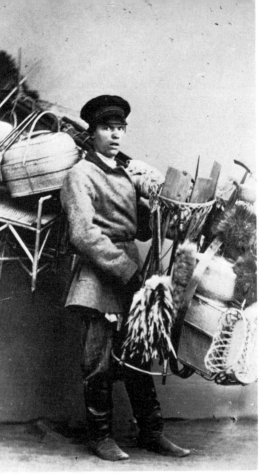

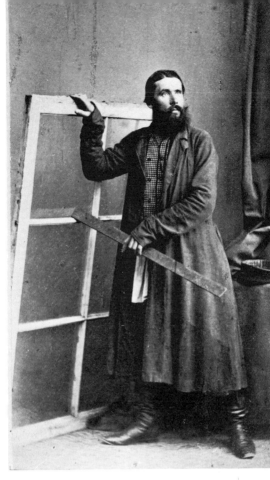

40 Milkmaid.

41 Hawker of brooms, dusters, woven baskets, etc.

42 Glazier.

46 A saintly man (*starets*).

47 Peasants having tea.

48 Hawker of brooms.

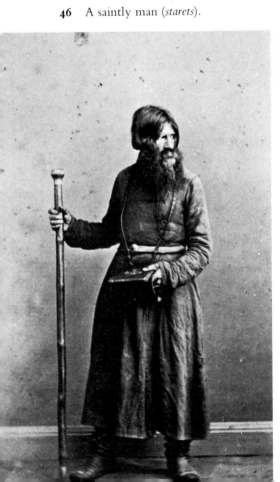

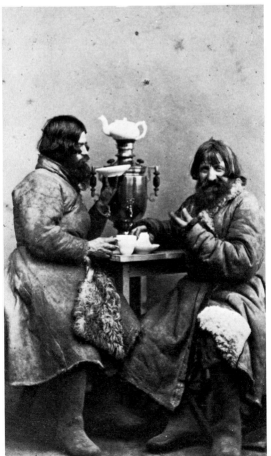

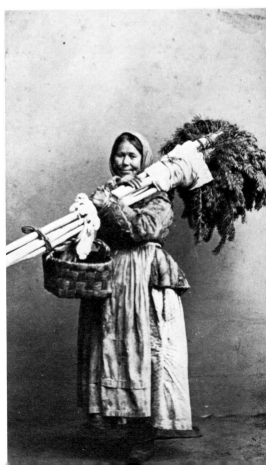

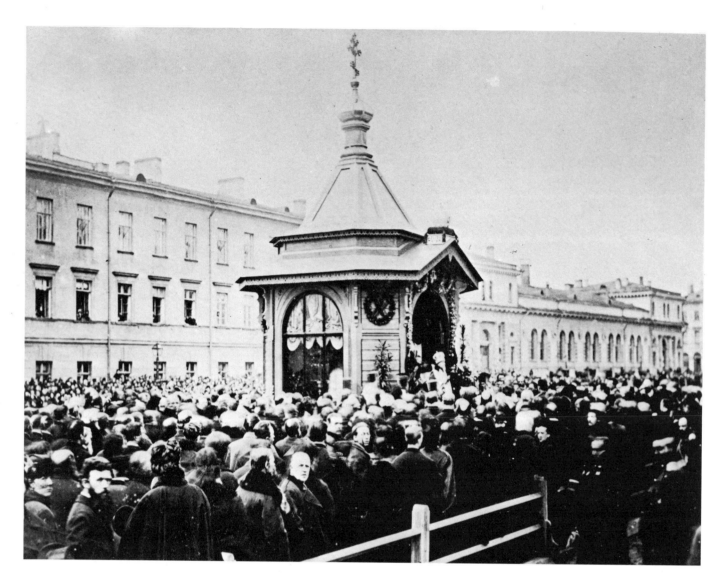

49 Te Deum on the Ekaterinski Canal dedicating the opening of a temporary chapel on the spot where the Emperor Alexander II was assassinated, St Petersburg, spring 1881.

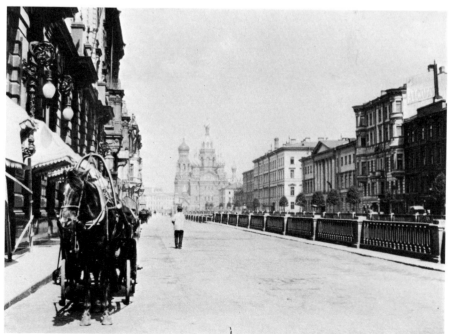

50 Looking down the Ekaterinski Canal, *c.* 1910, towards the Church of the Resurrection, built on the spot where the Emperor Alexander II was assassinated on 1 March 1881. Begun in 1883, it was completed only in 1907.

51 Procession conveying the body of the murdered Emperor Alexander II from the Winter Palace to the Cathedral in the Fortress of SS Peter and Paul, 7 March 1881.

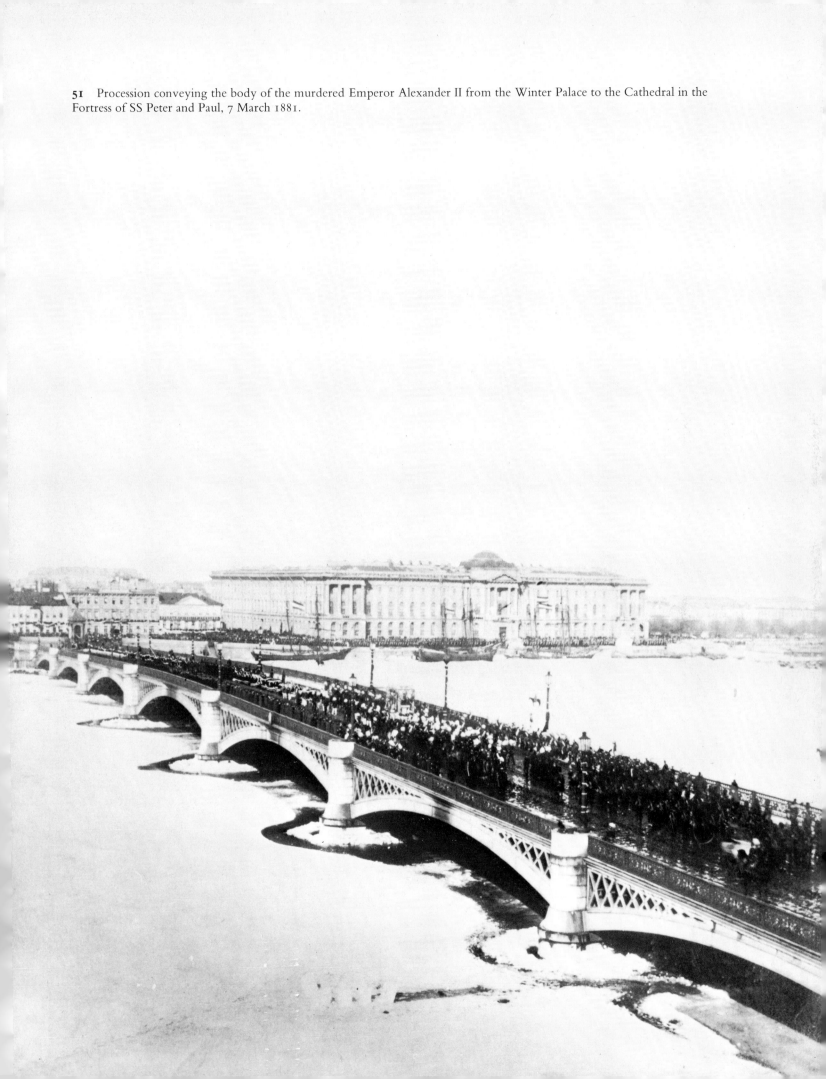

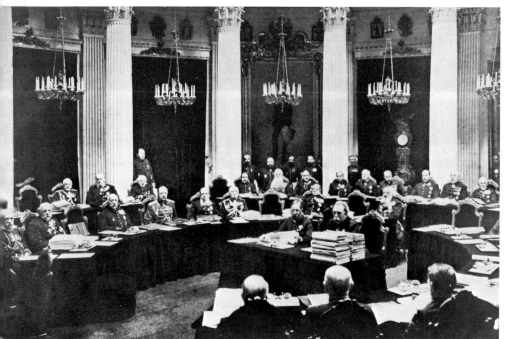

52 Session of a General Meeting of the State Council, 22 May 1900.

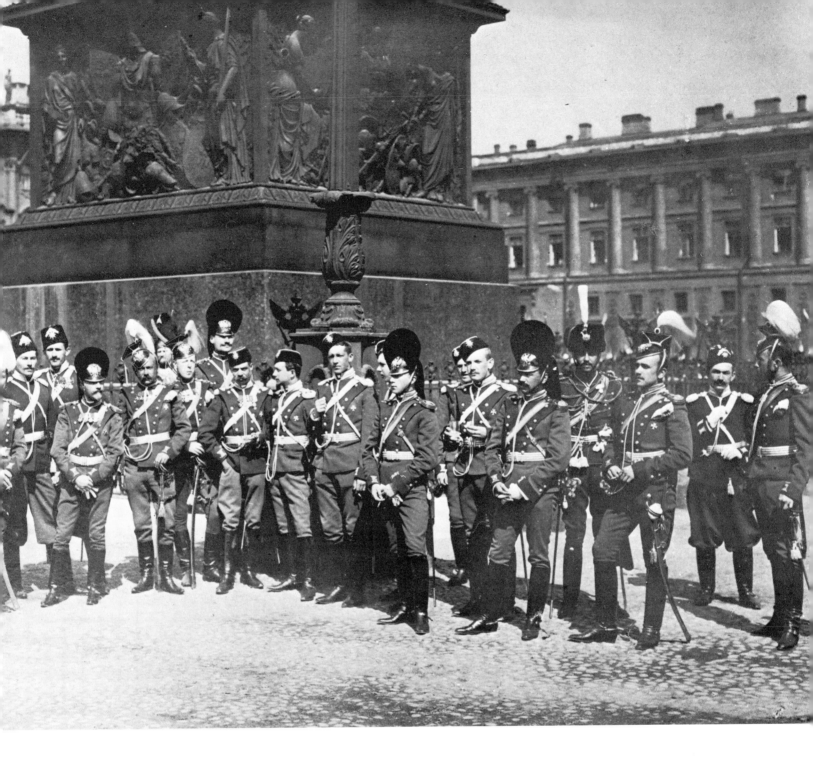

53 Opening of the State Duma, St Petersburg, 27 April
1906 o.s. Officers of the Imperial Guard standing in front of
the Alexander Column on the Palace Square. In left
background, the Winter Palace. At the right, the
Headquarters of the Imperial Guard. The substantial number
of troops drawn up in the Palace Square was consistent with
standard practice on any important public occasion which was
honoured by the Emperor's presence, but more than one
important personage believed that the people might
demonstrate and even attack the new 'representatives of the
people'.

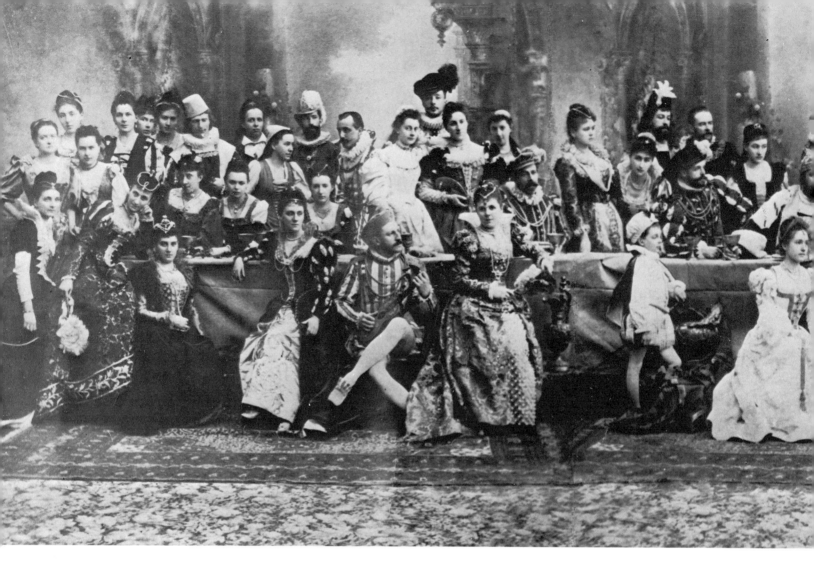

54 Costume Ball at the Mikhailovski Palace, St Petersburg, *c.* 1893.

1 Nadezhda Illarionovna Taneev née Tolstoi
2 Princess Ekaterina Alexandrovna Kudashev
3 Evgenia Petrovna Vasilchikov, later Princess Volkonski
4 N Taneev
5 Olga Petrovna Albedinski
6 Princess Maria Konstantinovna Obolenski née Naryshkin
7 —
8 —
9 Ekaterina Illarionovna Vsevolozhski née Tolstoi
10 Princess Alexandra Nikolaevna Golitsyn
11 —
12 Princess Nadezhda Vladimirovna Dondukhov-Izedinov, née Princess Dondukhov-Korsakov
13 Princess Maria Vladimirovna Dondukhov-Korsakov
14 —
15 Countess Maria Petrovna Bobrinski née Countess Shuvalov
16 Vladimir Vladimirovich Westman
17 Countess Varvara Petrovna Heyden, later Volkov
18 Baron Georgi Alexandrovich Graevenitz
19 Alexander Alexandrovich Levashov (Chevalier Gardes)
20 Countess Alexandra Feliksovna Sumarokov-Elston, later Miliutin
21 Evgeni Nikolaevich Volkov (HM's Hussar Guards)
22 Princess Iashvil née Filipson
23 Countess Sofia Petrovna Gendrikov née Princess Gagarin
24 Princess Maria Nikolaevna Golitsyn
25 Konstantin Nikolaevich Gartong
26 Princess Kudashev
27 Countess Evgenia Kreutz
28 —
29 —
30 Baron Vladimir Romanovich Knorring (Chevalier Gardes)
31 Baron Otton Fehleisen
32 Baroness Olga Feodorovna Heyden
33 Countess Ekaterina Nikolaevna Ignat'ev
34 Duke Nikolai Nikolaevich Leuchtenberg
35 —
36 Nikolai Figner (the famous tenor)
37 Alexander Alexandrovich Benois
38 Maria Vladimirovna Pantaleev née Rodzianko
39 Olga Nikolaevna Bulygin, formerly Khvoshchinski, née Delianov
40 Princess Elisaveta Nikolaevna Obolenski née Princess Saltykov
41 Elisaveta Dmitrievna Novosiltsov née Princess Obolenski
42 Maria Petrovna Albedinski
43 —
44 —
45 Princess Zenaida Nikolaevna Yusupov, Countess Sumarokov-Elston

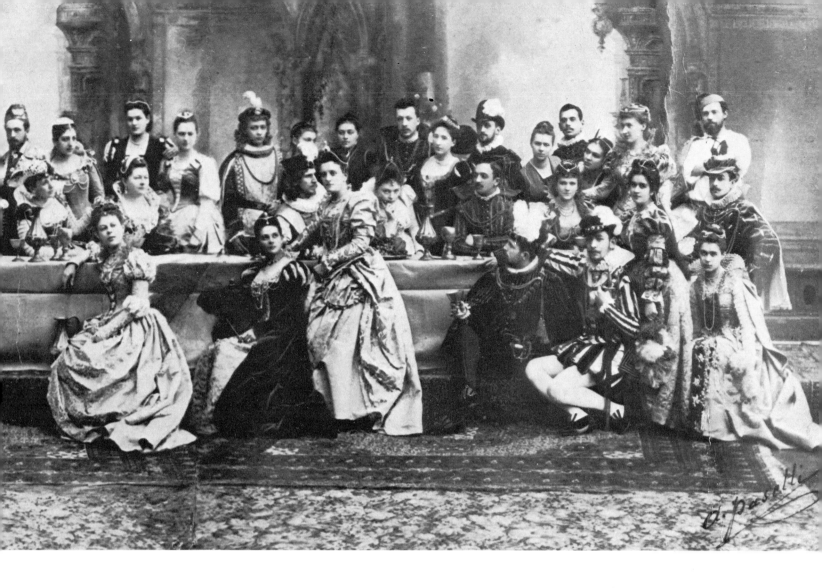

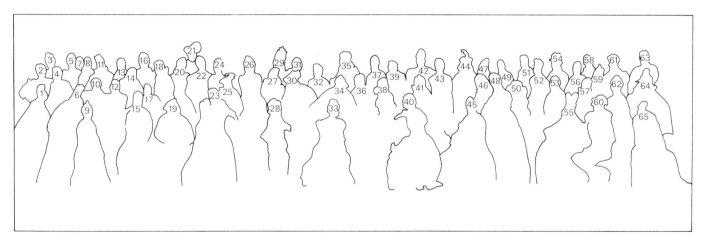

46 Konstantin Nikolaevich Giers

47 —

48 Princess Elena Georgievna Saxe-Altenburg née Duchess of Mecklenburg-Strelitz

49 Elna Alexandrovna Ozerov

50 Elisaveta Novosiltsev

51 Vladimir Vladimirovich Korobin

52 Countess Maria Nikolaevna Ignat'ev

53 Count Tyszkiewicz (Horse Guards)

54 Prince Nikolai Alexandrovich Kudashev

55 Baron Andrei Knorring

56 Maria Stakhovich

57 Baroness maria Karlovna Graevenitz née Simens

58 Alexander Fedorovich Efimovich (Horse Guards)

59 —

60 Alexander Petrovich Albedinski

61 Baroness Anna Georgievna Hoyingen-Huene née Latrov (?)

62 Countess Elisaveta Semenovna Olsuf'ev née Princess Abamelek-Lazarev

63 —

64 Vladimir Khristoforovich Roop (Horse Guards)

65 —

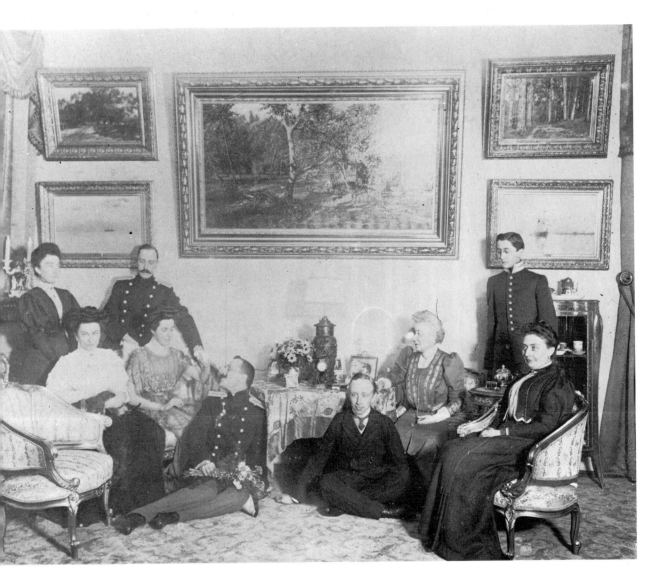

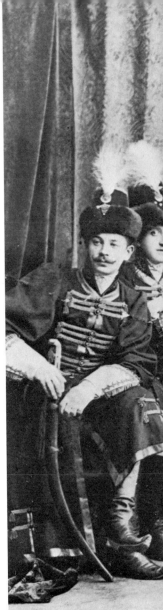

55 The Miklashevski family—St Petersburg, 1908. Of Little Russian (Ukrainian) Cossack origin, the Miklashevski had long served the Empire and its great wealth and ability had brought it a prominence it well deserved.

The family on the engagement of the eldest son Ilia Mikhailovich (seated on the floor at left) to Countess Ekaterina Alexeevna Bobrinski (seated 2nd from left), St Petersburg, 23 February 1908. Seated 2nd from right, Mme Olga Nikolaevna Miklashevski née Troinitski. Standing 2nd from left, her son-in-law Prince Anatoli Anatolievich Gagarin; at right, her son Vadim Mikhailovich (in the uniform of the Imperial Alexander Lyceum); seated at left, her daughter Princess Tatiana Mikhailovna Gagarin née Miklashevski; seated on floor at right, her son Konstantin Mikhailovich Miklashevski. Ilia Miklashevski and Anatoli Gagarin were officers of the Chevalier Gardes.

56 *above right* Officers of the Preobrajensky Guards Regiment in the costumes they wore to the Imperial ball (see page 48). They are dressed as officers of one of the regiments of Streltsi of Moscow (the Streltsi being the first regular regiments of the Russian Army).

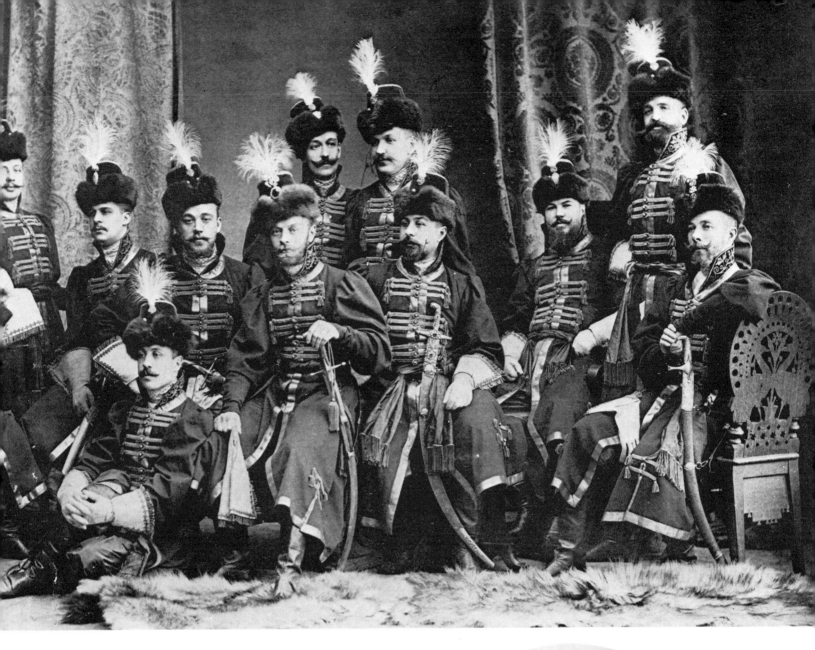

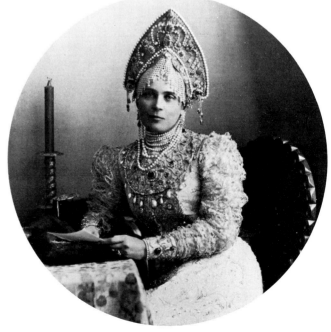

57 Princess Zenaida Nikolaevna Yusopov, Countess
Sumarokov-Elston (20 September 1861 + 24 November
1939). The last of her line and the richest person in Russia, she
married an officer of the Chevalier Gardes, Count Felix
Feliksovich Sumarokov-Elston (5 October 1856 + 11 June
1928), who was given permission by the Emperor, at her
request, to assume his wife's name in order to prevent the line
from dying out. A beautiful and charming woman, she wears
the costume of the wife of a Boyar at the beginning of the
seventeenth century.

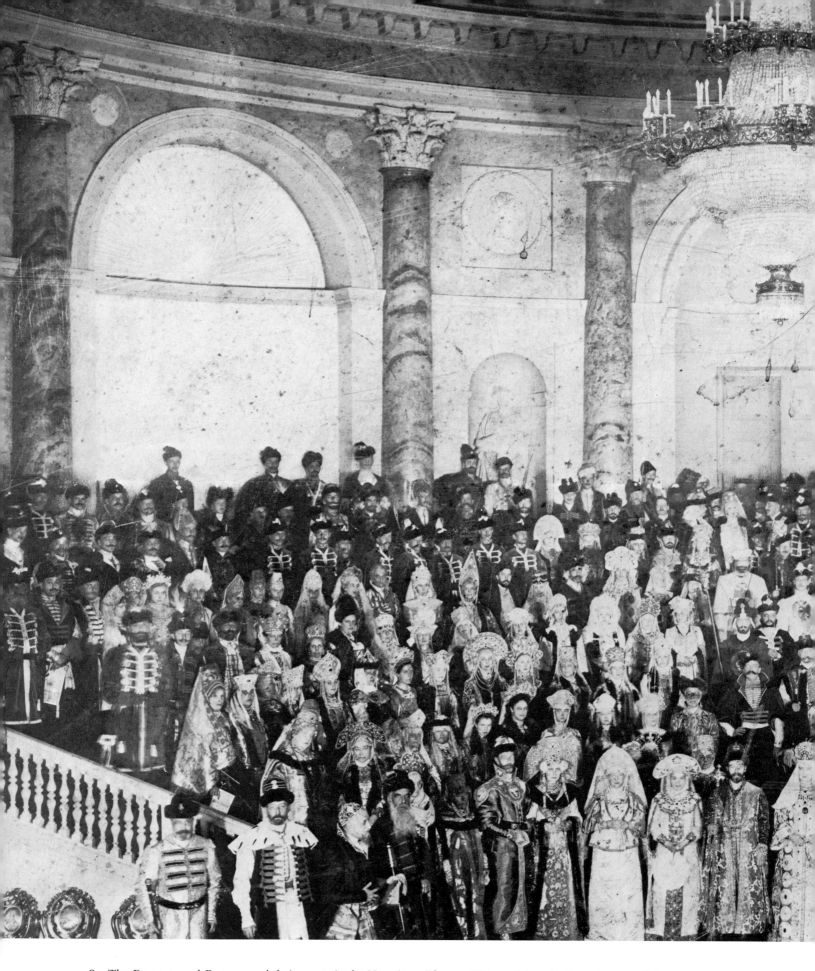

58 The Emperor and Empress and their guests in the Hermitage Theatre, Winter Palace, St Petersburg, 27 February 1903 o.s.

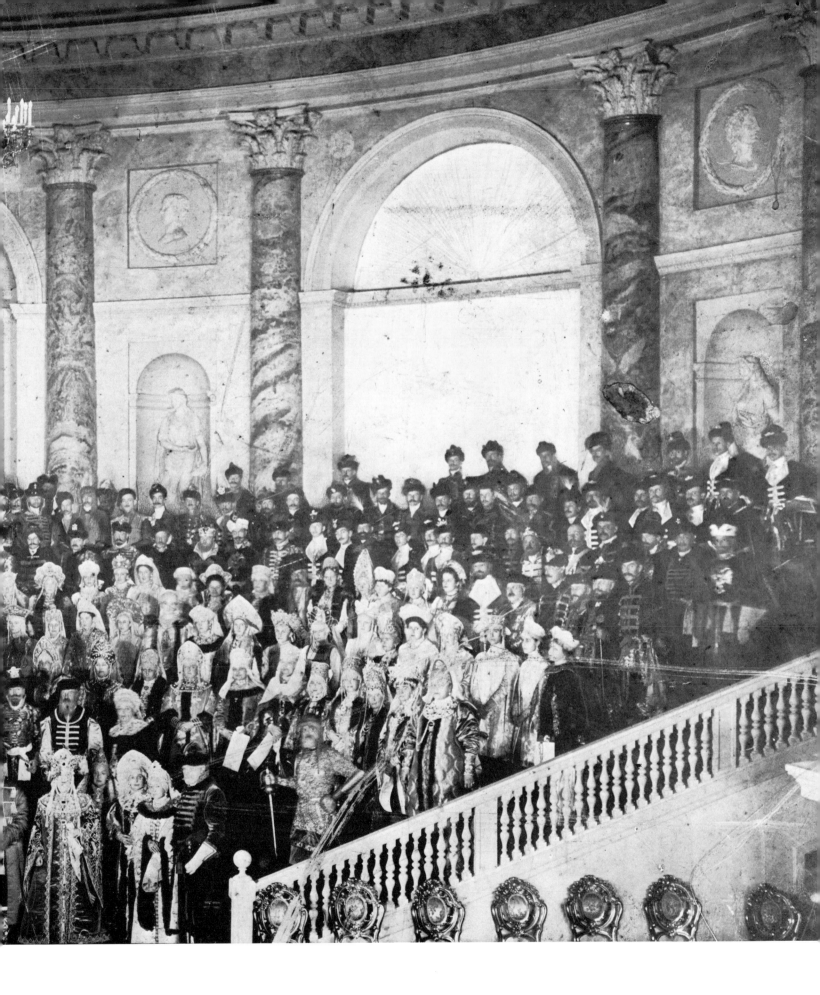

49

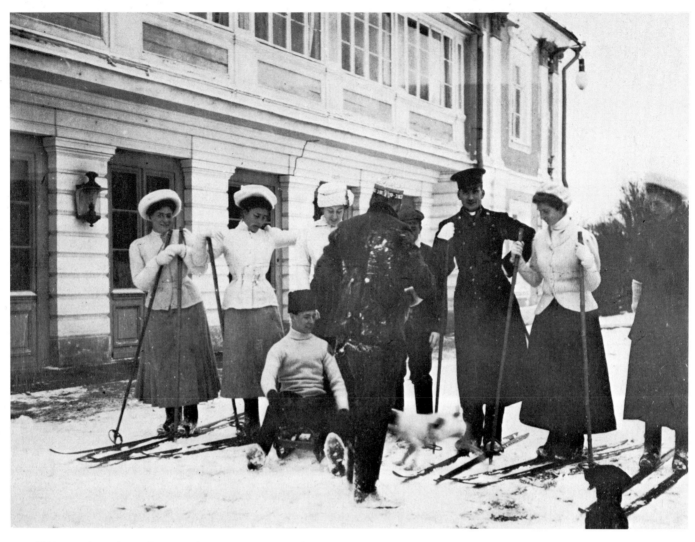

59 Skiing at the Palace of Oranienbaum, near St Petersburg, *c.* 1908. (L to R) Countess Ekaterina Georgievna Carlow, Countess Maria Georgievna Carlow, Baroness Maria Alekseevna Stael von Holstein, Petr Nikolaevich Malevski-Malevich (back to camera), Edgar Robertovich Minkeldi, Alice Robertovna Minkeldi, Andrei Shidlovski (in front).

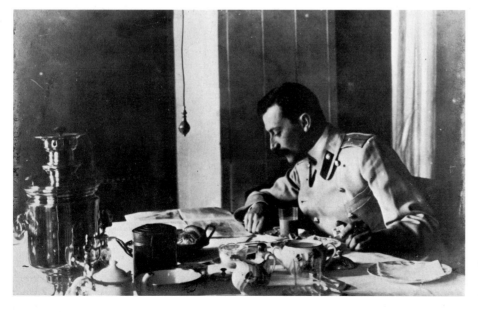

60 Chevalier Gardes Regiment Staff-Captain Ilia Mikhailovich Miklashevski at breakfast, *c.* 1907.

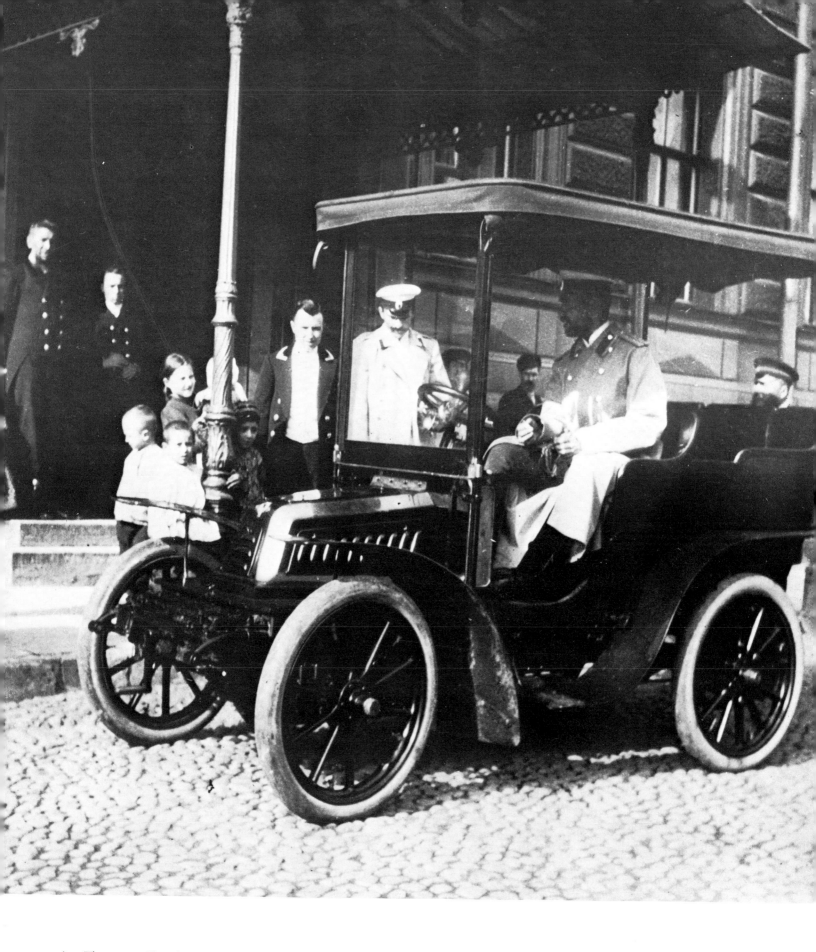

61 The young Chevalier Garde Lieutenant Pavel Pavlovich Rodzianko and his new 'Richard-Brassier' automobile, St Petersburg, 1903. (Walking towards the car, the owner's brother-in-law Prince Alexander Zakharovich Chavchavadze.)

62 Directress of the Smolnyi Institute HSH Princess Elena Alexandrovna Lieven (2 May 1842 + 20 June 1915).

63 The Smolnyi Institute on the banks of the Neva, and the Smolnyi Convent (founded in 1748 by the Empress Elisabeth). The school was founded by Catherine the Great in 1764. In the background are the domes of the Cathedral of the Resurrection.

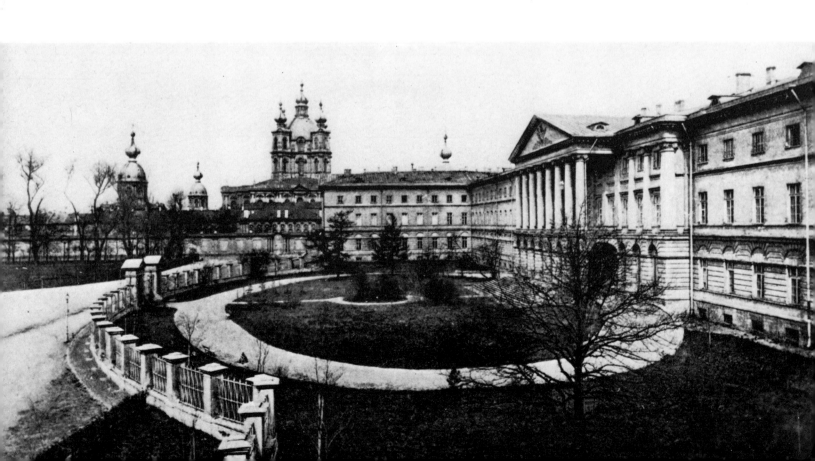

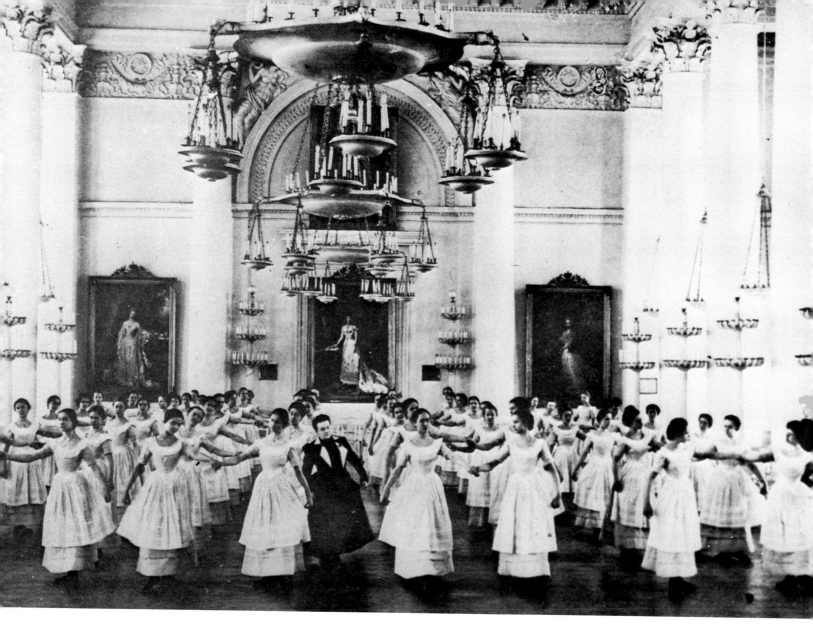

64 Dancing class at the
Smolnyi Institute,
c. 1910.

65 Ice-skating at the
Smolnyi Institute,
c. 1910.

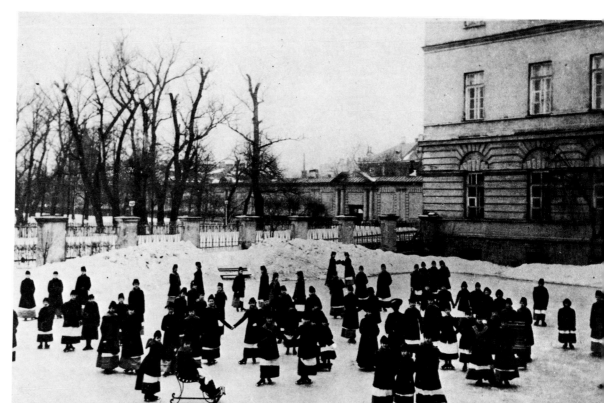

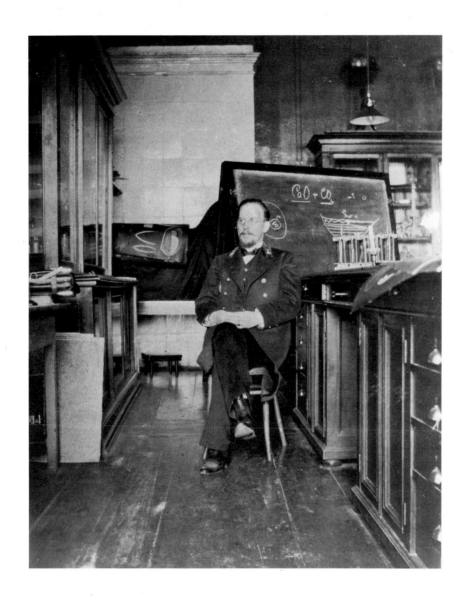

66 Chemistry master in his laboratory at the Smolnyi
Institute, *c.* 1904.

67 *right* Young ladies of the Fourth Class of the Smolnyi
Institute, April 1904.

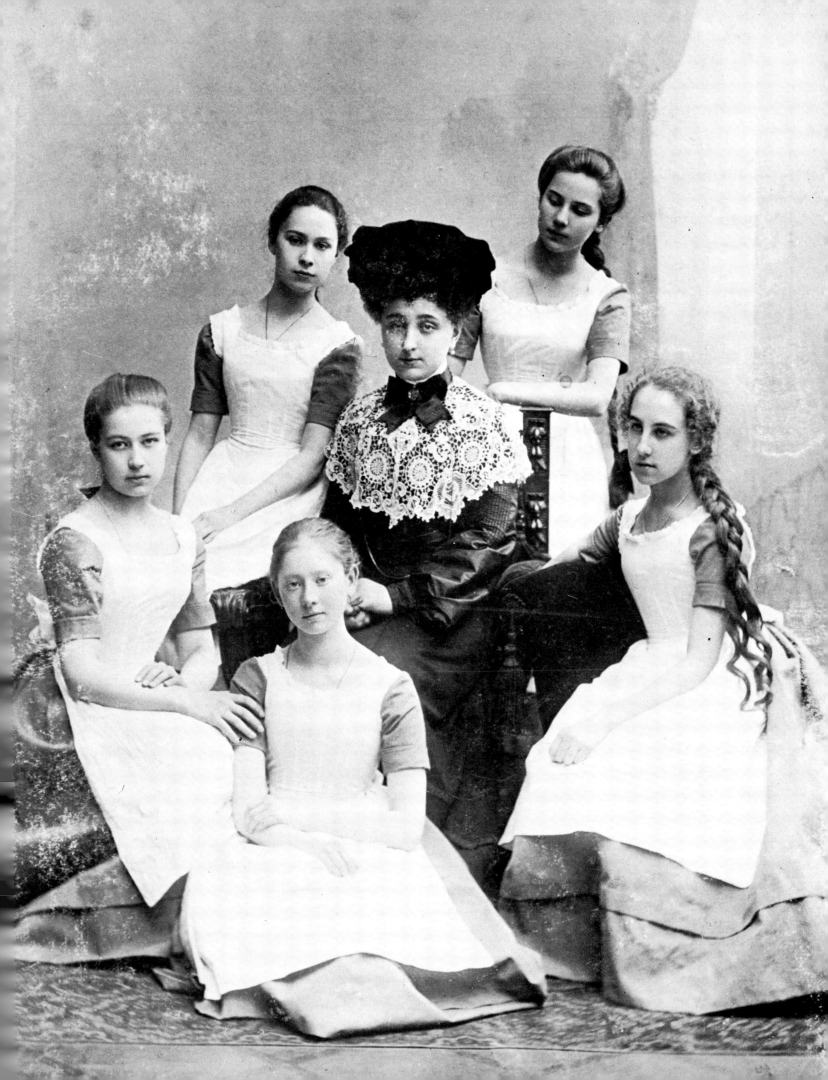

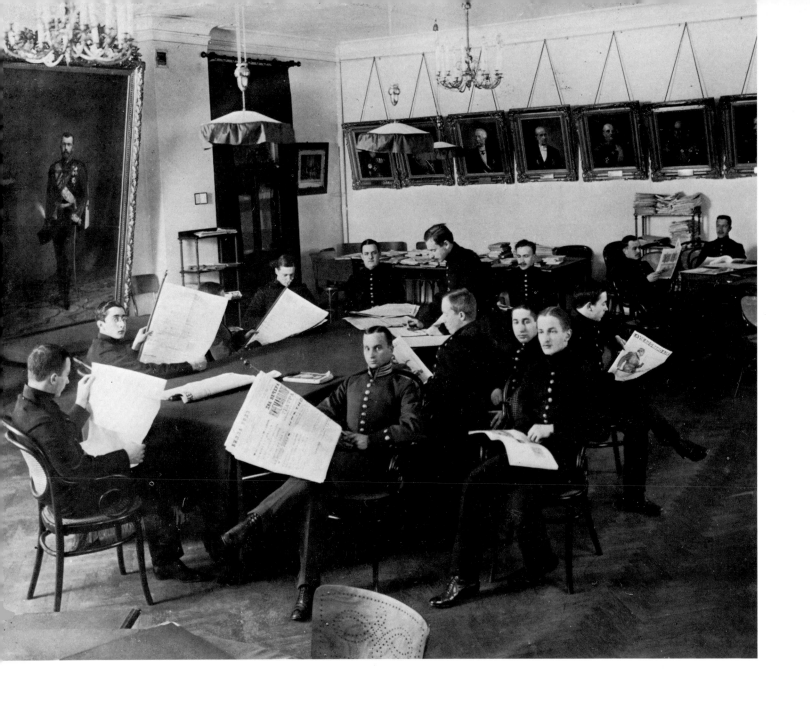

68 Members of the Senior Class of the Alexander Lyceum, in their reading room, *c.* 1910. On the walls are portraits of Emperor Nicholas II and former Directors of the Lyceum.

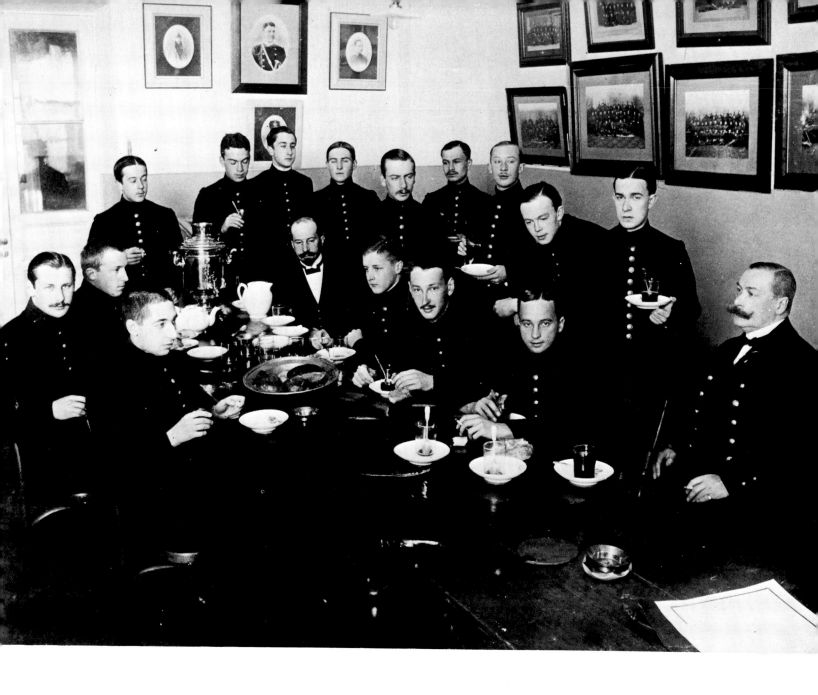

69 Members of the Senior Class of the Alexander Lyceum having tea with two of the masters, *c.* 1910.

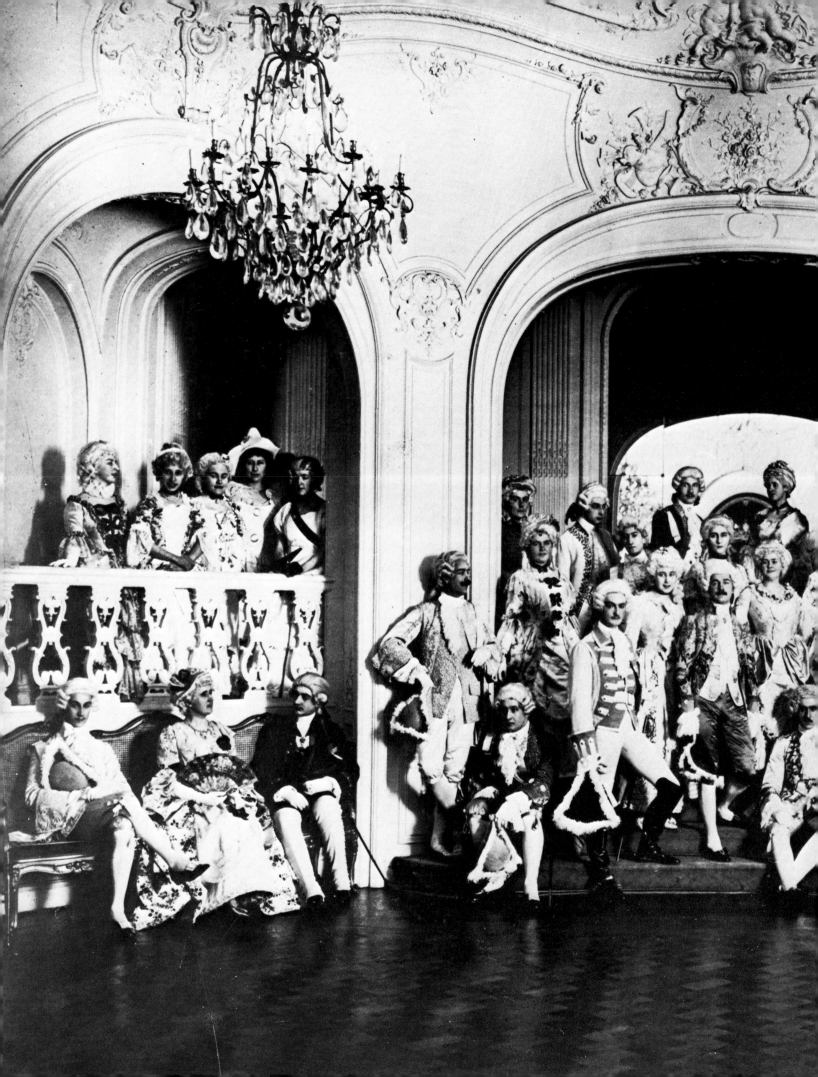

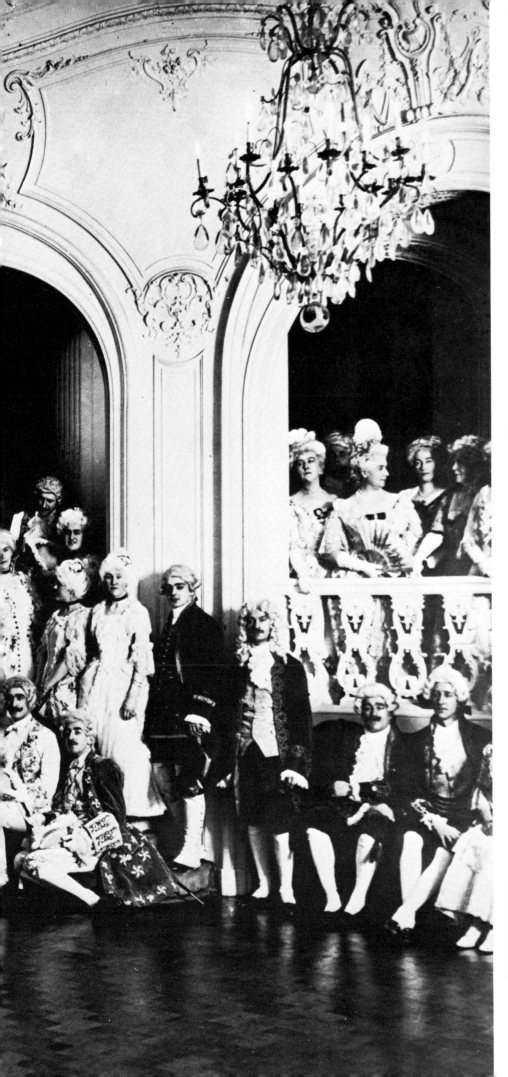

70 Costume Ball at the Palace of Mme M. K. Brianchaninov (formerly Princess Kudashev, née Princess Gorchakov)—St Petersburg, early 1914. This ball was given by Mme Brianchaninov (seated at left) for her two daughters (Kudashev) and their friends.

HOLY MOSCOW

Of all the cities of Russia, Moscow made the deepest impression on a foreign visitor. Lady Londonderry described the impact which the 'white wall-encircl'd holy Mother' made upon her:

> St. Petersburg is a magnificent town and on a colossal scale, but it can never be the capital of Russia. Moscow is Russia with an Asiatic colouring. The greatest difference is seen in the streets. The immensely wide ones of the former are thinly peopled, while the enormous size of all surrounding objects gives to these few the appearance of Pygmies. But in Moscow the streets swarm and the crowds jostle.

The massive inner city of the Kremlin, surrounded by one and a quarter miles of walls, 65 feet high, the dozen domes and spires of the Cathedral of St Basil in Red Square, the 450 churches and 25 convents, all conspired to create the impression of a historical monument, a city ossified in a mediaeval past. But Moscow, in addition to its architectural curiosities, was an industrial centre of the first rank, in population and importance second only to St Petersburg. Rivalry and competition between the two cities was intense, and Muscovites firmly believed that they incarnated the true spirit of Russia. Many of the nationalist organisations had their headquarters there and reactionary ideas of every hue flourished. But most of Moscow, despite the city's ancient heritage, post-dated its rival. The famous fire of Moscow in 1812, which had forced Napoleon to begin his fatal retreat from Russia, had destroyed a vast number of buildings, and their replacements had little of the patina of the old. With the fire, many of the old Muscovite nobility left, never to return; their place as leaders of society was taken by a new generation of merchants and businessmen.

But however much Moscow had altered in form or people, its hold on the minds of the

Russian people was unshakeable. Baron Haxthausen, with his usual acumen, put his finger on it:

> Moscow has an importance in the eyes of Russians such as no city has for any other people: it is the centre of all the national and religious feelings of the Russians. There is no Russian in the immense empire, in Archangel or Odessa, in Tobolsk or Novgorod, who does not speak of Moscow, the 'holy mother', with deep reverence and enthusiastic love. Every Russian peasant, when he sees the towers of Moscow, after travelling hundreds of leagues, will reverentially take off his hat and bless himself. . . . But it is not only the common, uneducated, Russian in whom this deep affection is manifest; I have observed it, with scarcely any exceptions (some *blasés* of St. Petersburg, perhaps), in all classes of people, in high and low, educated and uneducated.

It was, indeed the 'Asiatic colouring' which made Moscow so much the microcosm of the whole of Russia, for if in St Petersburg it was possible to believe that Imperial Russia was a 'western' state, a few days in the sights and smells of Moscow, in the bazaars, among the food pedlars, the carpet merchants and the beggars, would make it clear to the most insensitive observer that Russia's heart, and her destiny, lay in the east.

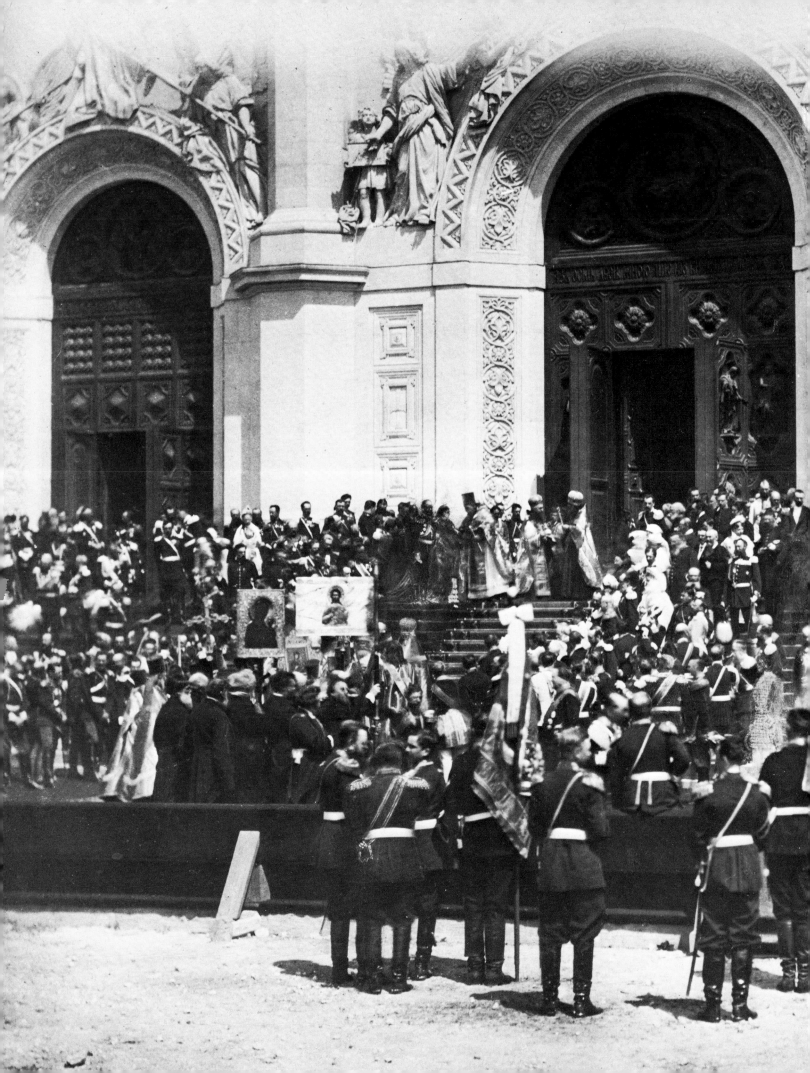

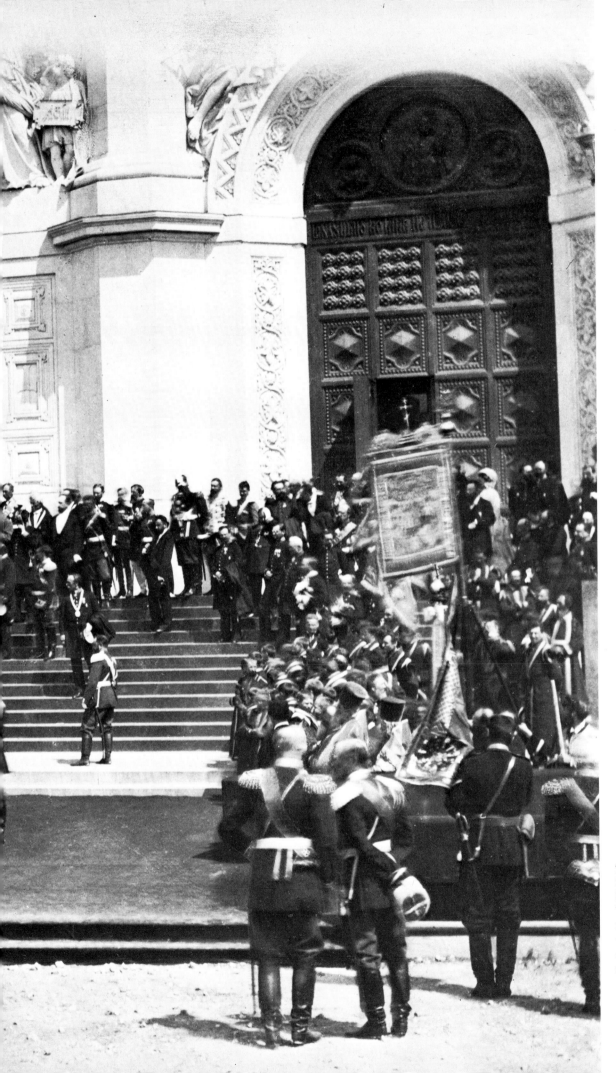

71 Consecration of the Cathedral of the Saviour, Moscow 1883. The scene in front of the Cathedral while waiting for the arrival of the Emperor and Empress.

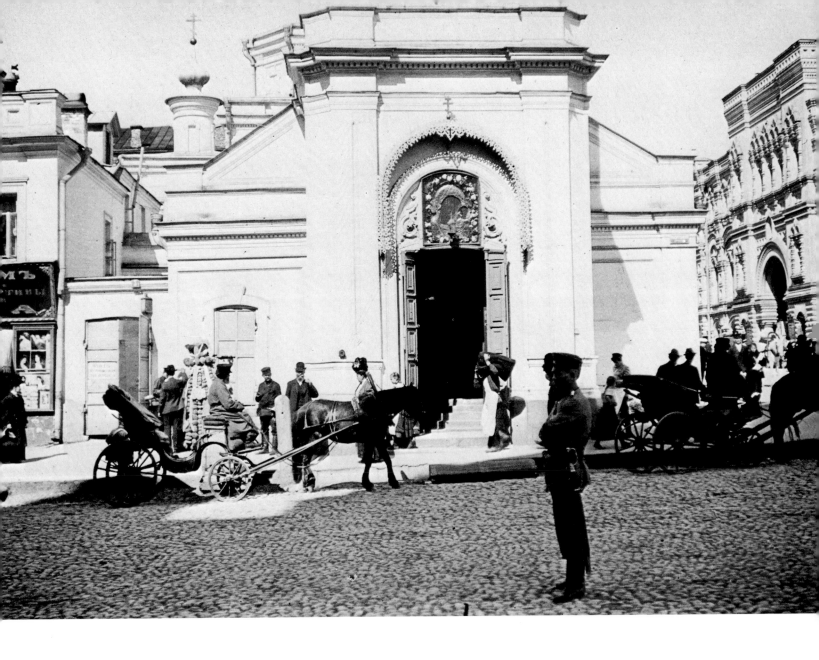

72 One of the small churches of the Varvarka (street) next to the Znamenski Monastery. At the right, the main entrance of the Gostini Dvor (Merchants' Court, an arcade of small shops), *c.* 1910.

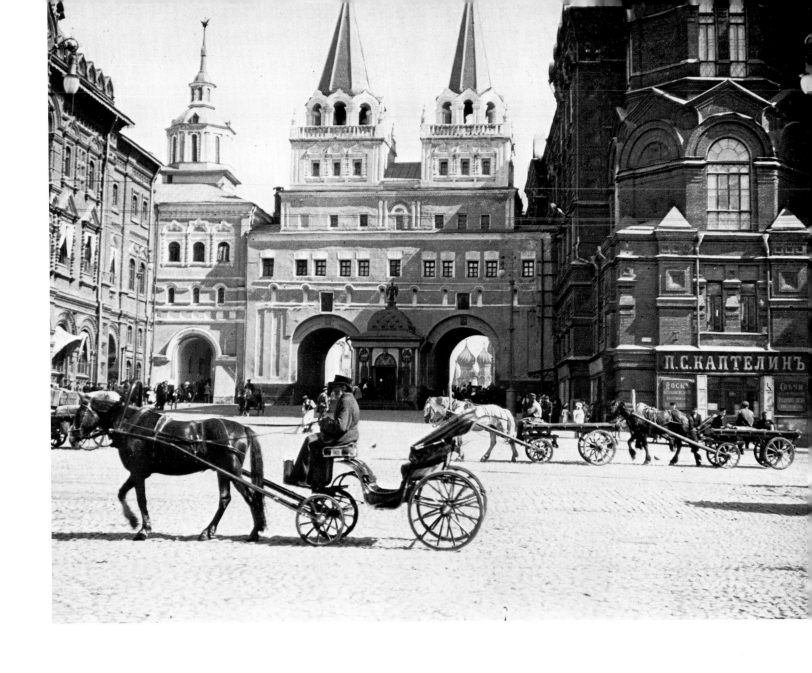

73 The Iberian Gate and, between its two arches, the Chapel
of the Iberian Virgin. The Chapel was one of the most
revered in Russia, the Emperor's first stop on visiting the city,
but Baedeker warned his readers that it was also the haunt of
pickpockets. At the left is the corner of the City Hall and at
the right is the rear of the Historical Museum. Through the
right arch one can see St Basil's Cathedral.

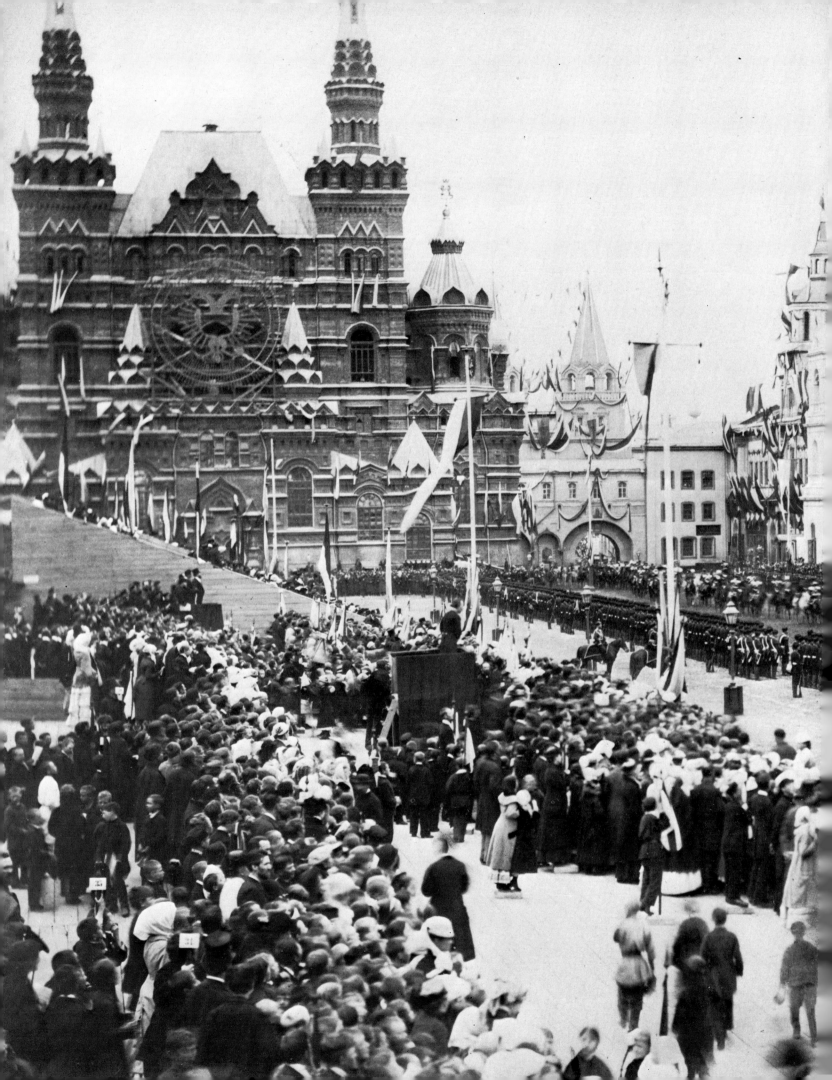

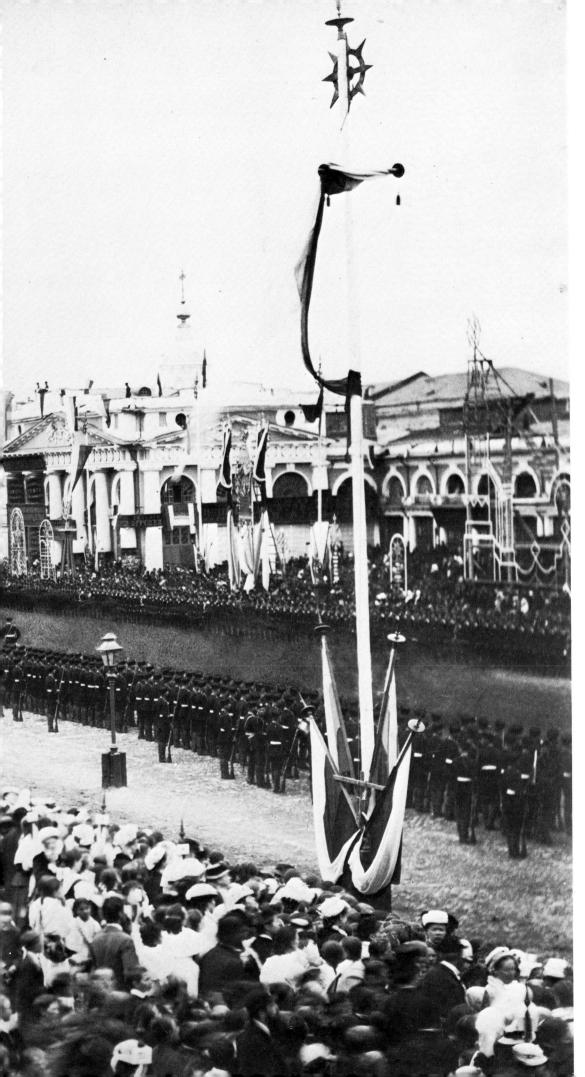

74 View on Red Square during the State Entry into Moscow, for the Coronation of Alexander III, 10 May 1883. The procession passes through the Iberian Gate. Note the police on the rooftops and the distance of the crowd from the procession—both security precautions against a terrorist outrage.

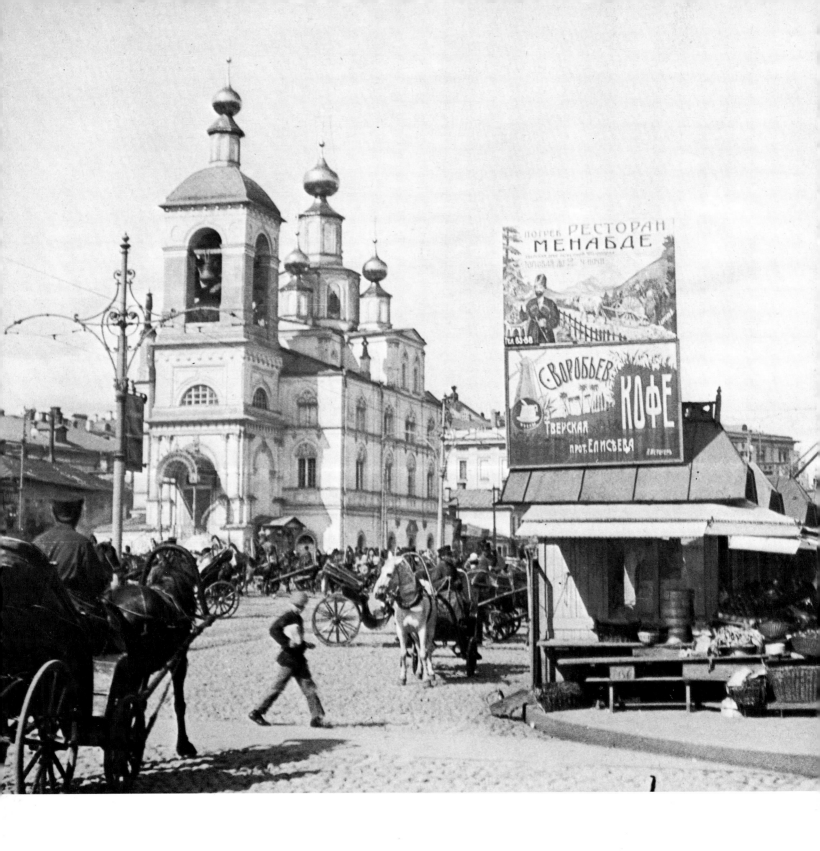

75 Stalls of one of the many street markets in Moscow. The two signs advertise a mediocre restaurant and an equally mediocre brand of coffee, *c.* 1910.

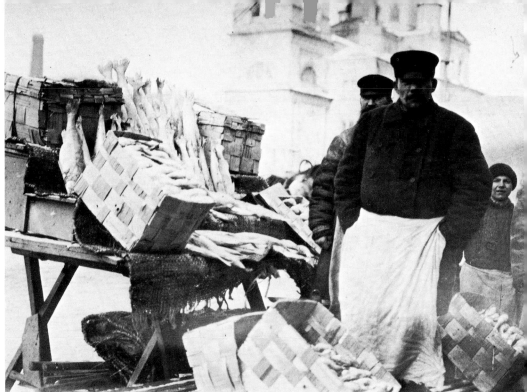

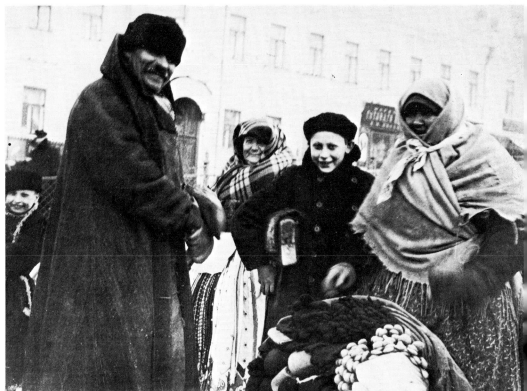

76 *above*　A fish seller, Moscow.

77 *below*　A hawker of gloves, mittens, socks and other woollens, Moscow.

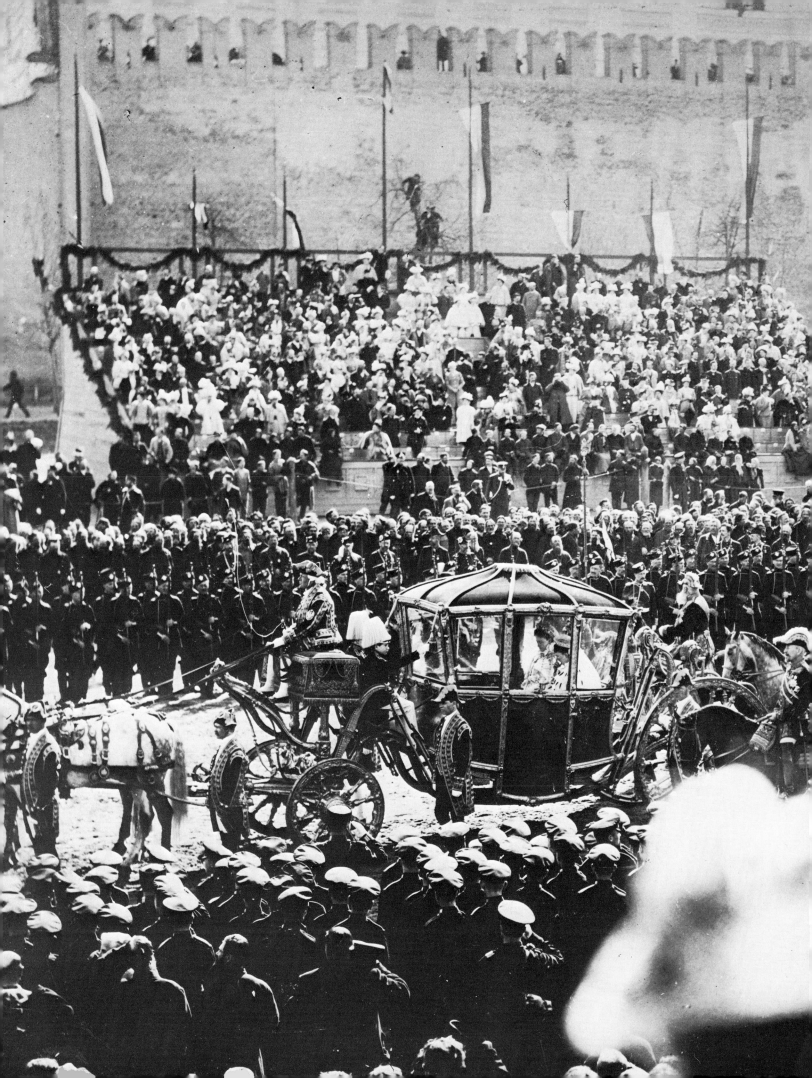

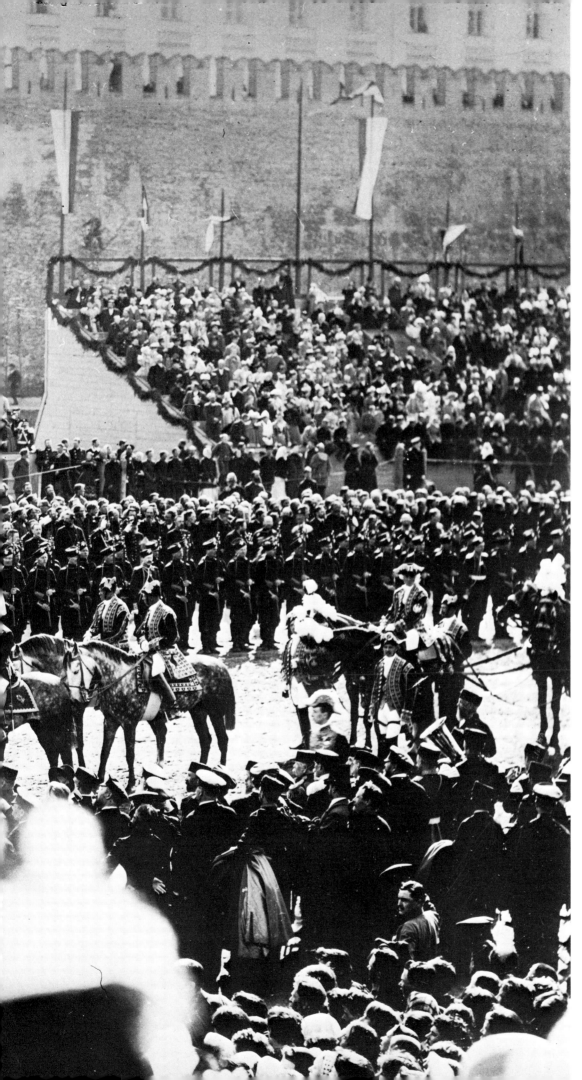

78 The Empress Alexandra Feodorovna and her mother-in-law the Empress Maria Feodorovna passing through Red Square during the State Entrance into Russia's ancient capital for the Coronation—Moscow, 9 May 1896.

Immediately behind the Infantry of the Guard lining the far side of the road is a mass of Village Elders and Mayors of the towns and cities of the Empire.

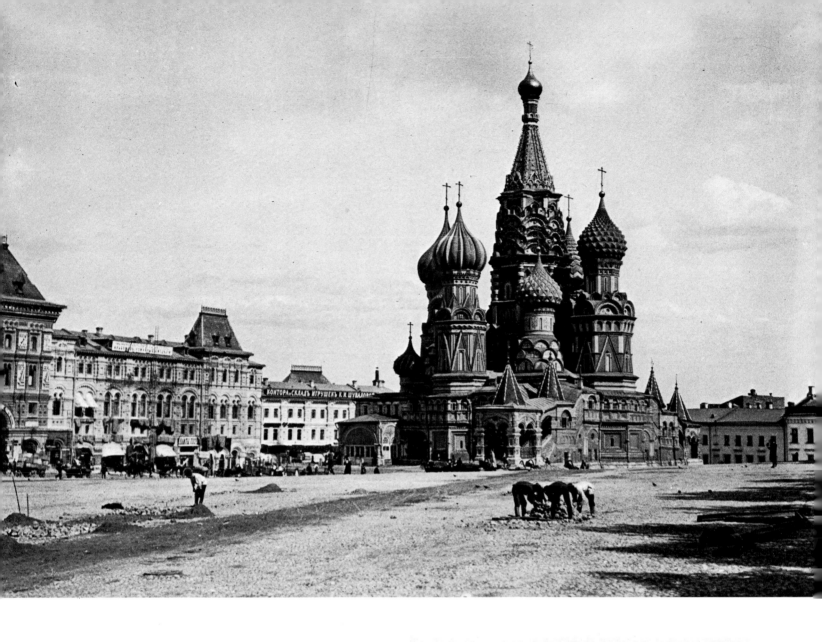

79 *above* The dreary emptiness of Red Square in summer,
almost abandoned except for workmen re-cobbling the
square. At the centre is the Cathedral of St Basil, built by Ivan
the Terrible to celebrate the conquest of Kazan. *c.* 1910.

80 *right* An example of an overly baroque Russian
church, 1910.

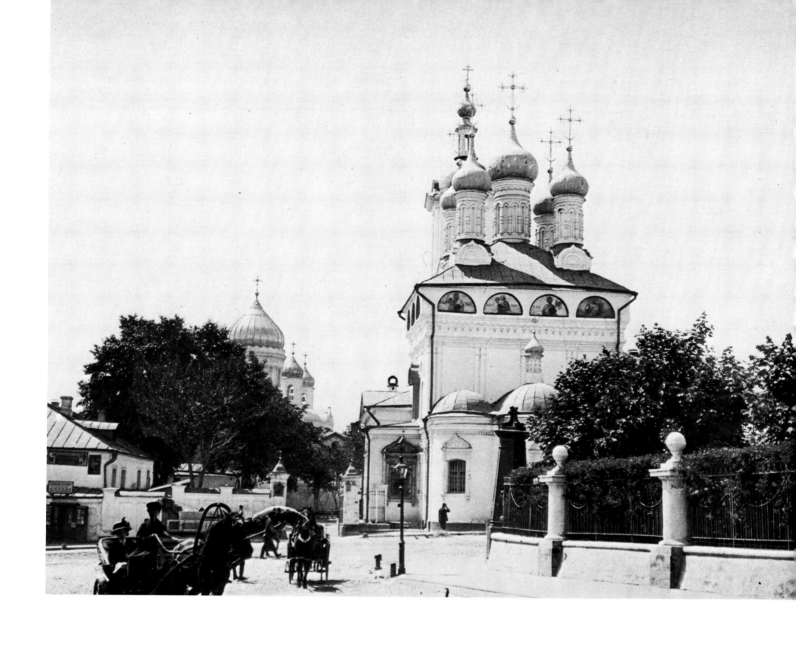

81 The beautiful Church of St Nicholas and beyond it the Church of the Saviour. The railing on the right is of the Rumiantsev Museum, housed then in the Pashkov Palace, *c.* 1910.

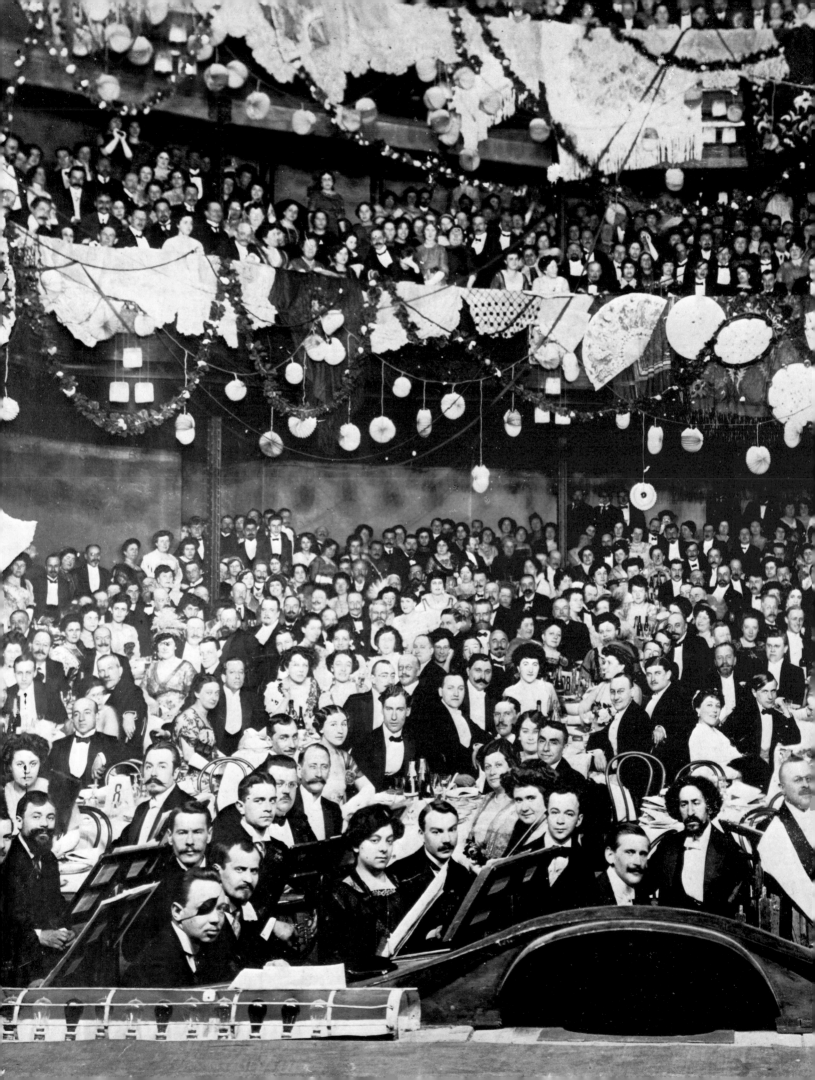

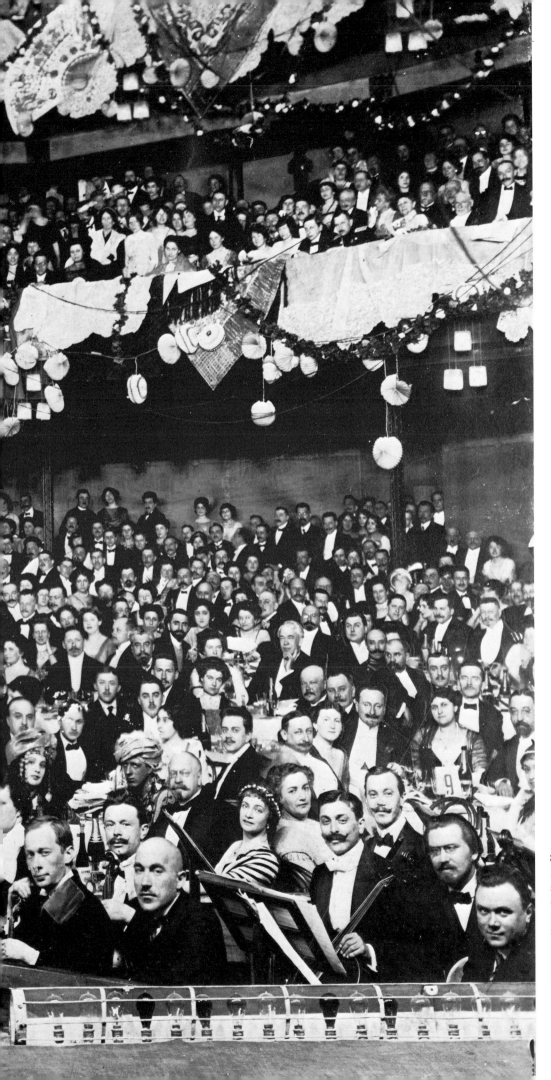

82 Gala performance at the Moscow Art Theatre in 1912. The audience is composed of members of the artistic world, the Moscow merchant families and the intelligentsia. The two founders of the theatre, Stanislavski and Nemirovich-Danchenko are in the audience.

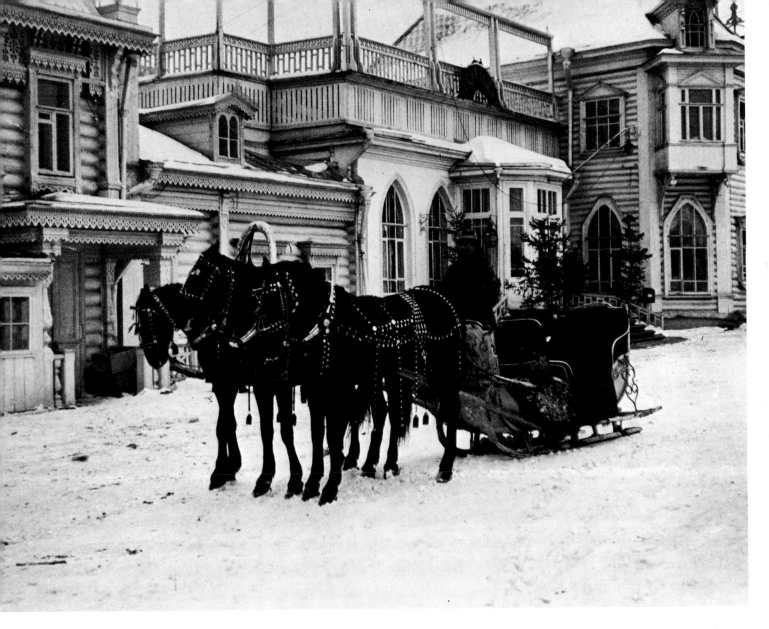

83 A very fine equipage in front of one of Moscow's better restaurants.

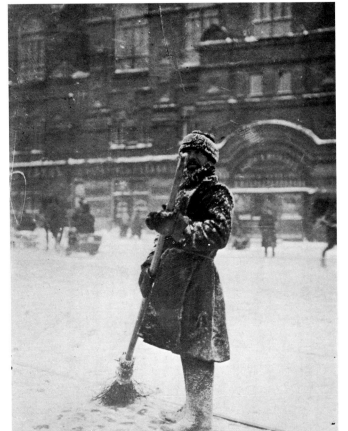

84 Sweeping the snow from the pavement during Moscow's winter was a full-time occupation. In the background is the Historical Museum.

85 An *izvoshchik* (cabby) waiting for a fare on Theatre Square. In the background through the falling snow one can just make out the form of the Bolshoi (Great) Theatre.

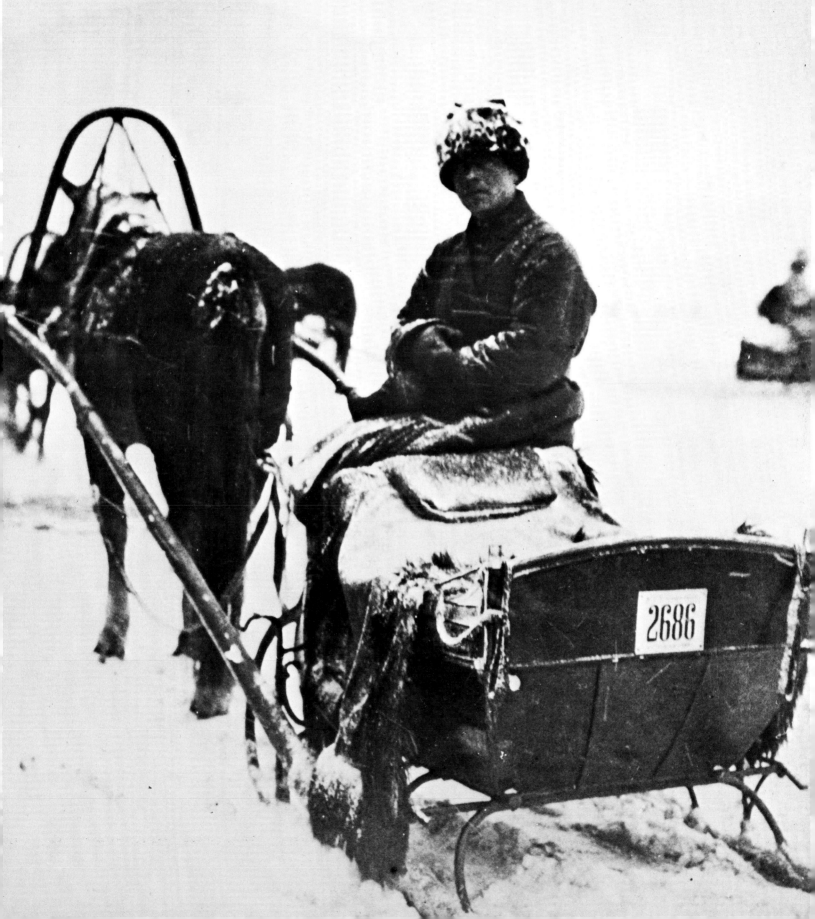

86 Moscow rooftops during the winter. Notice the cow. A surprisingly large number of people in Russia's two capitals kept cows for fresh milk—and other livestock.

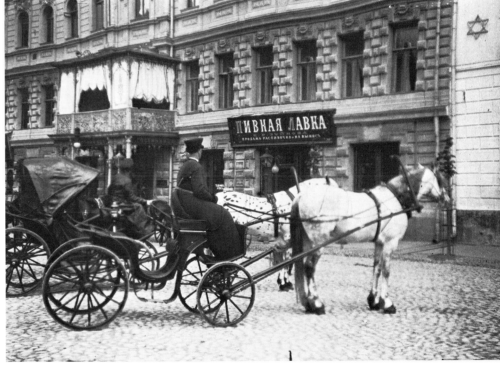

87 *Izvoshchiks* waiting for fares at a hotel. The large sign advertises the presence of a pub, *c.* 1910.

88 Part of Russia's vanished heritage. View from Ivan Veliki looking North towards the Chudov Monastery (left foreground), the small Nicholas Palace (at the right), the church of the Archangel Michael (in the centre), and the Court of Justice (left rear). The three buildings in the foreground were destroyed and replaced by the new regime with a modern theatre.

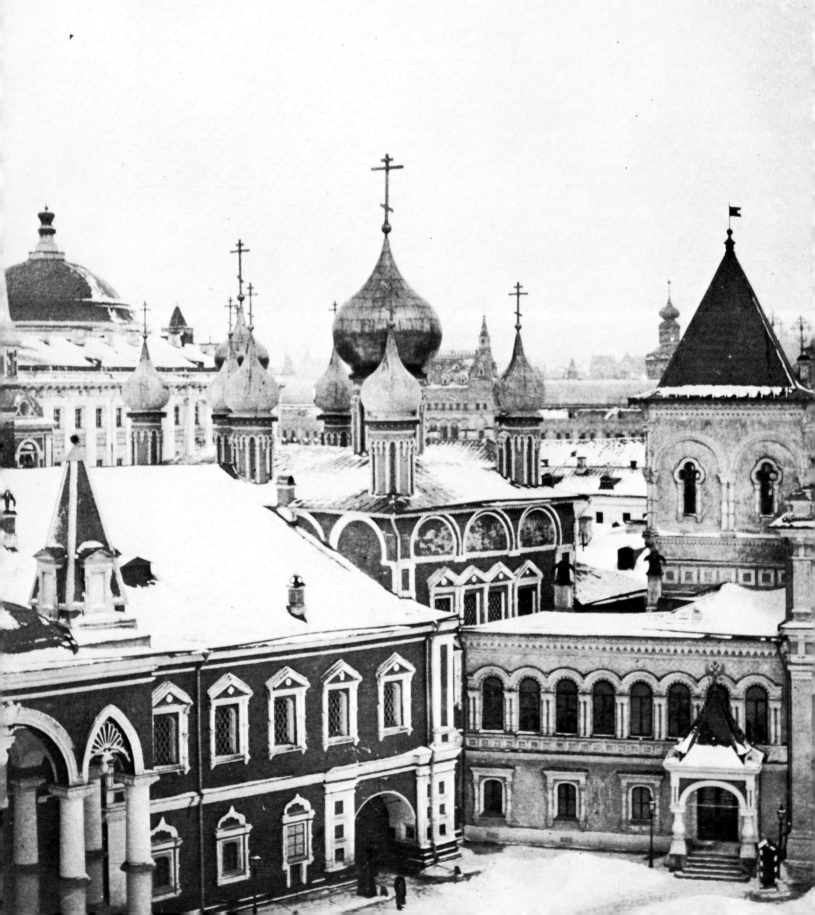

NOBLES

In Russia, shortly after the Crimean War, over one million people possessed noble status; yet, to the mystification of foreign visitors, none except a tiny minority of less than 20,000 bore any resemblance to the long-established landowning gentry and aristocracy of the west. Indeed, in some provinces, some 'nobles' were indistinguishable from their serfs, constituting, the official enquiry reported, 'a single family with their peasants [who] partake of food at the same table, and live together in one *izba* [hut]'. Nobility (*dvorianstvo*) in Russia was acquired by service to the state: all bureaucrats above a certain rank, all field officers in the army and navy—and their descendants thereafter—possessed noble status; the less important becoming only non-hereditary nobles. All might possess resounding titles, but be as poor as church mice, for in the whole of Russia only some 1,400 families lived in the princely splendour that foreigners imagined was the lot of all Russian nobles. For this tiny group—the Shuvalovs, Beloselsky-Belozerskys, Sheremetevs, Stroganovs, and the Princes Orlov and Golitsyn, the Demidovs, Balashovs, Vorontsov-Dashkovs and Yusupovs—and others like them, behaved like oriental potentates. Yet this group was not exclusively addicted to the pursuit of pleasure, for they provided the leading patrons of Russian art and culture, and had numbered among them the country's most prominent statesmen and soldiers; in the field of literature, Tolstoy and Turgenev, if not typical of the noble class, showed its tremendous potential energy and creative force. In music, with Rimsky-Korsakov, Borodin and Mussorgsky—Russia experienced a similar cultural flowering. But the few magnates were swamped, in number if not in wealth, by the vast and growing body of the nobility. Whole classes, such as the Polish or Finnish nobility were admitted at a stroke of a pen and, as the army and the bureaucracy enlarged, so the ranks of the nobility were inexorably swollen.

But these nobles or 'gentry' possessed little of the power and influence which landed nobles wielded in the west. Even the great magnates, with their vast estates, had them split up into innumerable small holdings; at a lower level, Baron Haxthausen found one village of 260

peasants which was owned by no less than 83 proprietors. In the villages, the local nobility had few aristocratic qualities. Entirely typical were those from whom Chickikov purchased his 'dead souls', in Gogol's satiric masterpiece, men whom an English visitor described as: 'eating raw turnips and drinking kvass, sleeping one half of the day and growling at his wife and family the other . . .'. But neither magnate nor bumpkin was representative of the noble class as a whole. Many who feature in these pages lived exemplary family lives, on modest incomes, as loyal and efficient servants of the state: they too were immortalised in literature and in social observation. But the *dvorianstvo* were a rootless class, landed bureaucrats, seldom possessing strong connections with the countryside or the people. Baron Haxthausen noted that:

> The majority of the nobles indeed have houses in the country, but they visit them for only a few weeks or months, and reside for the rest of the year in town: they do not regard these estates as their homes. . . . The feeling of attachment to the soil is nearly unknown to the Russian [noble]; he sees the land pass into strange hands with unconcern.

Small wonder therefore, that Alexander Pushkin could write:

> In Europe . . . people believe in the aristocracy, some to scorn it; others to have something to hate. . . . In Russia, none of this exists. Here one simply does not believe in it.

89 A hunting party, the quarry being either wolf or hare. Voronezh Province, *c.* 1903. The man on foot is an Imperial Huntsman. To his right, the Grand Duke Michael (younger brother of the Emperor Nicholas II), Captain Kossikovski of the Chevalier Gardes, Prince Peter of Oldenburg (husband of the Grand Duke's youngest sister Grand Duchess Olga), and two Princes Golitsyn.

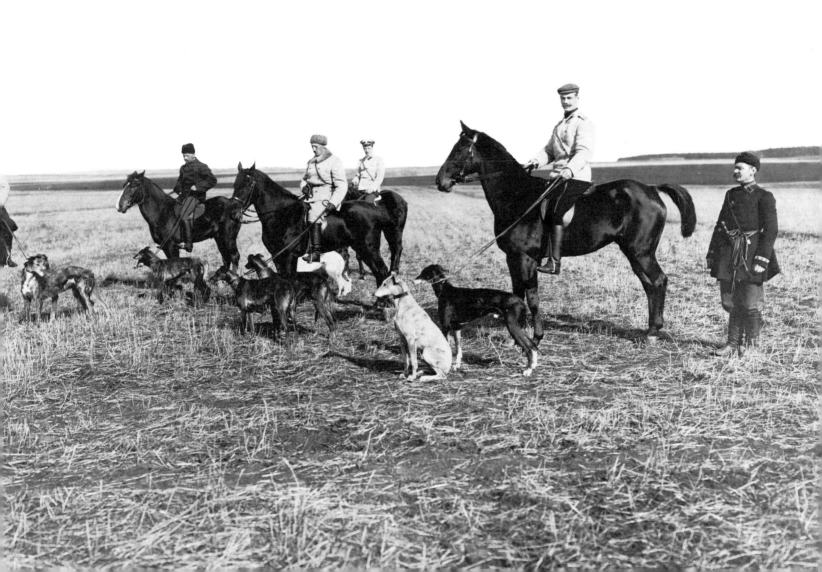

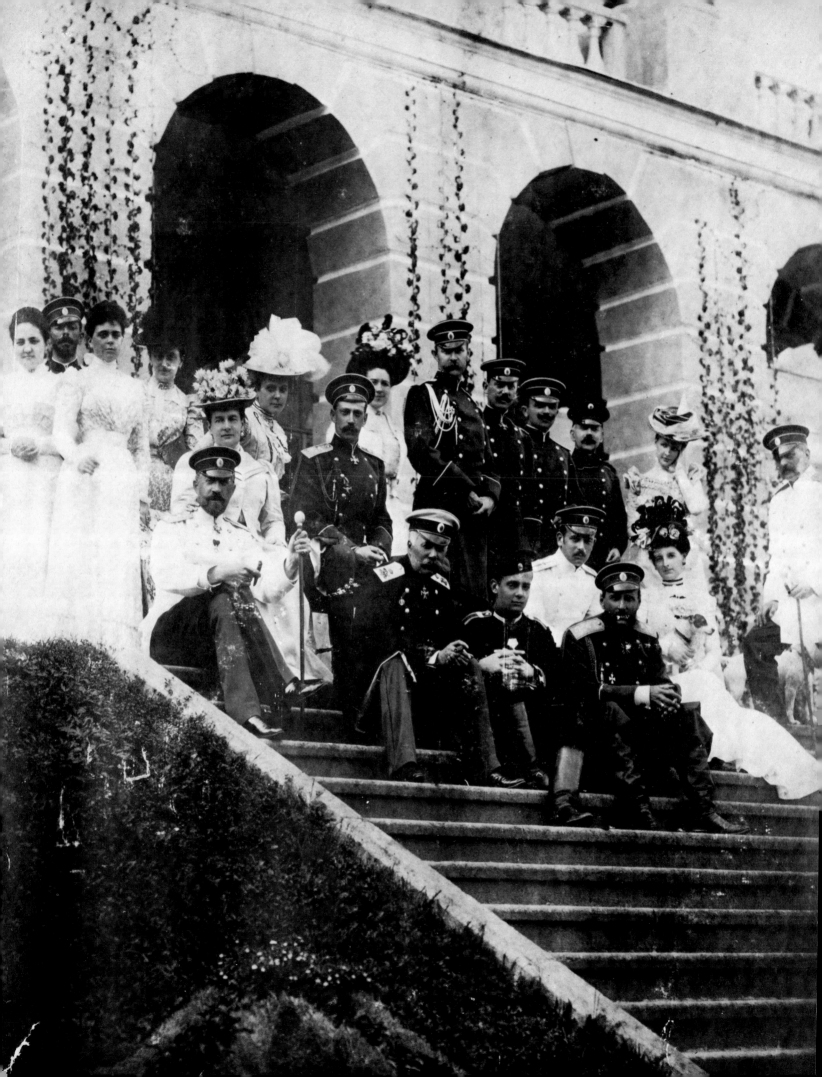

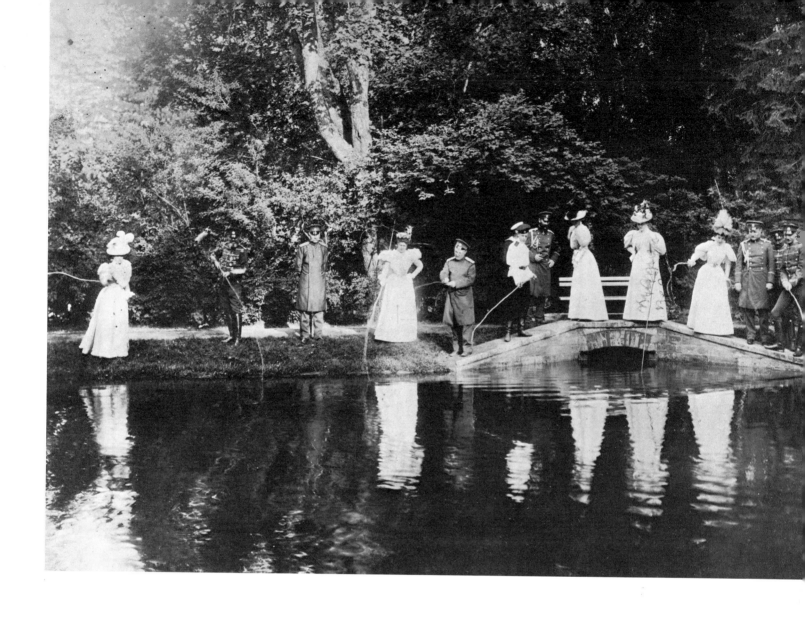

90 *left* A happy group at the Imperial Château, Ropsha, *c.*1894.

1 Mme Volkov
2 I. L. Tatishchev.
3 Grand Duchess Elena Vladimirovna
4 —
5 Grand Duchess Maria Pavlovna
6 Grand Duke Nikolai Nikolaevich
7 Mme Pistolekors (later, Paley)
8 Grand Duke Pavel Alexandrov
9 —
10 Major-General A. N. Nikolaev
11 Count Fersen
12 —
13 Grand Duke Andrei Vladimirovich
14 —
15 Grand Duke Boris Vladimirovich
16 —
17 —
18 Princess 'Suzi' Beloselski
19 —
20 Grand Duke Vladimir Alexandrovich

91 *above* Fishing in the Imperial Park at Ropsha, 22 July 1900 (Names Day of the Grand Duchess Maria Pavlovna). (L to R) Princess 'Mania' Bariatinski, Prince Il. S. Vasilchikov, General Nikolaev, Mme O. Vl. Serebriakov, Ivan Orlov, Grand Duke Andrei Vladimirovich, Khristofer Derfelden, Princess 'Suzi' Beloselski, Mme Naryshkin, Countess O. Iu. Bobrinski, Prince 'Sasha' Bariatinski, Furman, 'Pavlik' Skalon.

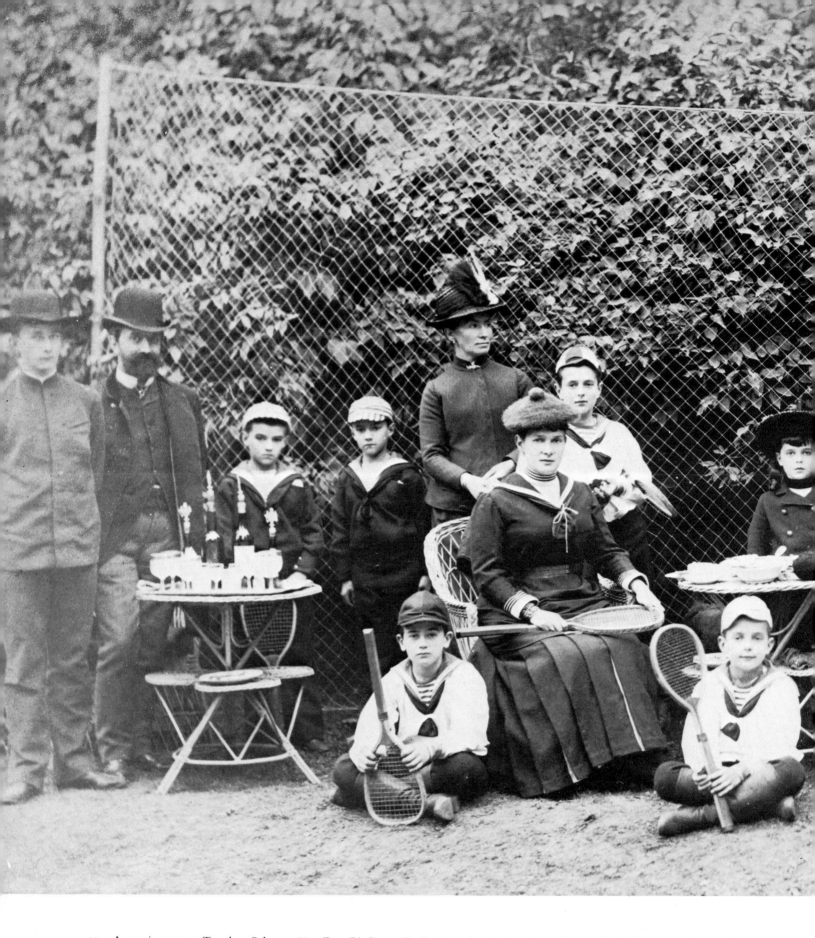

92 A tennis party at Tsarskoe Selo, *c.* 1885. (L to R) Count D. G. Mengden, ?, ?, ?, Grand Duke Boris Vladimirovich, ?, Grand Duchess Maria Pavlovna, Grand Duke Kiril Vladimirovich, Grand Duke Andrei Vladimirovich, Grand Duchess Elena Vladimirovna, ?, ?, ?, Mr Ushakov, Mme Lukka.

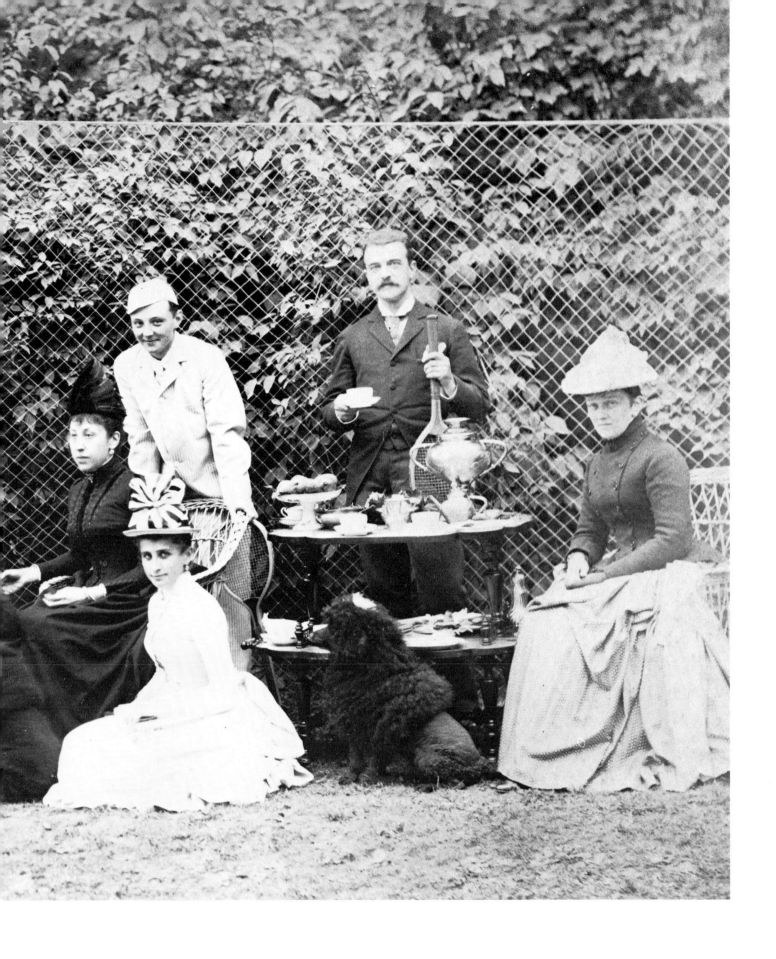

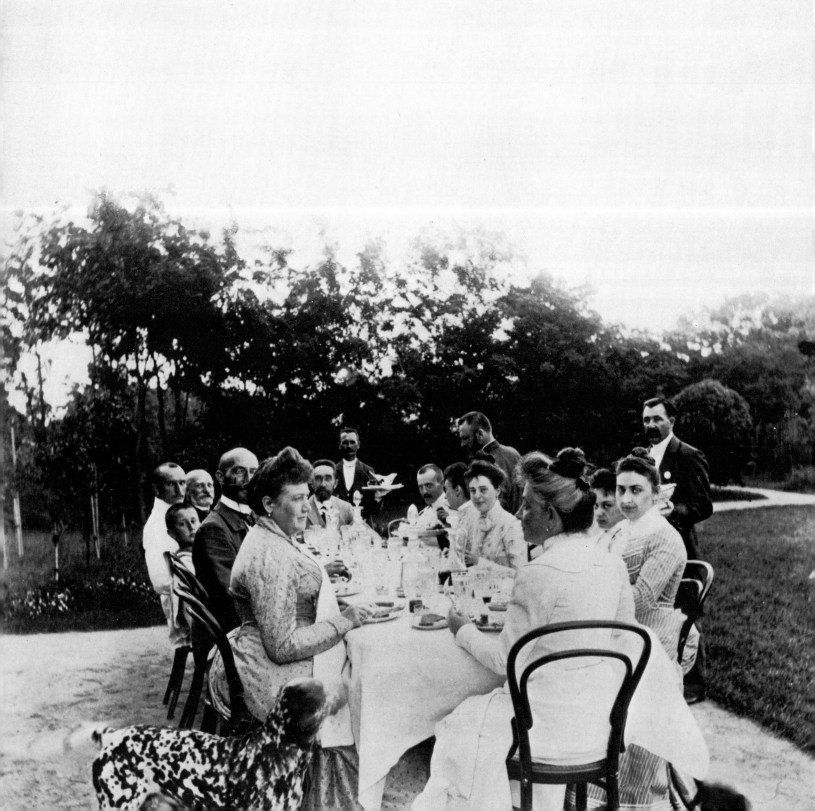

93 *left* Luncheon at Belenkoe, an estate of the Miklashevski family in Ekaterinoslav Province, *c.* 1900. Seated 3rd from left: Prince Vasili Vladimirovich Gagarin (white beard); 6th from left: Mikhail Ilich Miklashevski; 3rd from right: Mme Olga Nikolaevna Miklashevski; 2nd from right: Mlle Tatiana Mikhailovna Miklashevski.

94 *right* Tea at Brasovo, 3 February 1912. Brasovo was an estate of the Grand Duke Mikhail Alexandrovich and after his morganatic marriage his wife was given the title of Countess Brasova. She is standing with her arm around the shoulder of her future husband. To her right is the composer Sergei Vasilevich Rakhmaninov. Rakhmaninov seems to have enjoyed a relatively close relationship with the Grand Duke because he appears frequently in his albums. The gentleman seated at left is believed to be the Moscow lawyer Sergei Sheremetevski, the Grand Duke's future father-in-law.

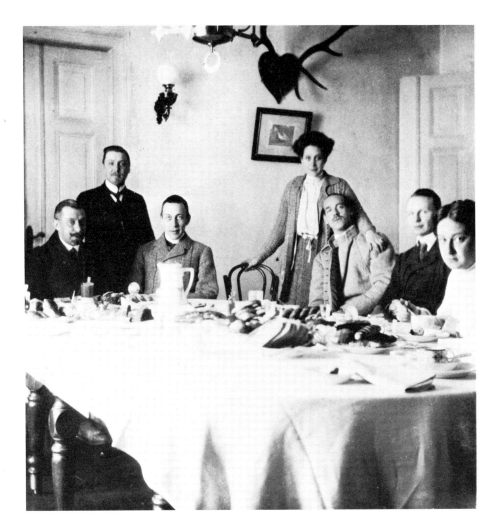

95 The Protasevich family—on the steps of their manor house in Russian Poland, 1910.

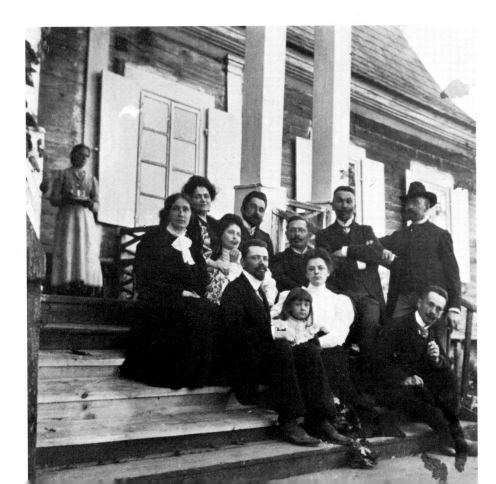

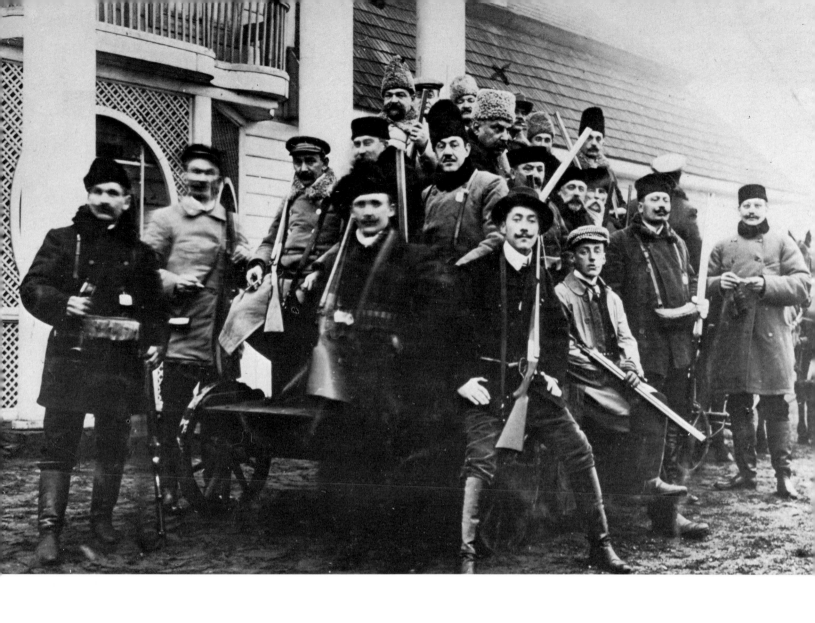

96 A Polish hunting party, *c.* 1908.

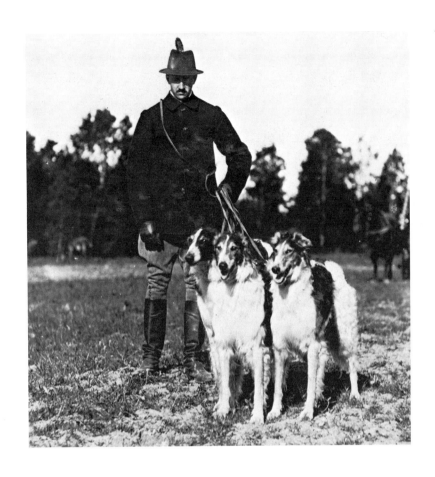

97 Lieutenant Prince Vladimir Emmanuilovich Golitsyn (5 June 1884 + 13 July 1954) and three of his dogs at the Borzoi Trials at 'Pershino', a property of Grand Duke Nikolai Nikolaevich in Tula Government, *c.* 1910. Both the Grand Duke and his young adjutant Prince Golitsyn were well-known sportsmen and breeders of the Borzoi.

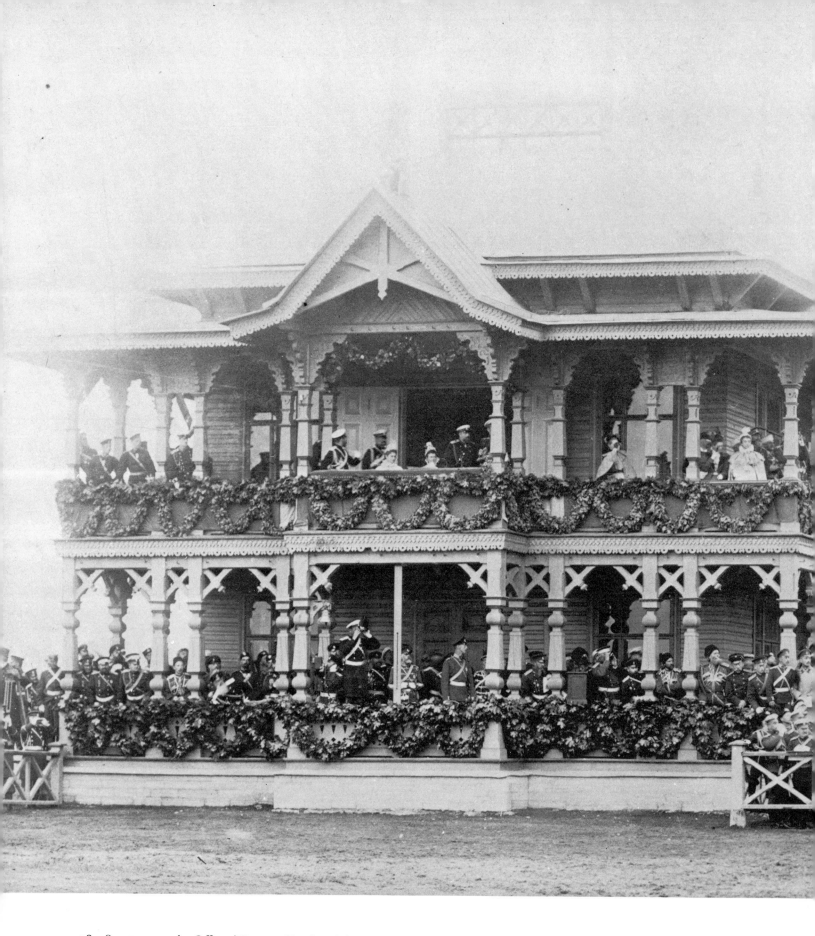

98 Spectators at the Officers' Races at Tsarskoe Selo, August 1896. At the left, the small Imperial Pavilion; in the Imperial Box in the centre of the upper balcony (L to R): the Emperor, Grand Duke Vladimir, the Empress, Grand Duchess Maria Pavlovna, Grand Duke Alexei Alexandrovich.

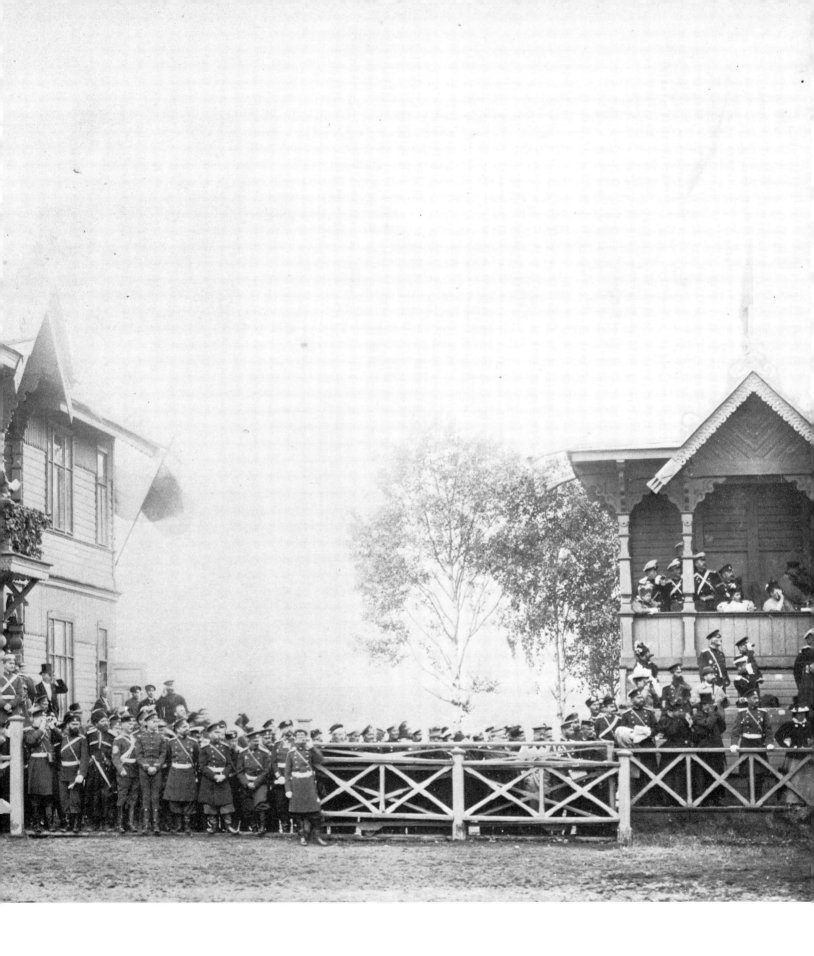

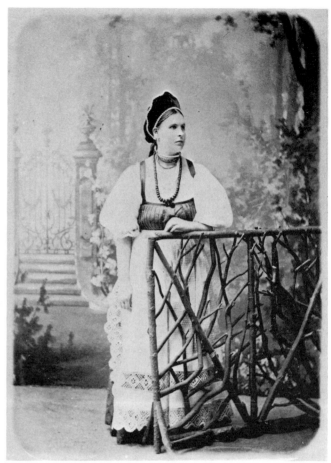

99 *above* Countess Ekaterina Georgievna Carlow (25 July 1891 + 8 October 1941), aged one, 26 July 1892.

100 *above right* Mimka, the infant Countess Carlow's wetnurse, August 1892.

101 *right* Russian noblewomen seemed to enjoy dressing in local peasant costumes, some of which were extremely beautiful. Princess Elisaveta Semenovna Abamelek-Lazarev, later Countess Olsuf'ev (1866 + 1934). Goloshchapova (an Abamelek estate). Tula Government, August 1887.

102 *far right* Her daughter, Countess Anna Andreevna Olsuf'ev (b. 1900). San Remo, 1905. Both mother and daughter are wearing the costume of Tula Government.

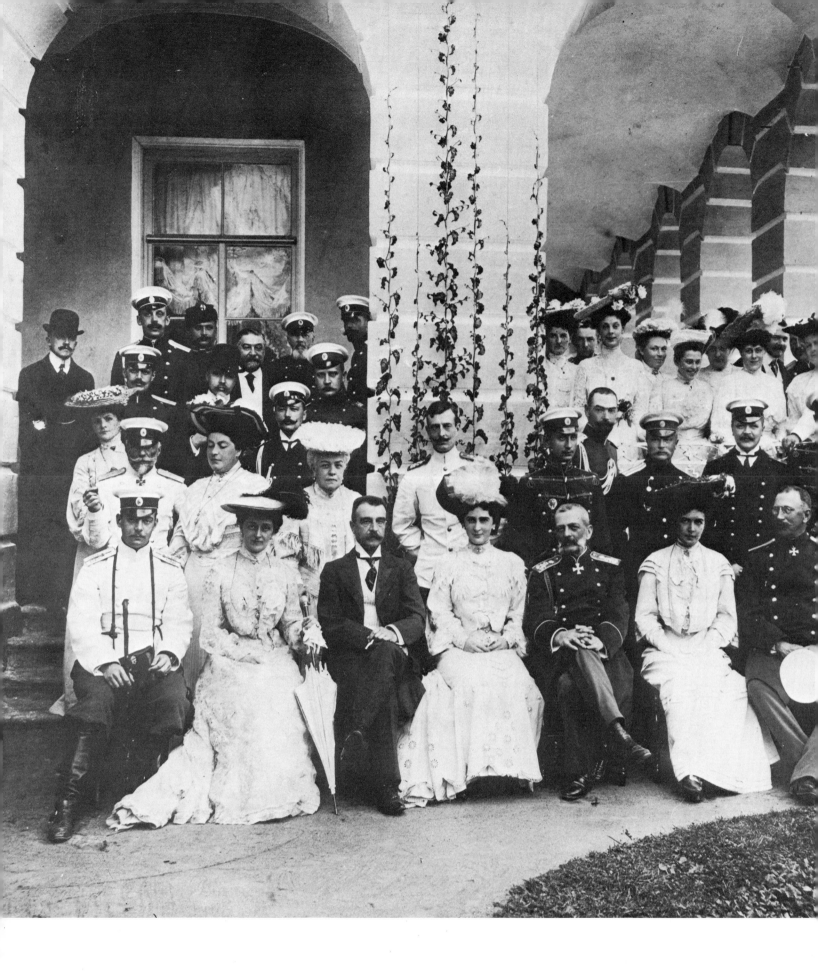

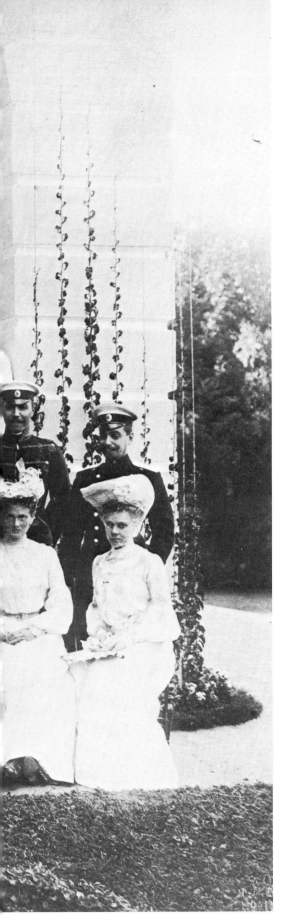

103 Names Day of the Grand Duke Vladimir—Ropsha, 15 July (*c.* 1906).

1 —
2 Prince S. K. Beloselski
3 —
4 'Mita' Benckendorf
5 General Prince Golitsyn
6 Baron V. R. Knorring
7 —
8 —
9 N. A. Volkov
10 Prince Alexandr V. Bariatinski
11 —
12 —
13 Countess Mikhail Grabbe
14 Grand Duke Andrei Vladimirovich
15 Mme de Peters
16 Mme Arapov
17 'Sashuk' Ushakov
18 Grand Duke Kiril Vladimirovich
19 Princess E. A. Bariatinski (née Iur'evski)
20 Princess 'Suzi' Beloselski
21 I. L. Tatischev

22 Princess Olga Orlov
23 Countess Carlow
24 Mme Mansurov
25
26 Mme Olga V. Serebriakov
27 —
28 —
29 Grand Duchess Maria Pavlovna
30 Grand Duke Boris Vladimirovich
31 N. A. Kniazhevich
32 Count Mikhail Grabbe
33 M. A. Serebriakov
34 —
35 —
36 A. A. Frederitsi
37 Prince M. M. Cantacuzene
38 Grand Duke Vladimir Alexandrovich
39 Princess 'Julia' Cantacuzene
40 Duke Georgi Georgievich Mecklenburg-Strelitz
41 Mlle 'Nita' Istomin
42 Princess Nadia Golitsyn

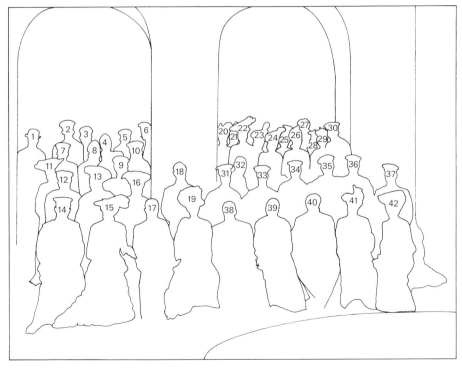

104 Ternovo—a property of General S. M. Somov in Zemlianski District in Voronezh Province.

105 *below* Arkhangelskoe—the magnificent property of Prince Yusupov near Moscow, August 1912. Although only of medium size by Central or Western European standards, primarily because of the climate, Arkhangelskoe was one of the half-dozen finest private houses in the Empire. Unlike the majority of Russian manor houses which were built of wood (the climate again), Arkhangelskoe was built of stone.

106 *right* The Swallow's Nest (Yalta in the background), *c.* 1910. This pavilion (it never was a residence) was apparently built on tracks and could be rolled out to the edge of the precipice and rolled back, as the owner fancied, but the mechanism soon failed and it remains to this day on its crumbling perch.

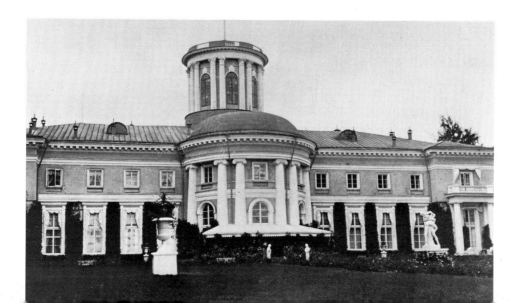

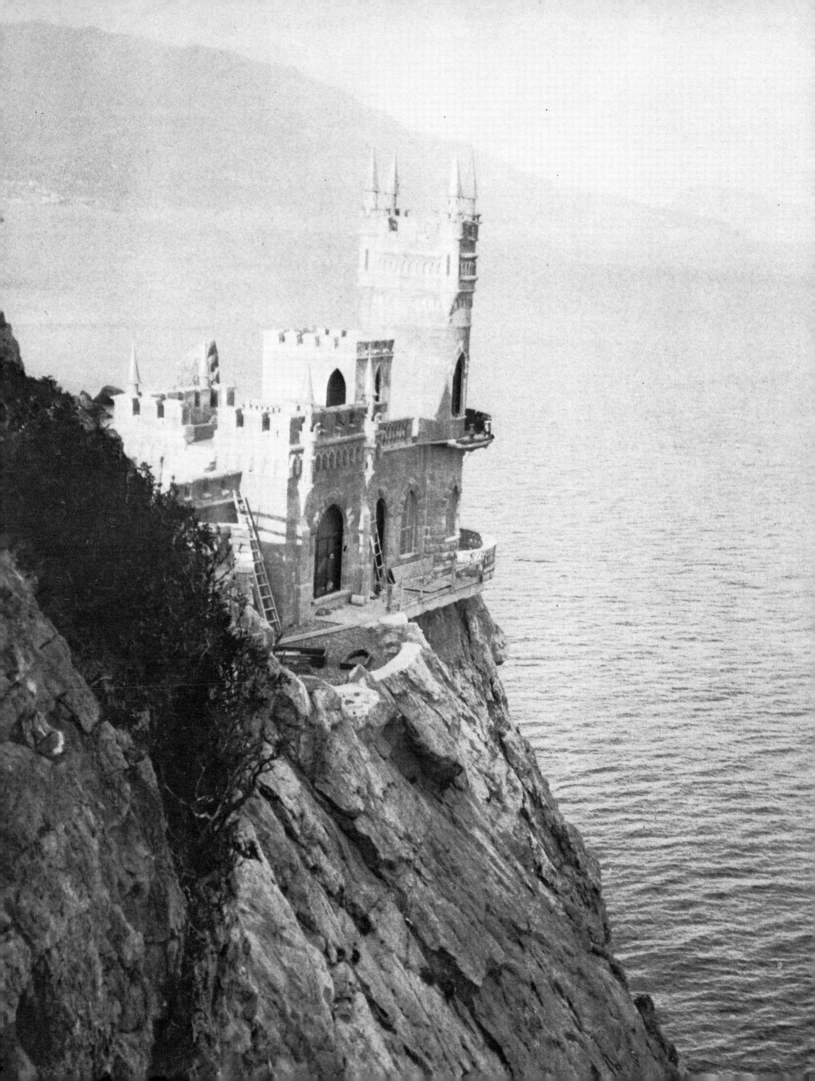

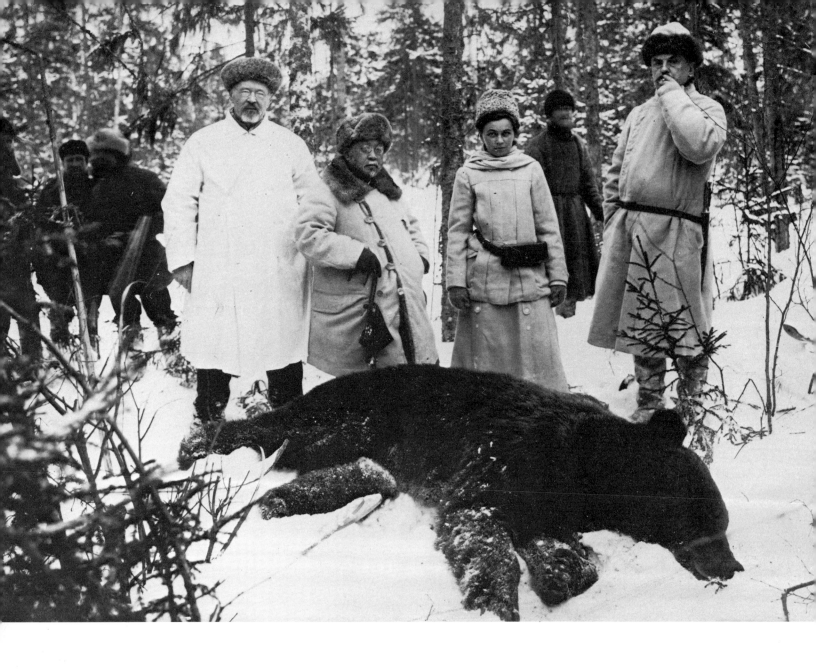

107 In the winter of 1915, the Japanese Ambassador Baron Motono decided he wanted to shoot a bear. All the normal companions and hosts for the Ambassador being at the Front or otherwise engaged, the foremost huntswoman in Russia Countess Sollohub was asked to act as guide and hostess. An Imperial Domain, Lissino, was made available by the Minister of the Court. Alas, the good Baron was not up to it and the Countess had to shoot his bear for him.

BREAD AND SALT

The revolution of 1917 obliterated, by fire, erasure and death, every vestige of Russia's old regime. Yet it could do nothing to destroy the essence of Holy Mother Russia, since her heart lies not in buildings, institutions or individuals, but in the earth, the 'sacred soil' of Russia, as writers consistently aver. No other country has been so dominated by its climate and geography; no Russian, at home or in exile, can throw off the deep atavistic bondage to the land. Russia presents a panorama of flat, featureless plains, great rivers, swamps and marshes. Only in the distant south, in the Caucasus, is there a warm sea and a mountain landscape; to the east, the endless steppe leads only to an arid plateau and to the Pacific. The Russian tradition held that the land was a gift from God to the sons of Adam, and the disposal of it, as in a family, belongs to the father, the head of the Russian people. The Tsar, the 'little father', gave the land to the Russian 'children', who could enjoy it so long as they lived in loyalty and subjugation to their ruler. The autocracy of the Tsars was rooted deep in Russian society, fixed so firmly that it required a military and social cataclysm to destroy it. And the Tsars' successors, having assumed their patrimony, took over, also, their structure of power and their absolutism. Thus, since the countryside, for all its bleakness in winter, bulks so large in the history and character of Russia, it is here that we should begin to discover Old Russia, rather than amid the splendours of St Petersburg, or the 'Asiatic curiosity' of Moscow.

The life of the Russian peasant, constrained by the bitter extremes of the Russian climate, was unique. The great Russian historian Kluchevsky has described it succinctly:

There is one thing a Great Russian believes in: that one must cherish the clear summer working day, that nature allows him little suitable time for farming, and the brief summer can be further shortened by . . . foul weather. [He must] hustle, get much done quickly, and quit the fields in good time, and then have nothing to do through the autumn and winter. He has

accustomed himself to excessive short bursts of energy; he has learned to work fast, feverishly. . . . No nation of Europe is capable of such intense exertion over short periods . . . but nowhere also in Europe shall we find such a lack of habit for even, moderate and well distributed steady work as in the Russian.

Yet Russia contained a clear example of what could be done with modern methods and Western enterprise. A group of Protestant émigrés from Germany, the Mennonites, settled in South Russia, and created a reproduction of their homeland. Baron Haxthausen, the celebrated traveller, noted, 'German was everything around us; not merely the people, their language, dress and dwellings, but every plate, and vessel, nay even the domestic animals, the dog, cow and goat, were German.' With Prussian efficiency, they developed mechanised farming, importing machinery and establishing model farms. No stronger contrast with traditional Russia could be imagined. In 1861, when the Mennonites were testing a harvester,

the Russian peasants following it 'noted an observer' . . . crossed themselves, praying devoutly that they might not have been present at some intervention of the devil. On another occasion, when our steam thresher was at work, a deputation came begging our man in charge to call out the unclean spirit that was at work.

Yet the superstitious awe of the peasant is understandable. He lived a life bound up entirely with his village, and the agricultural treadmill. It was a life of sustained rigour, and it was scarcely surprising that so many peasants flooded into the industry of the cities. Yet even they remained members of their village commune, and rarely settled permanently outside. The Russian peasant was honest, pacific, prone perhaps to perpetual drunkenness, but rarely offensive, and with a quiet stoic dignity in the face of adversity: the very salt of the earth.

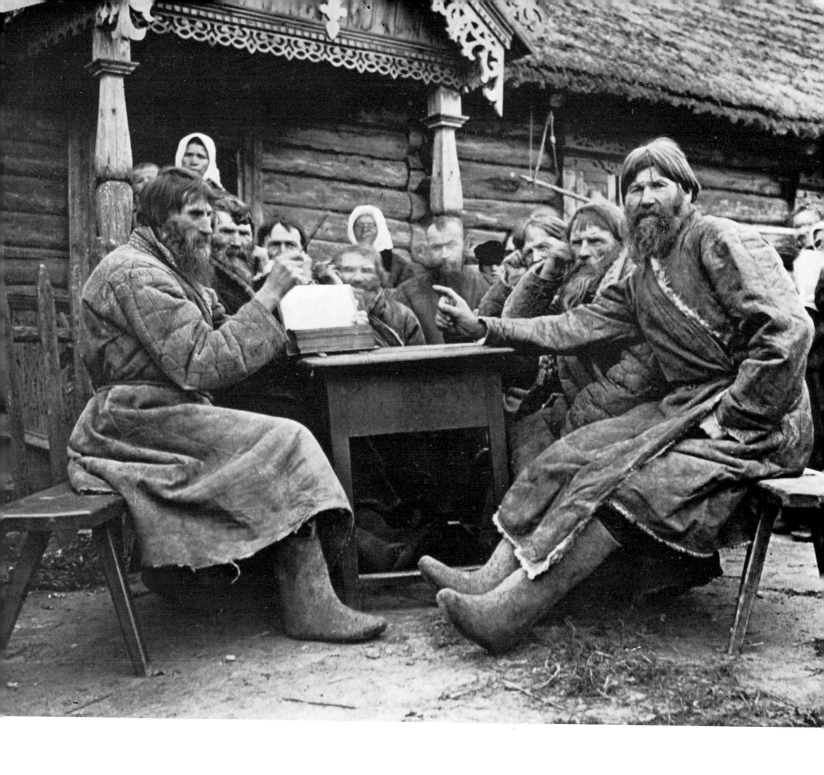

108 A meeting of the village elders, 1910.

109 *below* The smiles of the children, the more formal reserve of the elders, greet the photographer on the village street—*c.* 1910.

110 *right* The local manor house, as seen from the village in the photograph below—*c.* 1910.

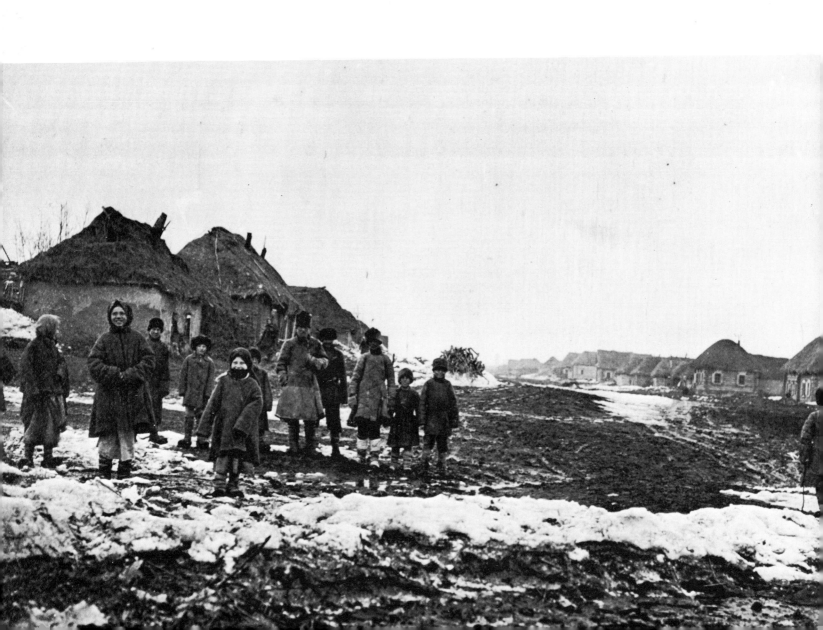

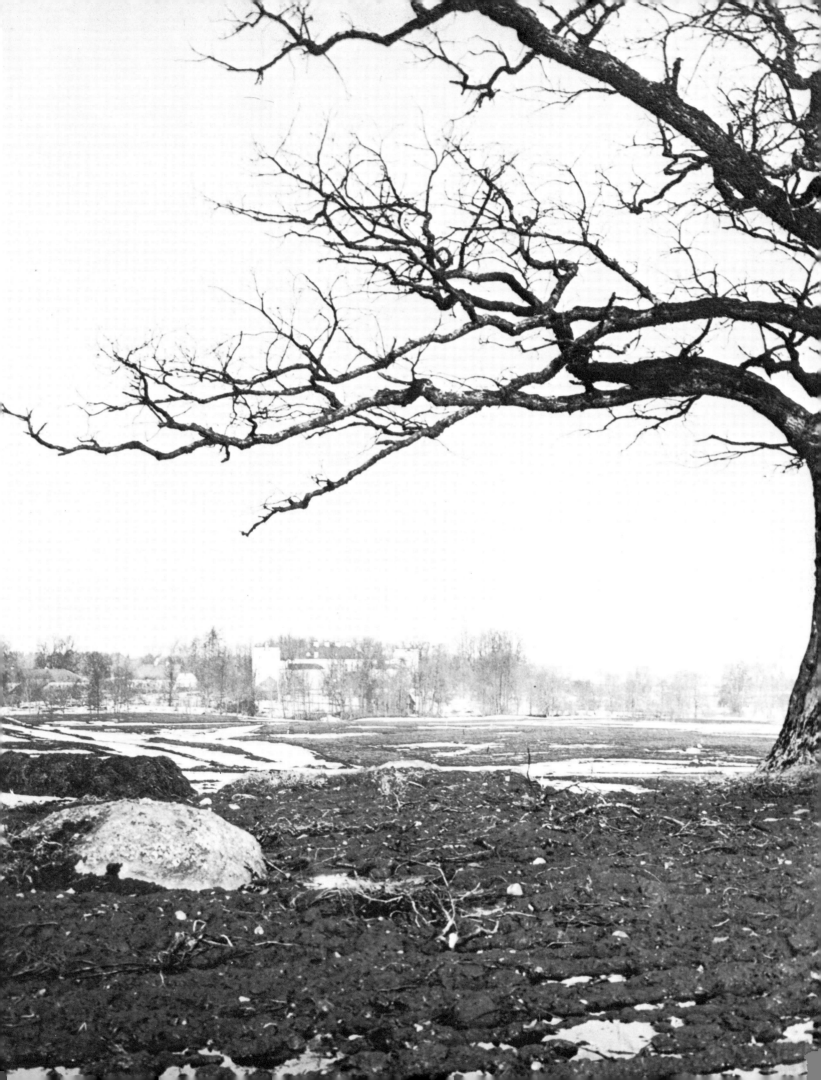

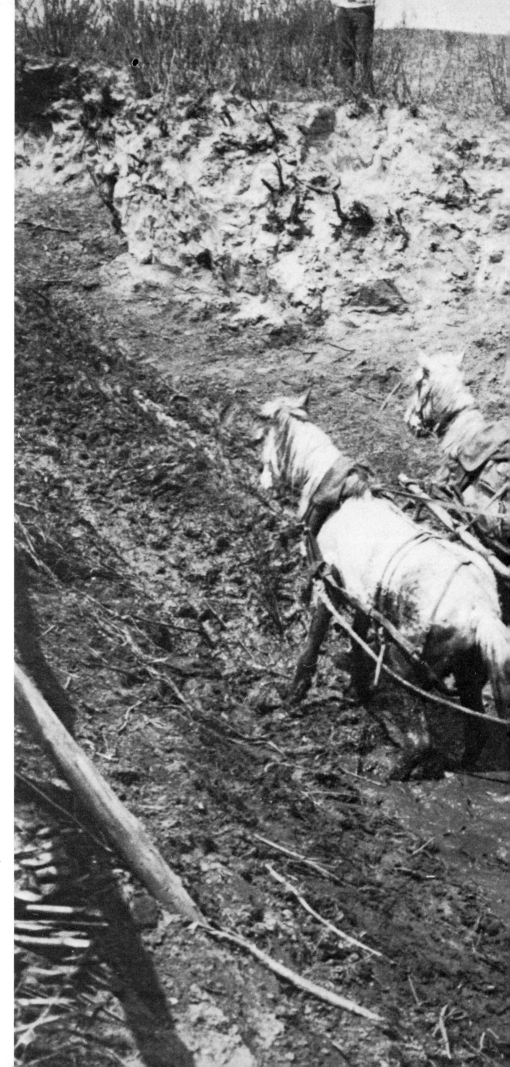

III The quagmire of the Russian spring.
For centuries it has served to protect the
state from its enemies—as all of them have
found to their distress. However, much as
the enemy suffered from it, the Russian had
no option except to live with it. If possible,
one would delay moving until it became
dry enough to do so with some guarantee of
not being bogged down at the first turn.
The military often had no option and these
soldiers are attempting to free a cart as its
peasant driver scratches his head (at right)
during the Russian move from Siberia into
Manchuria at the time of the Boxer
Rebellion, 1902.

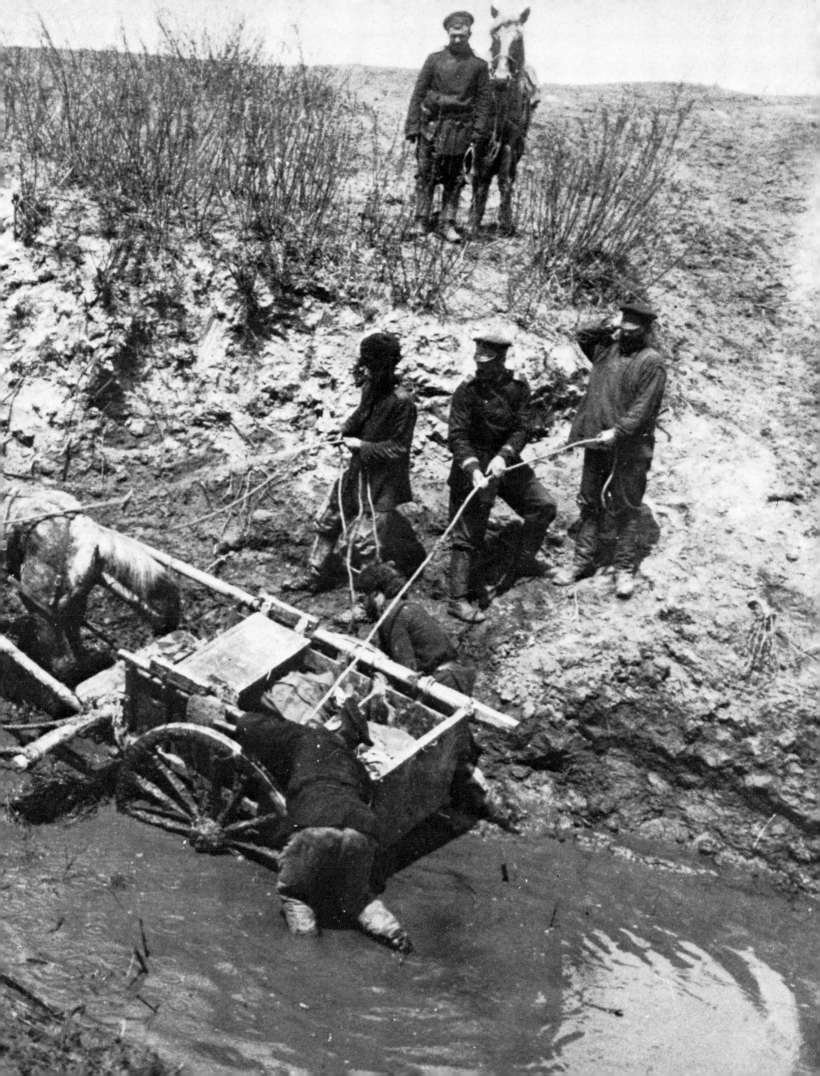

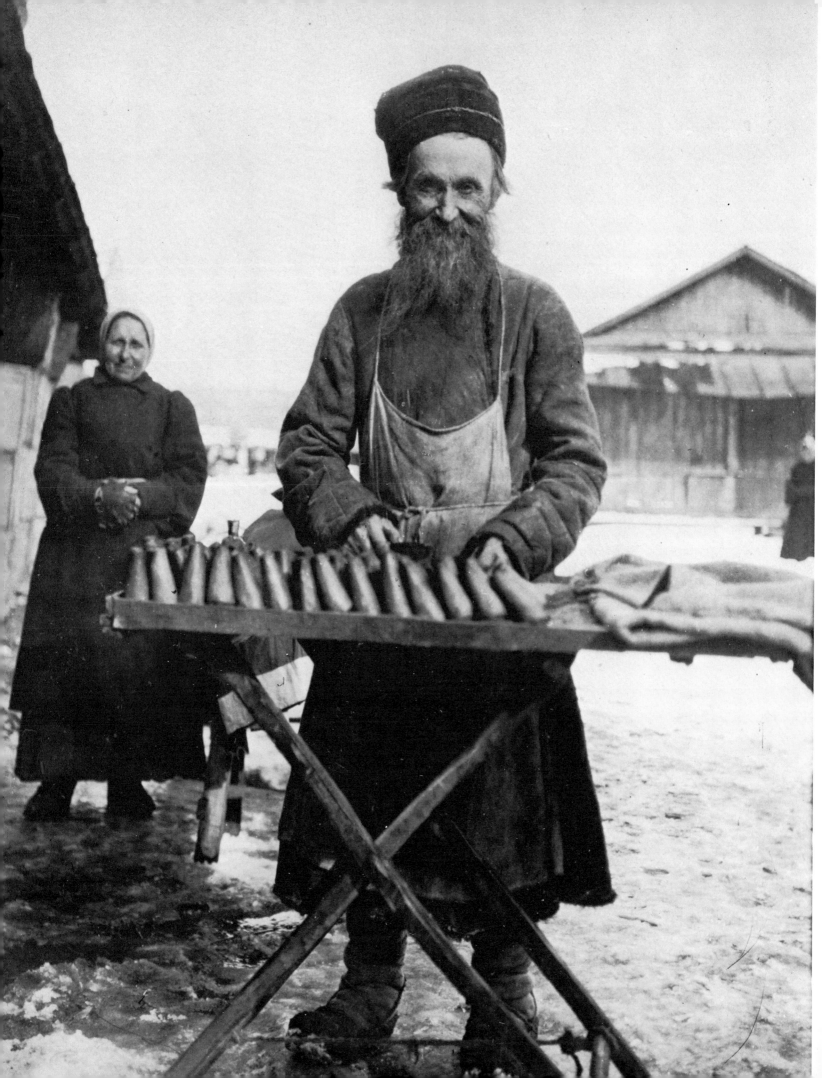

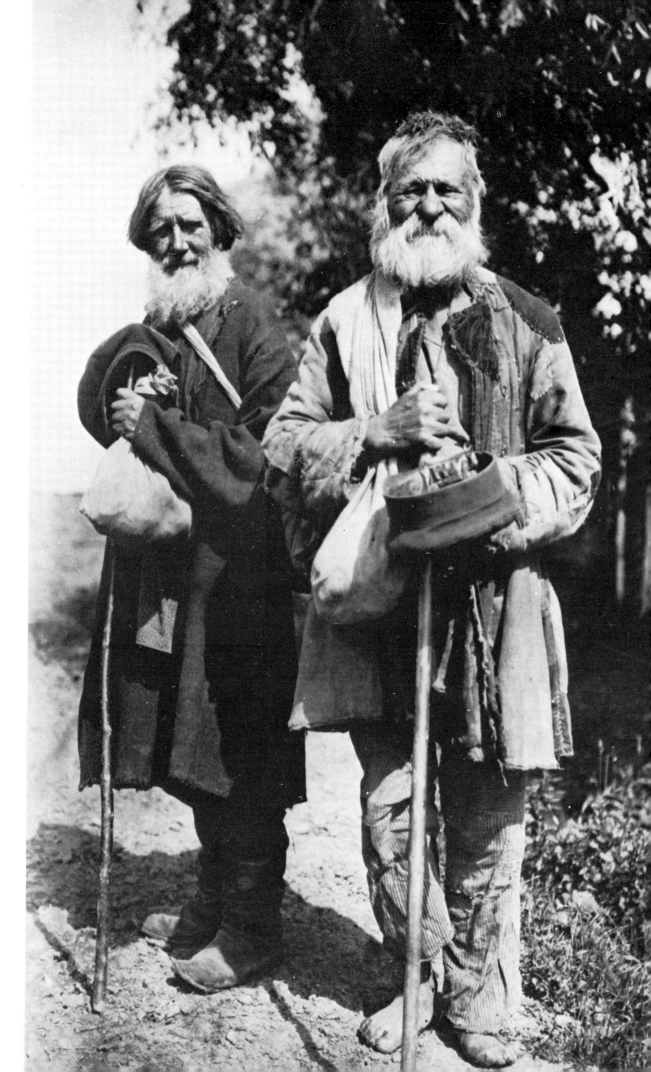

112 *left* Fresh
piroshki (meat pies)!

113 Pilgrims,
c. 1910.

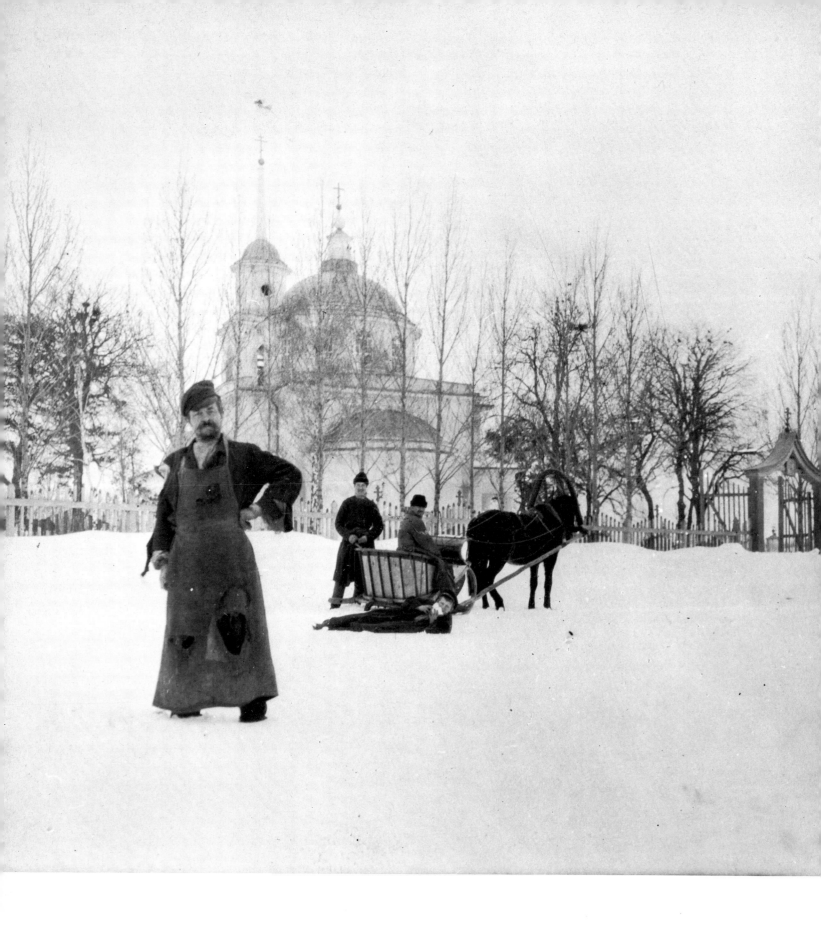

114 Villagers in front of their country church.

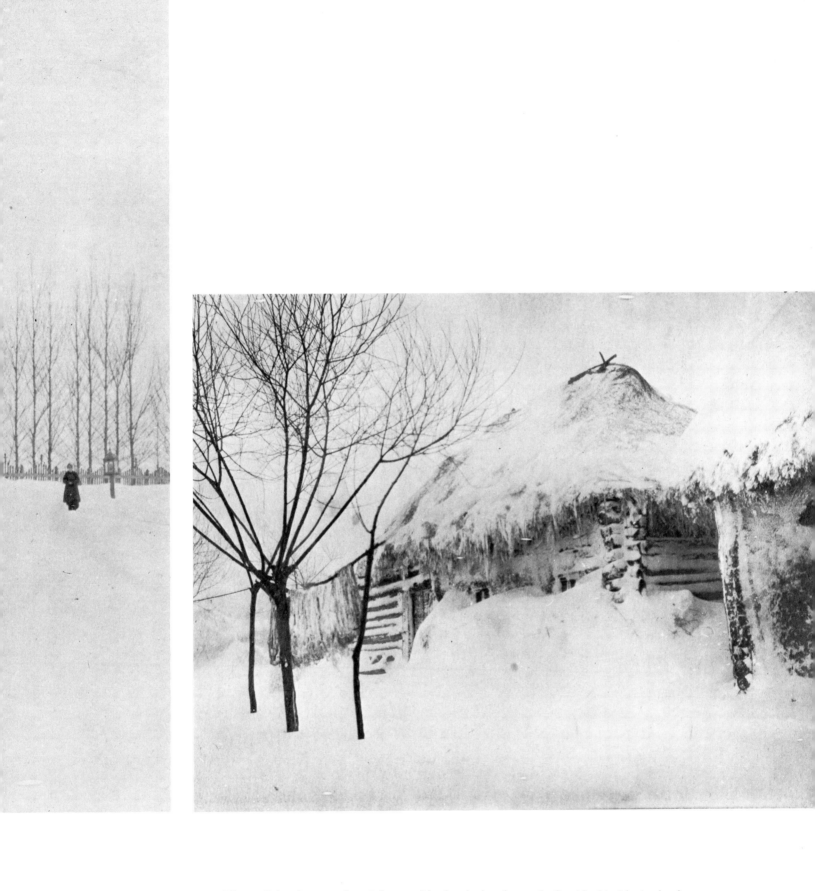

115 The traditional peasant hut, *izba*, roughly thatched and sparsely furnished inside, in the deep snow of midwinter.

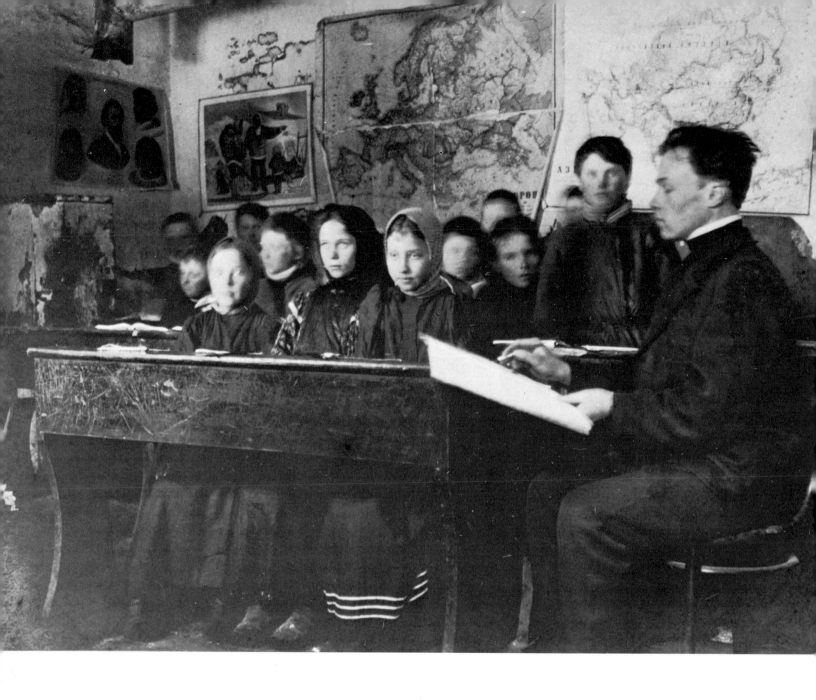

116 Schools in rural Russia were sparse and usually open only in winter: children worked in the fields with their parents during spring, summer and autumn.

117 Mennonite children playing. Tiegerweide Colony, Ekaterinoslav Government, 1906.

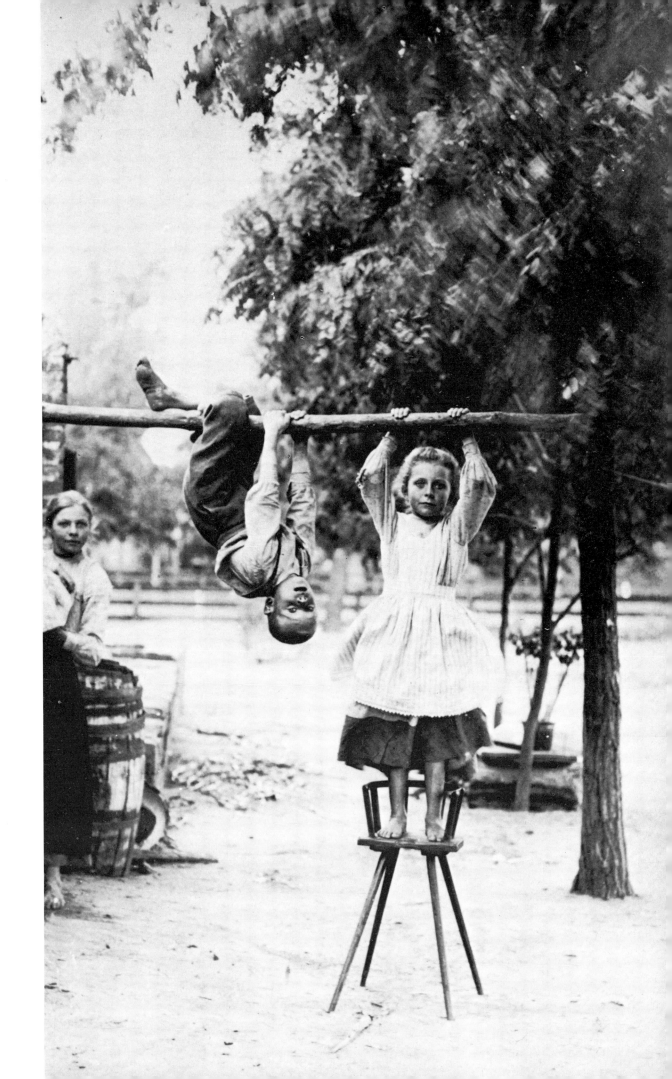

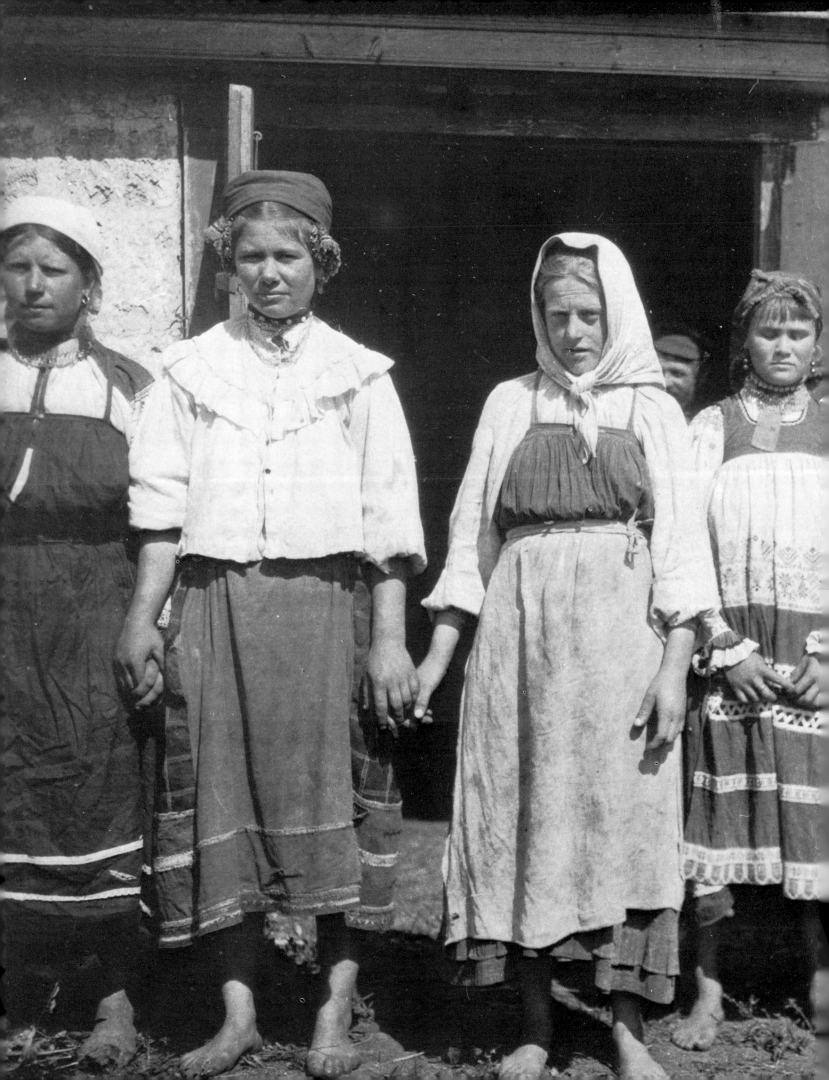

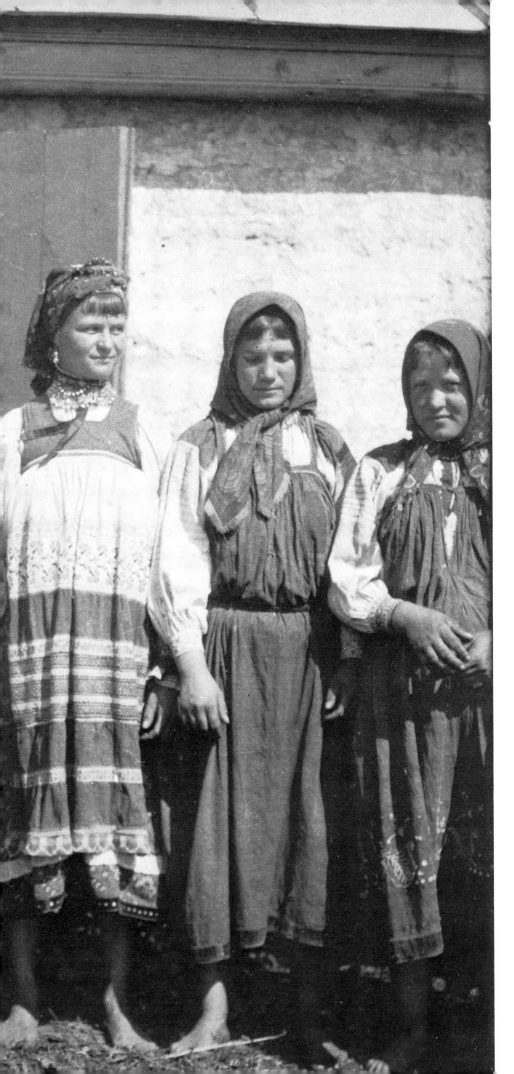

118 Peasant girls in Mtsensk, Orlov Province, 1911.

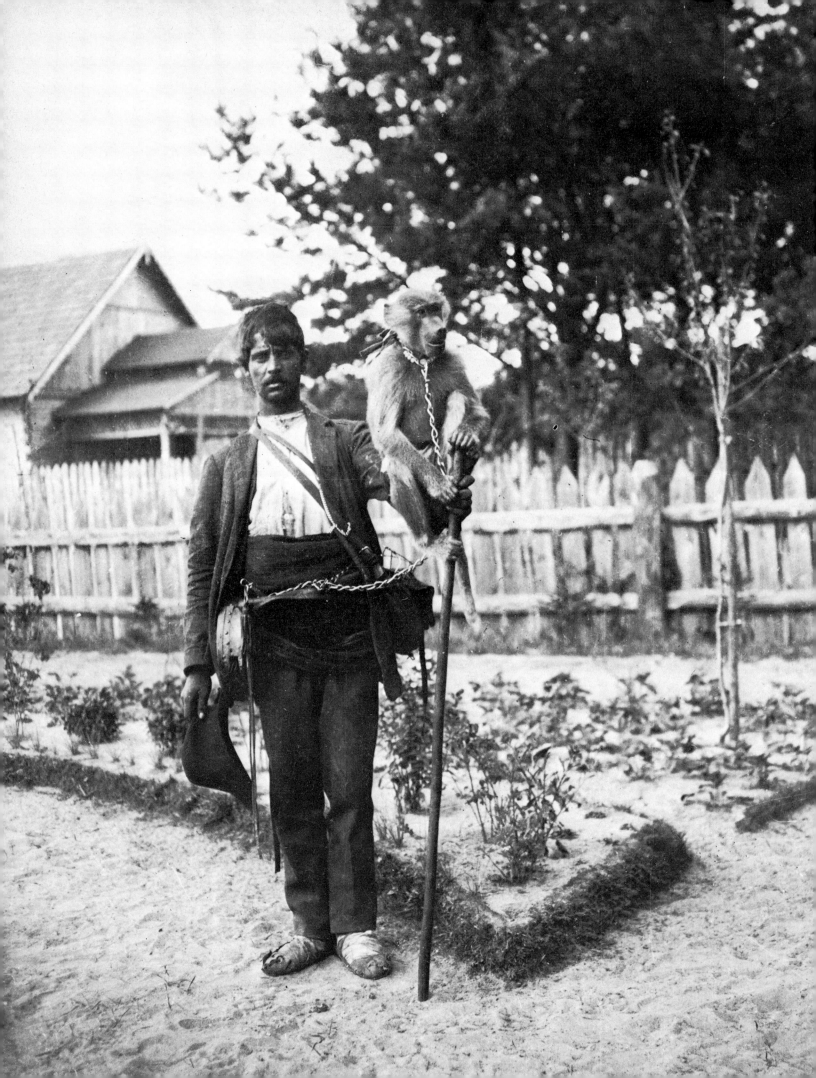

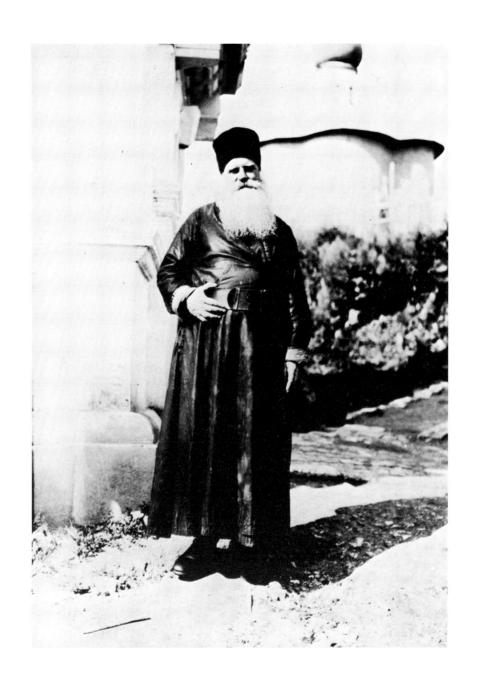

119 *left* A travelling gypsy and his baboon: Mtsensk, Orel 120 *above* A village priest, *c.* 1910.
Government, 1911.

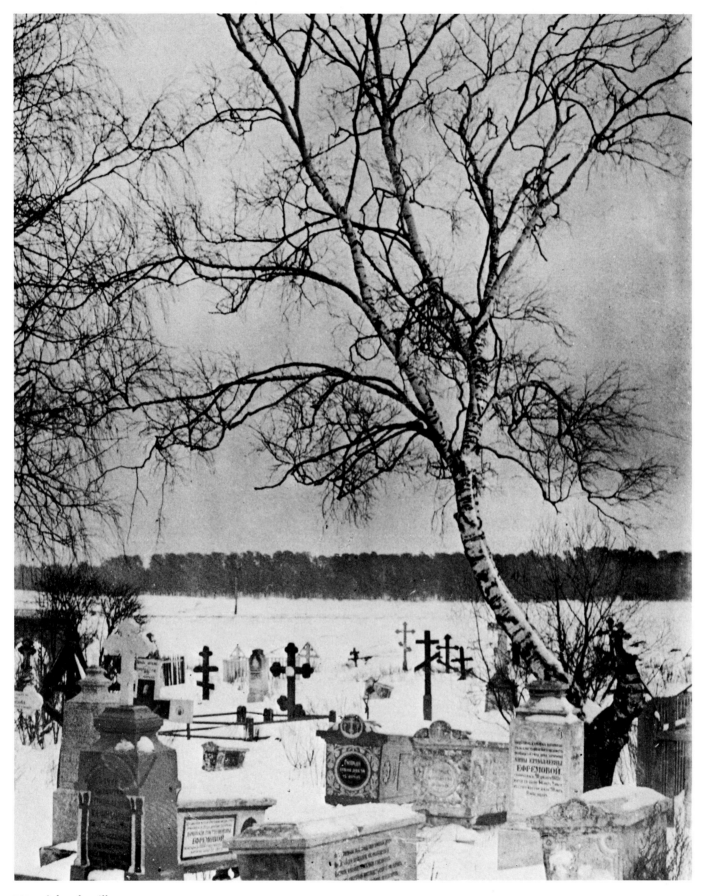

121 A lonely village cemetery.

SCENES FROM PROVINCIAL LIFE

Rivers were the great arteries of Russian communication and commerce. The Volga was the longest river of Europe, and an elaborate network of canals linked it with the Dnieper and Don: on their banks, great cities—Nizhni Novgorod, Kiev, Rostov—were established. To these natural channels were added in the nineteenth century an elaborate network of railways, beginning with the line from the Tsar's residence at Tsarskoe Selo to St Petersburg in 1837. Moscow and St Petersburg were linked by rail in 1851; by 1912, there were 35,000 miles of railway in European Russia, and another 20,000 in the Trans-Siberian network. In a state so large as Russia, railways assumed an extraordinary importance, and much of Russian literature and drama takes place to the accompaniment of train whistles, grinding wheels, and endless journeys across dismal landscapes; thus, Anna Karenina meets her end under the wheels of the train to Obiralovka, and Prince Mishkin in Dostoevsky's *The Idiot* is clearly a habitué of railway stations. But even under the pressure of economic integration, the provincial cities which were scattered across the face of Russia, joined by river and rail, continued to present a picture of total diversity.

Russia was split at the Urals into European and Asiatic Russia; a misleading distinction, for many of the peoples of Russia-in-Europe were of Asiatic stock. The Tartars who dominated the province of Riazan, to the south-east of Moscow, and made Kazan, once the capital of a mighty Khanate, into a city with a distinctly eastern flavour, could be found all along the Volga, as well as in great numbers in the Crimea and the Caucasus. The Crimea, by the end of the nineteenth century, a popular holiday spot for refugees from the summer heat of Moscow and St Petersburg, contained a bizarre mixture of races, while the Caucasus, with innumerable tribes and sub-tribes, remained in many districts a dangerous border zone, beset by bandits.

Each provincial centre had its own social hierarchy, led by the senior government officials, and aped as closely as possible the perceived manners of Moscow and St Petersburg. All

provinces—there were fifty-nine of them in European Russia—had their own Governor, and after the reforms of Alexander II, a structure of local representative institutions (*zemstva*), which were dominated by the local nobility. Even at village level, the council of the village commune (*mir*) administered justice and exacted punishments. In a sense, therefore, Russia was a profoundly 'democratic' society. But much of this notional 'power' in the hands of the people was illusory, for decisions were taken at the centre by the Tsar and his ministers. Yet this tradition of local communal action, made the demand during the chaos of the Revolution for 'All power to the Soviets [councils]' seem a natural and welcome step: in this, as in much else, the Bolsheviks turned the mechanism of Tsarist administration to their own advantage.

122 A temporary floating bridge over the Volga at Nizhni Novgorod. Such bridges were taken up during the winter and a roadway laid across the ice.

123 Breakup of the ice on the Volga at Nizhni Novgorod.

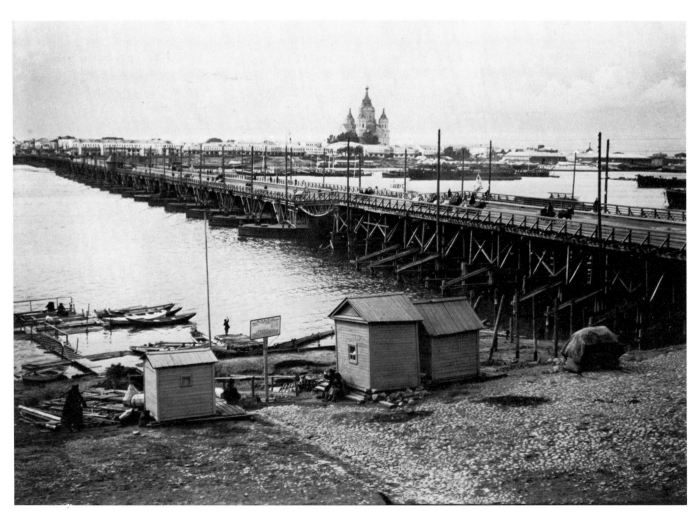

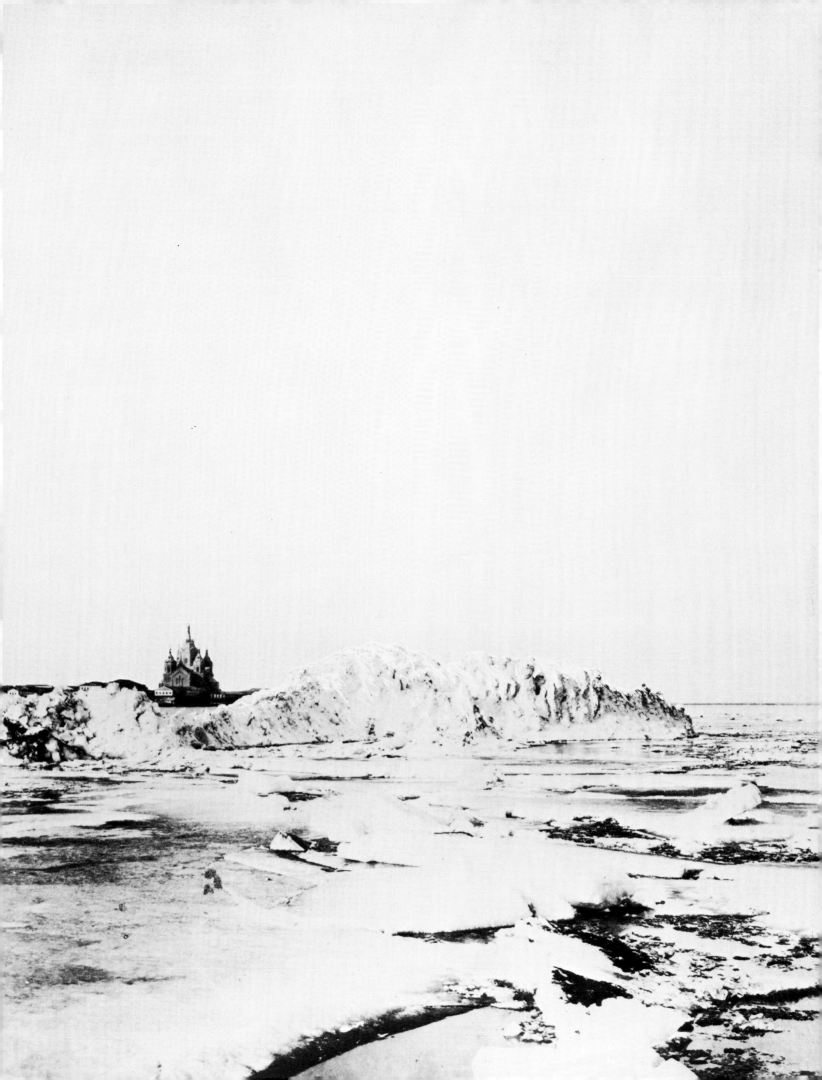

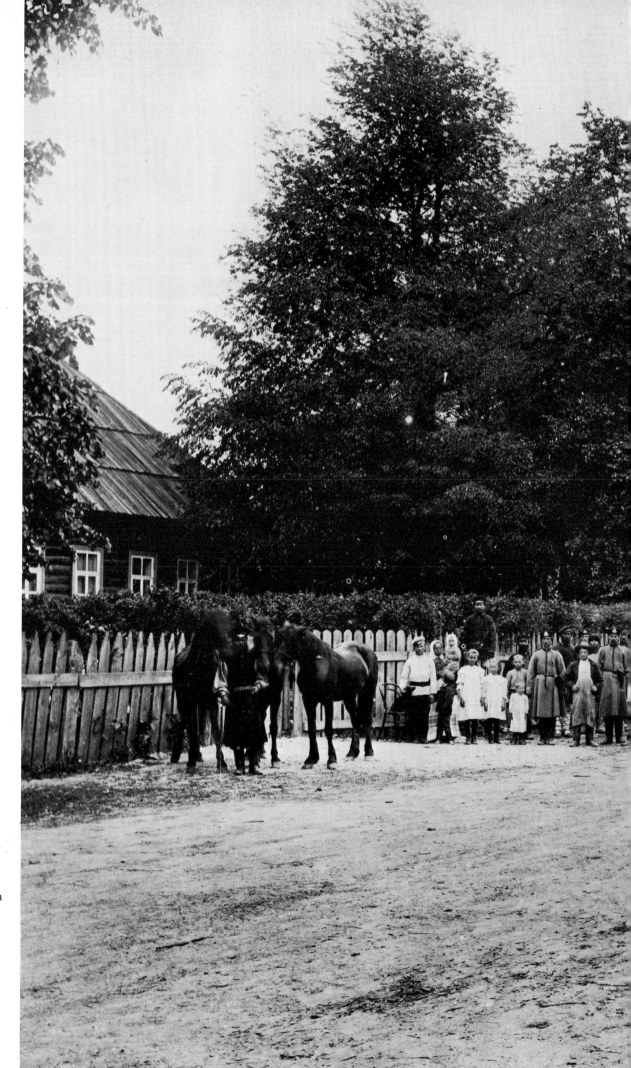

124 'Types' in the village of Brasovo, an estate of the Grand Duke Mikhail Alexandrovich in Orel Government, *c.* 1907.

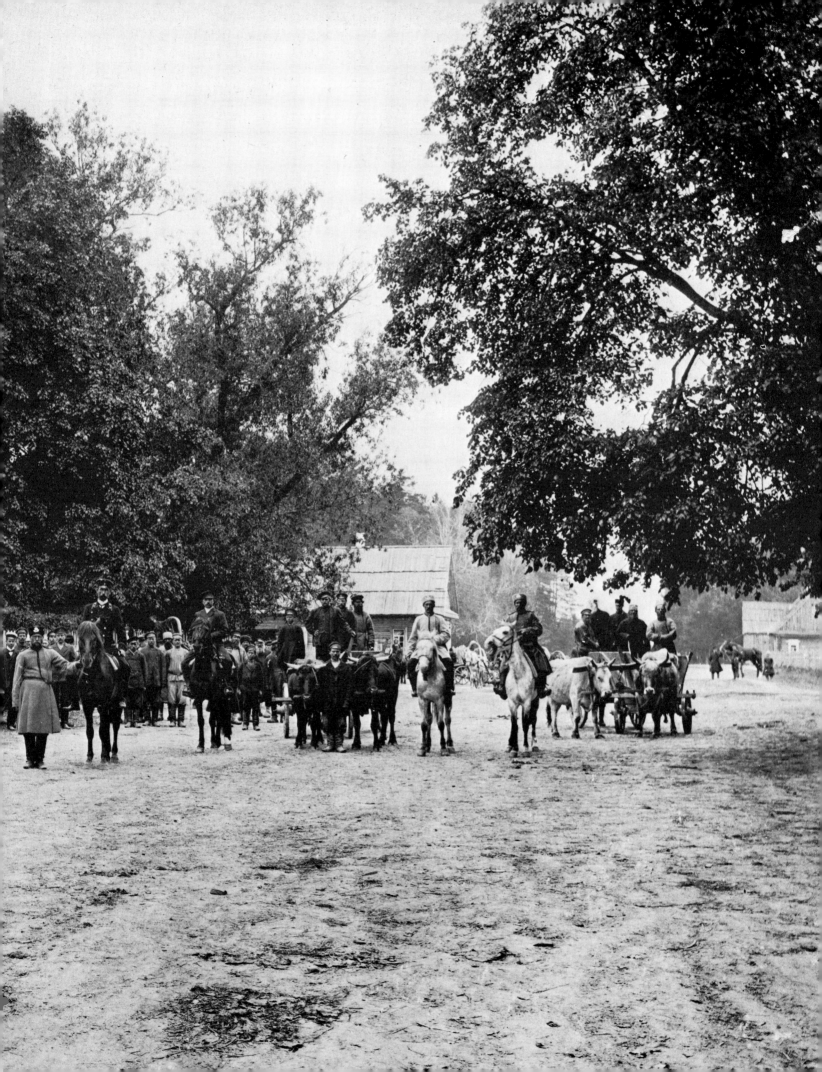

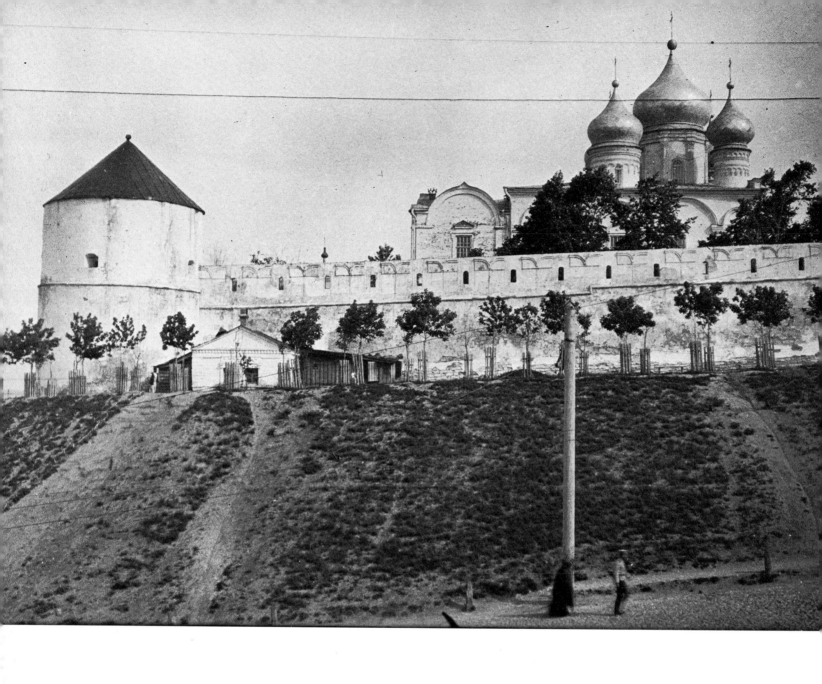

125 The Kremlin at Nizhni Novgorod. The city, with a population of over 100,000, was founded in 1221. It was famous for the great fair held every year from July to September. The Kremlin, with its walls up to 100 feet in height, and eleven massive towers, dominated the old city.

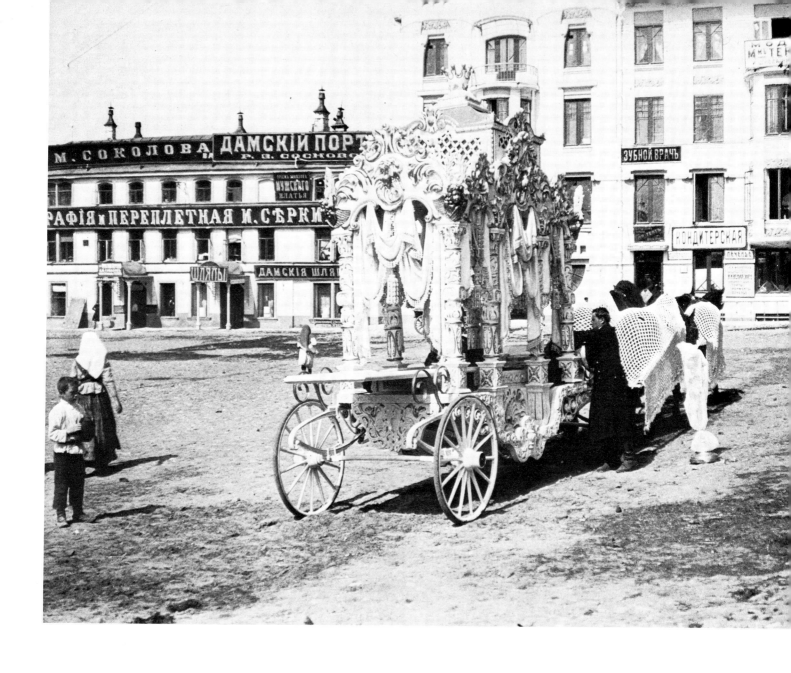

126 An elaborate hearse: Nizhni Novgorod, *c.* 1910.

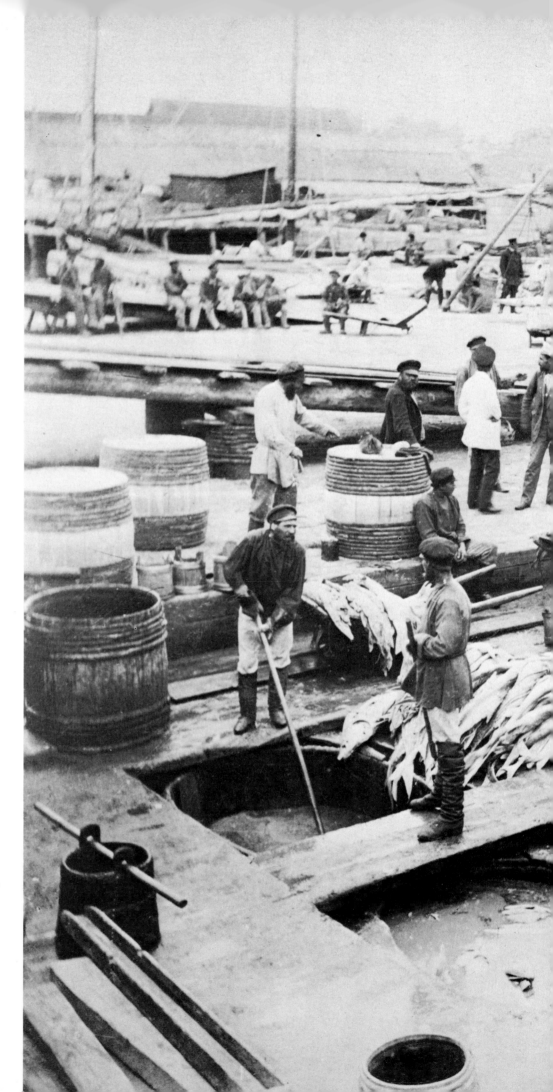

127 Processing sturgeon and sterlet, *c.* 1900. While the value of those caught on the Upper Volga amounted to less than 5 per cent of those from the Caspian Sea, more than 10,000 people were employed in the industry. Sterlet (small sturgeon) was frequently used as the basis of a soup.

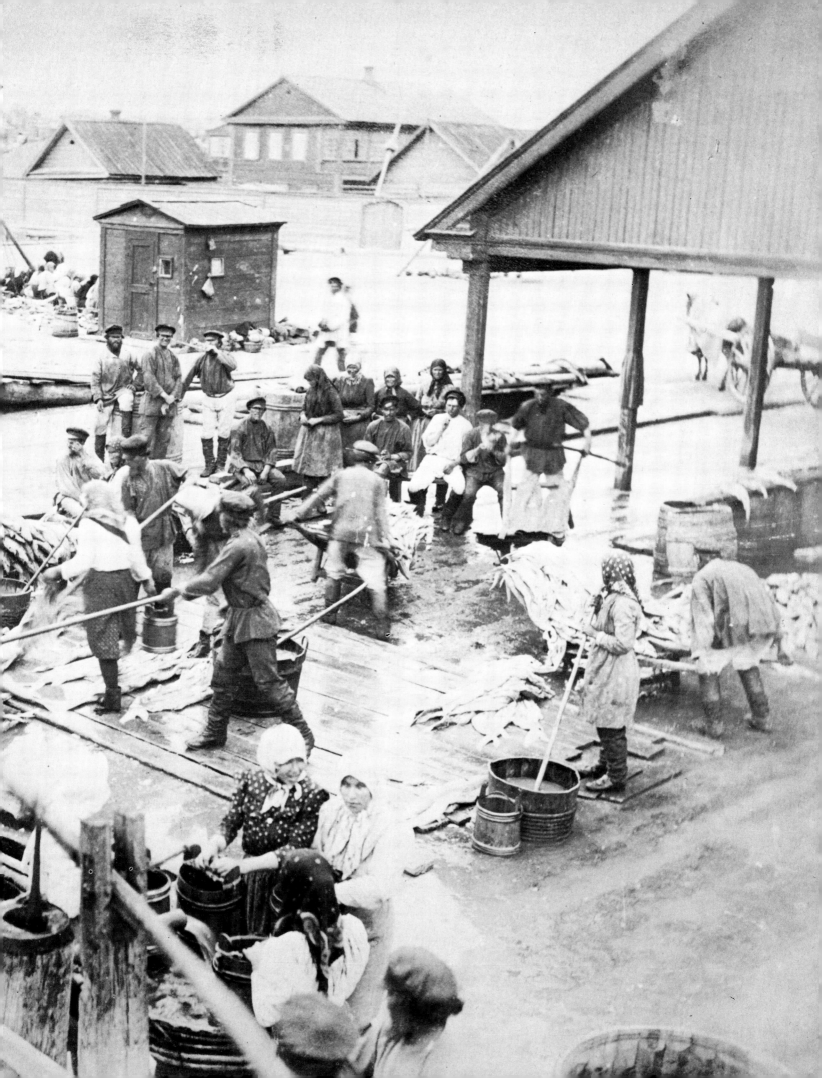

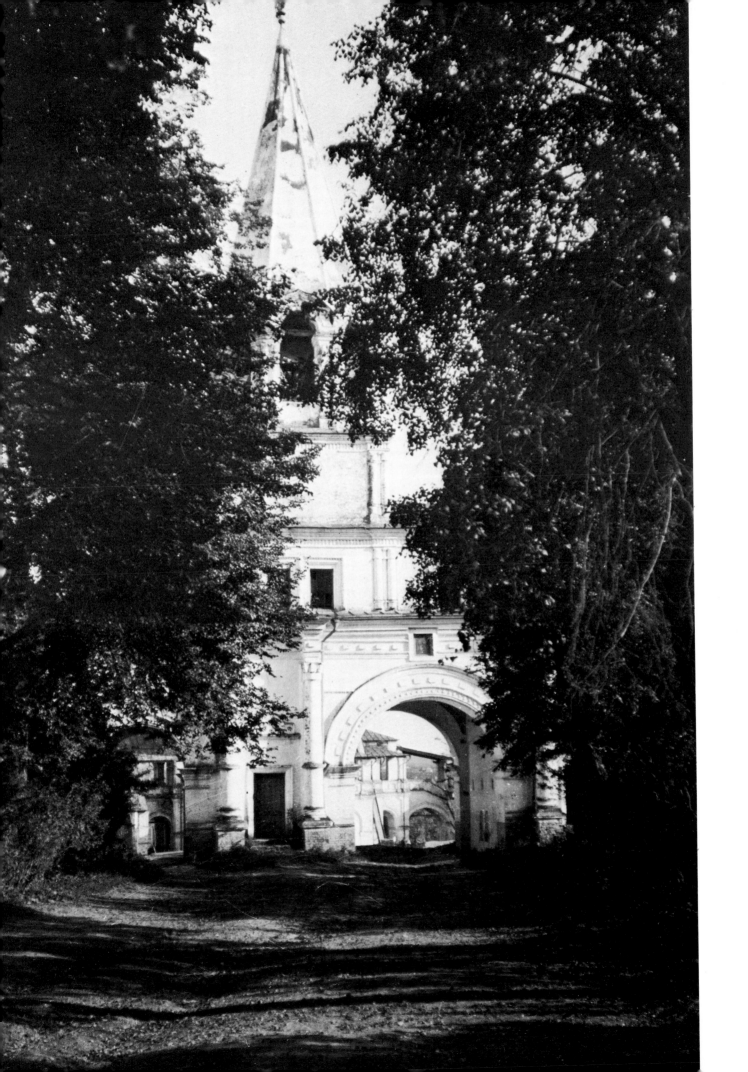

128 *left* An ancient gateway in Kazan. The city was built by the Tartars (its name means 'kettle') but was captured in 1469. One of the great trading centres of Russia, the city was razed during the Pugachev rebellion in 1774.

129 *below* Kazan, *c.* 1910.

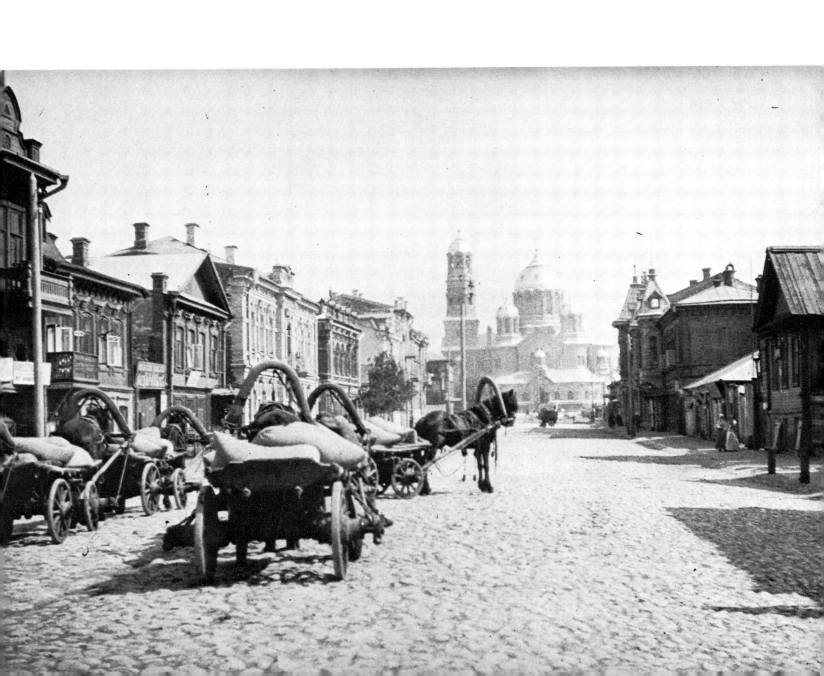

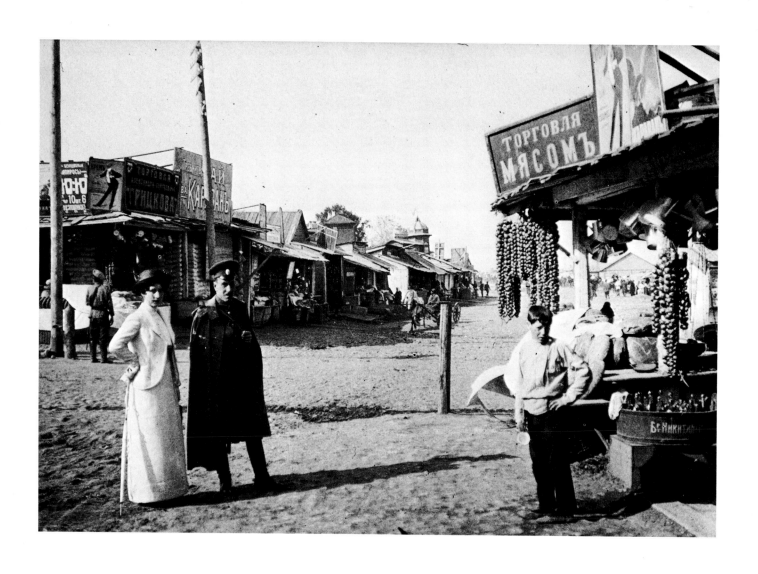

130 An officer and his wife in a village near Kazan. 131 Fishermen on the Volga, *c.* 1900.

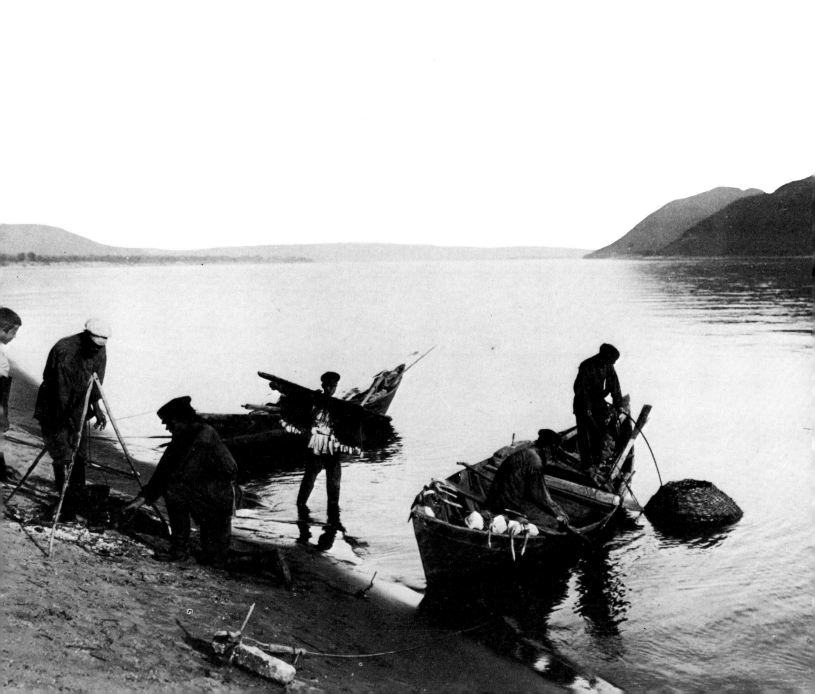

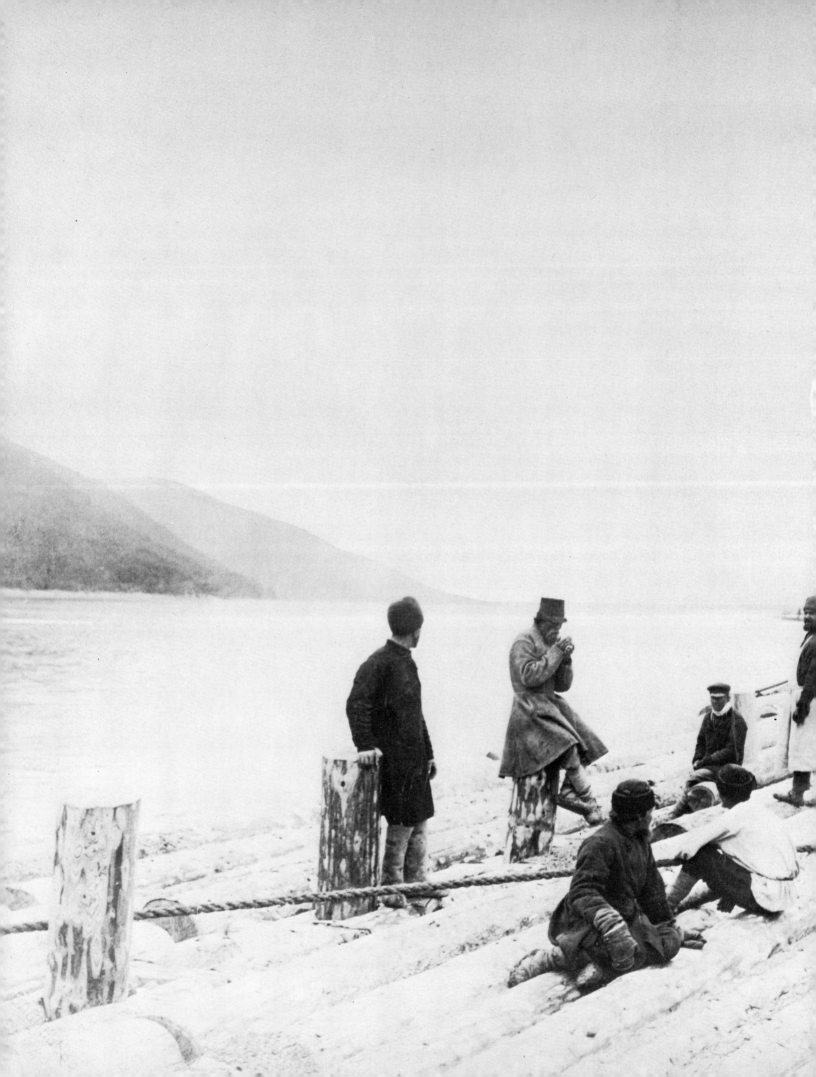

132 Log raft men. In addition to the vast traffic in timber, over 2,000 steamboats used the river as a highway.

133 Simbirsk landing stage on the Volga, *c.* 1910.

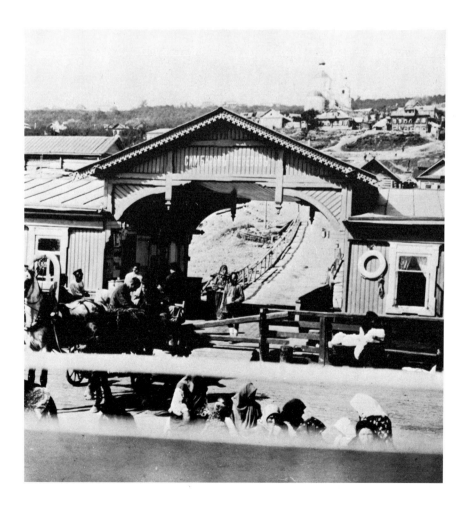

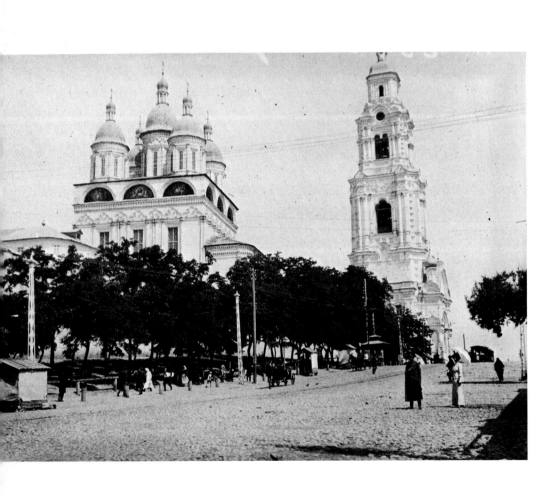

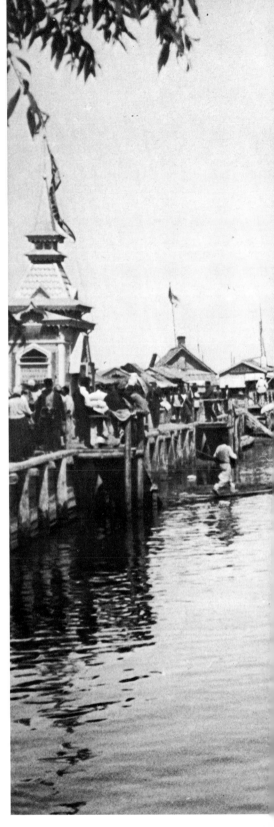

134 The Uspenski Cathedral at Astrakhan, near the mouth of the Volga and one of the most cosmopolitan cities in Russia. The Cathedral was built between 1700 and 1710

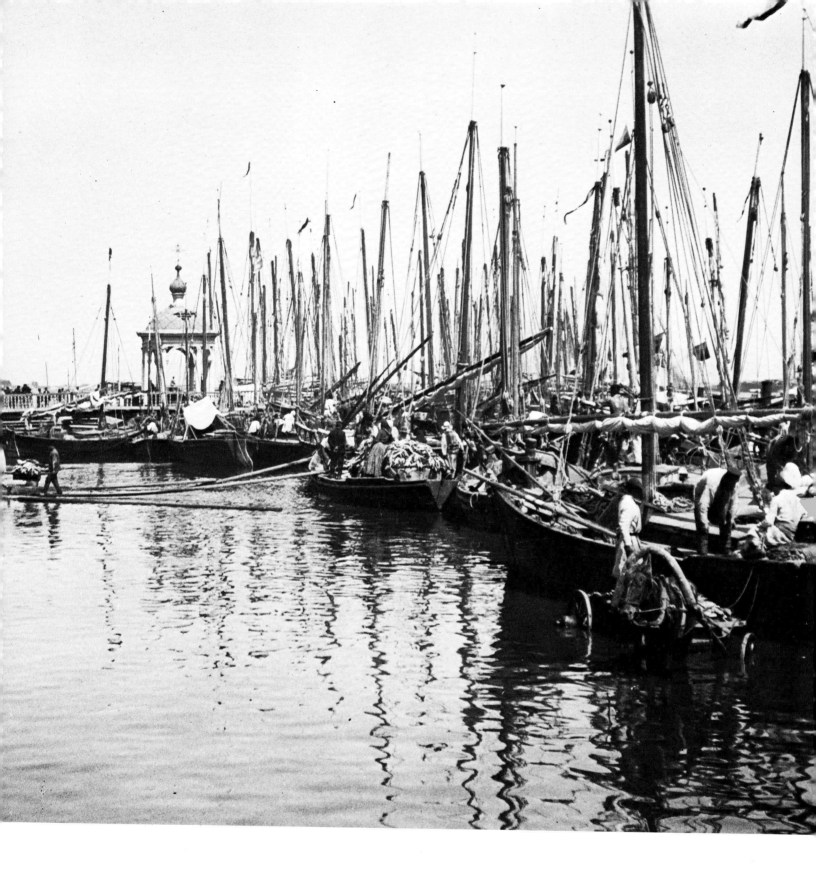

135 The fishing fleet at Astrakhan: fully half the population of the city depended on the fishing industry.

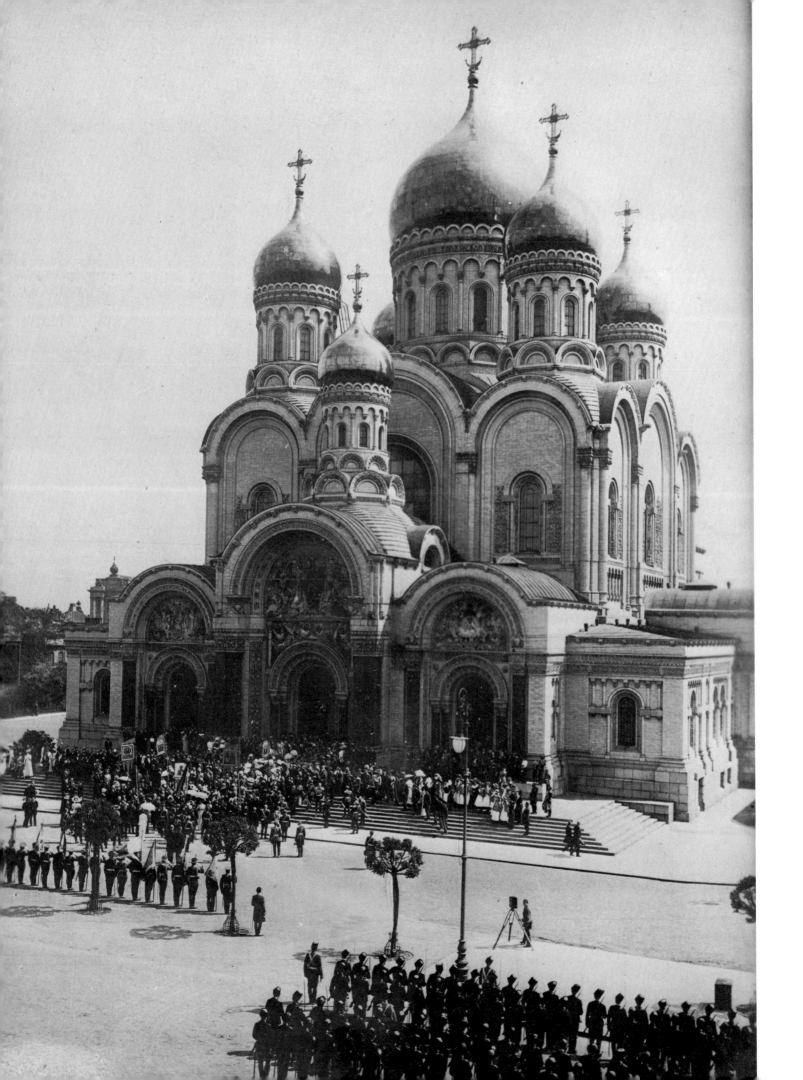

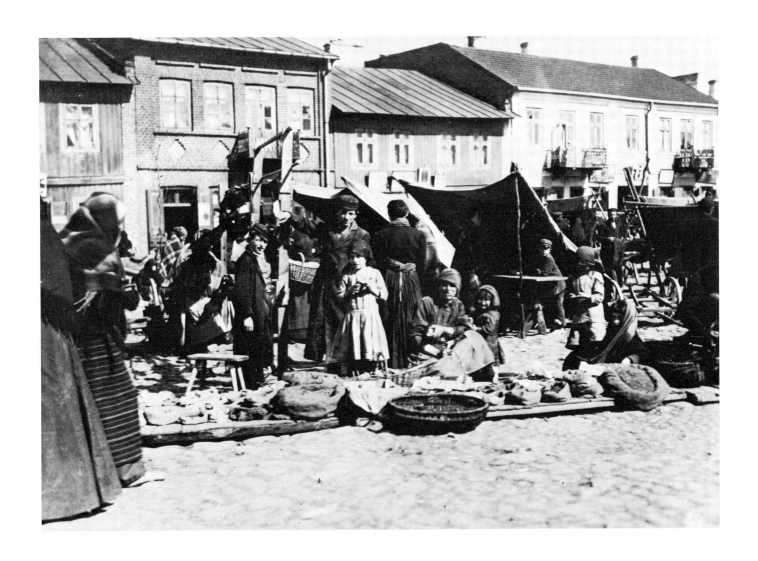

136 *left* Scene outside the Cathedral of St Alexander Nevski on the Saxon Square to commemorate the completion of the building (begun in 1894)—Warsaw, 1912. The erection of this great and fine Orthodox Cathedral greatly irritated the Polish subjects of the Emperor, who considered that it disfigured one of the city's great squares, already badly disfigured by other examples of 'Russian' architecture. It was one of the first symbols of Russian domination to go after the creation of an independent Poland.

The Cathedral seems to have been primarily a 'garrison church', almost all of those on the steps being Russian officers. In the left foreground, the standards of the regiments of the garrison. At the right, a 'guard of honour' from a Cossack regiment.

137 Market Day in a town in Russian Poland, 1915.

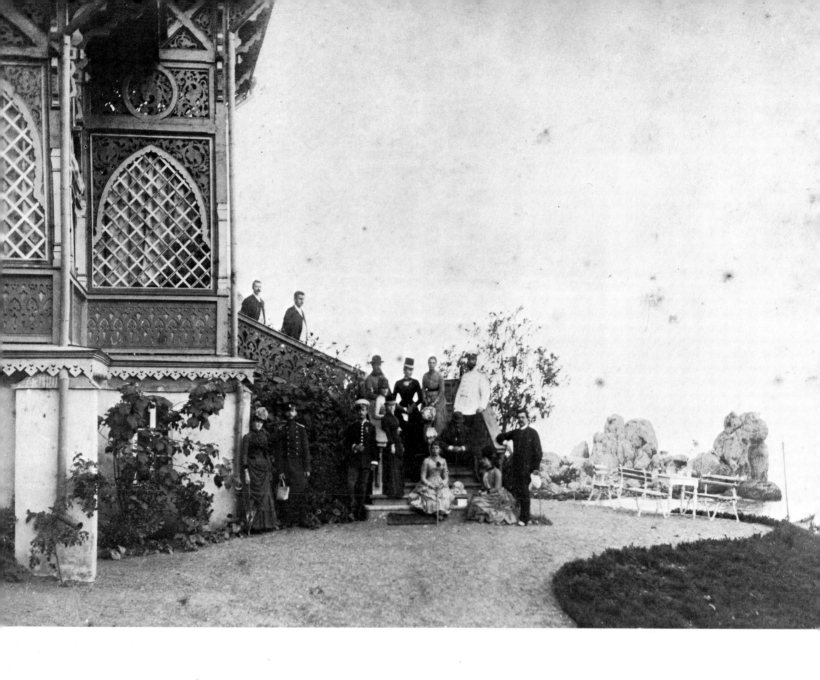

138 A fine example of Russian fretwork! The Sverbeev *datcha* at Massandra in the Crimea, late 1880s.

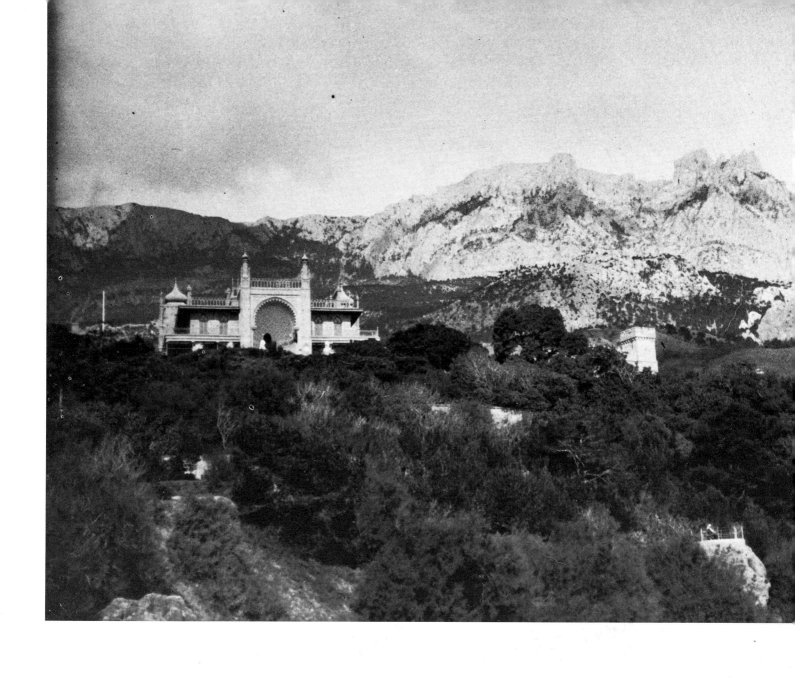

139 The palace of Count Vorontsov—Dashkov at Alupka, *c.* 1910. Built in 1837 for Prince Vorontsov at the cost of three million rubles in a combination of Gothic and Moorish styles, it was the largest house in the Crimea. In the background, Ai-Petri.

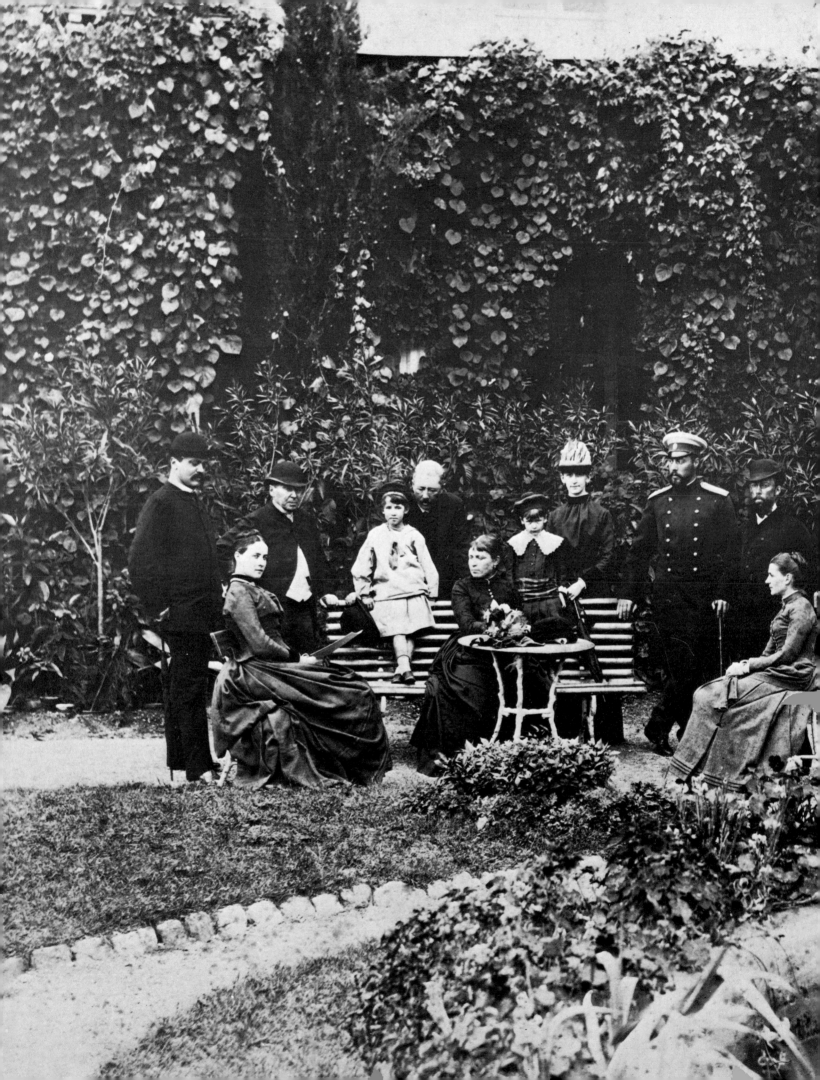

140 Massandra, late 1880s. (Standing—L to R) M. A. Sverbeev, Krushchev, Natalia Pubalov, M. V. Sverbeev, ?, Katia M. Sverbeev, D. F. Trepov, Baron Bistrom. (Seated—L to R) Mme S. R. Trepov, Baroness Bistrom, Mme S. N. Pubalov.

141 General view of Gurzuf—an attractive and popular bathing resort, on the coast of the Crimea, North of Yalta, *c.* 1910.

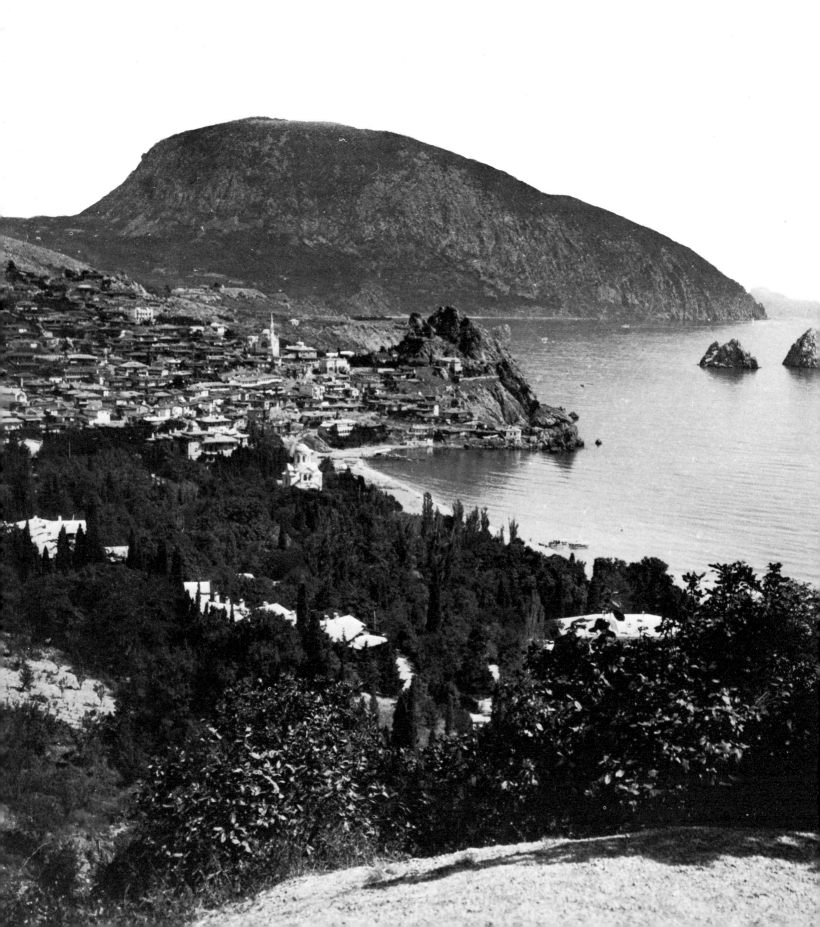

142 Boats, and drying nets—Gurzuf, *c.* 1910.

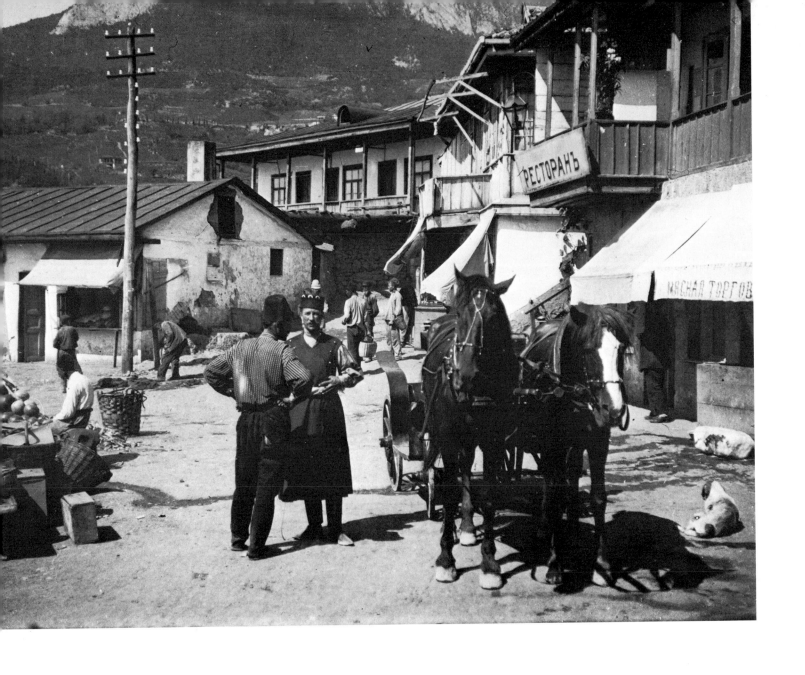

143 Tartar restaurants and market in Gurzuf, *c.* 1910.

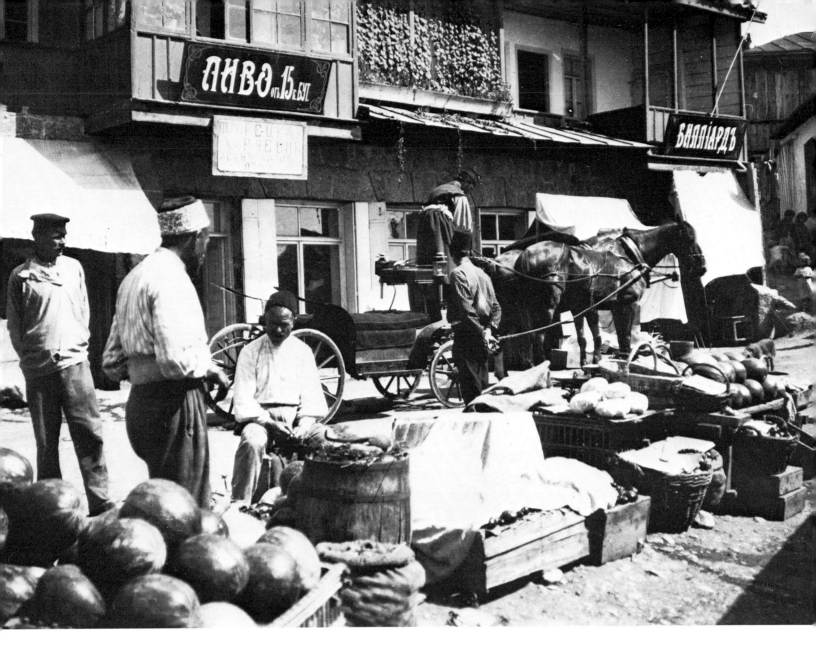

144 A street market in Gurzuf, *c.* 1910.

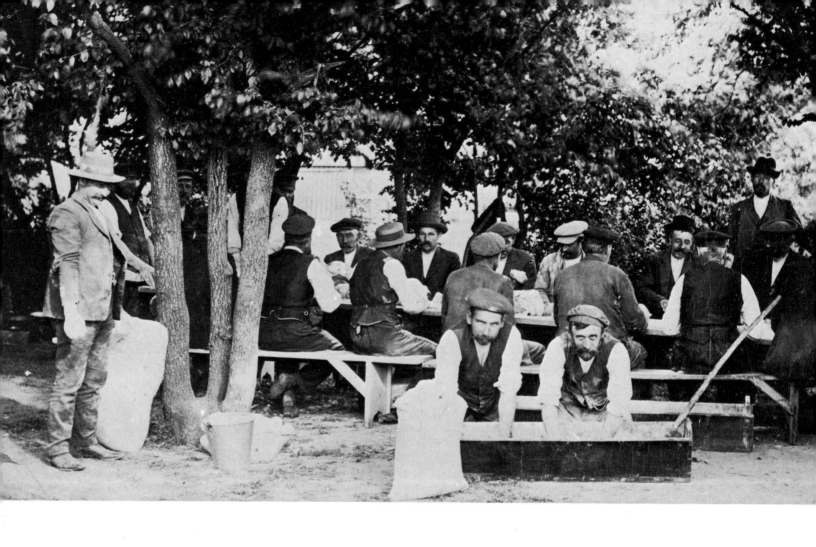

145 Preparing bait to destroy field mice, Tiegerweide, 1913.

146

146 Well-to-do Mennonites, 1916.

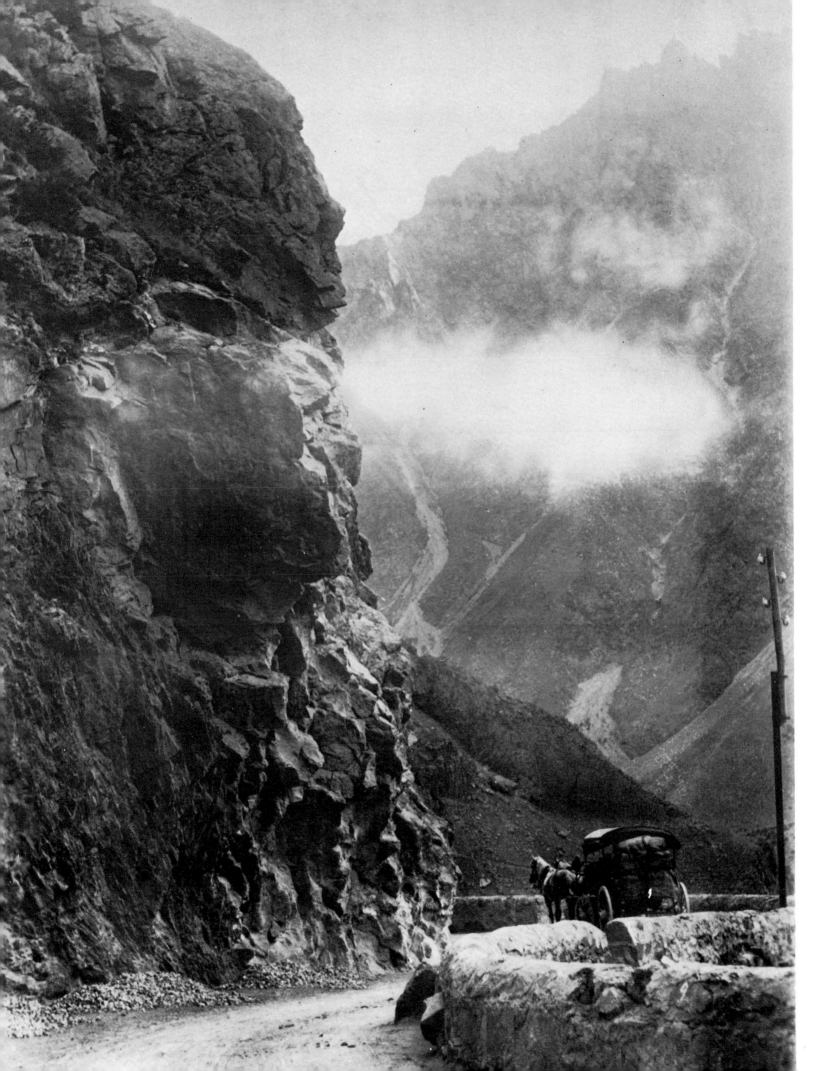

147 *left* The Darial Gorge. Five miles long, its rocky walls rose 6,000 feet straight up, with only enough room at the bottom for the river and the very narrow road. This was part of the Georgian Military Road which tied Tiflis to Vladikavkaz and Russia proper.

148 *below* The Castle of Ananri (sixteenth–seventeenth centuries), north of Tiflis along the Georgian Military Road, *c.* 1890.

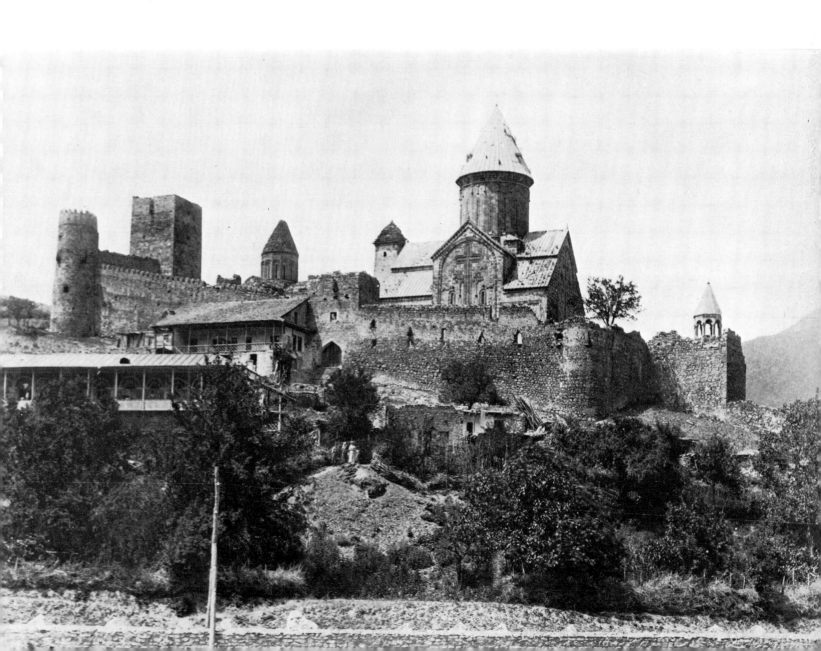

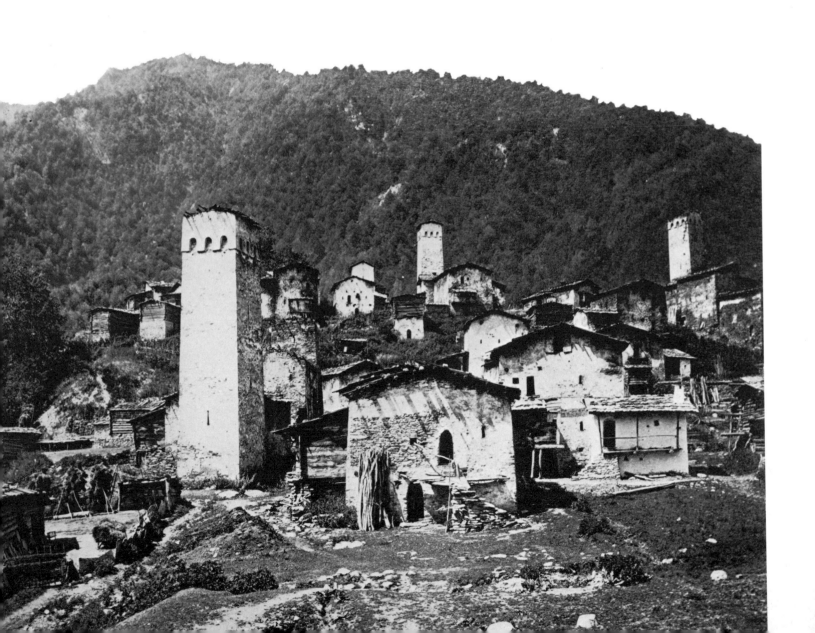

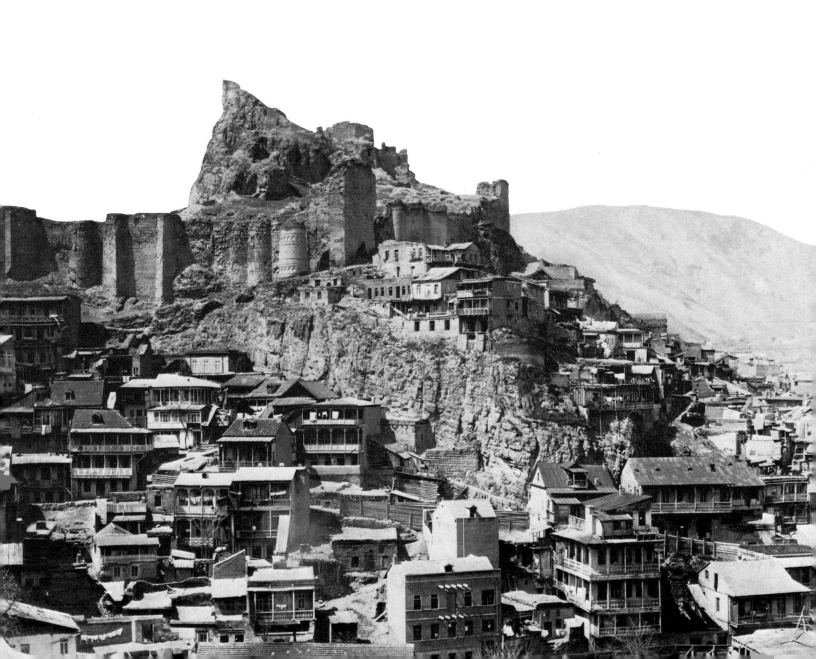

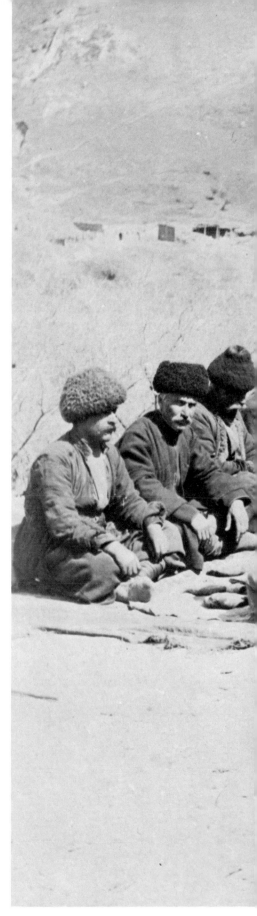

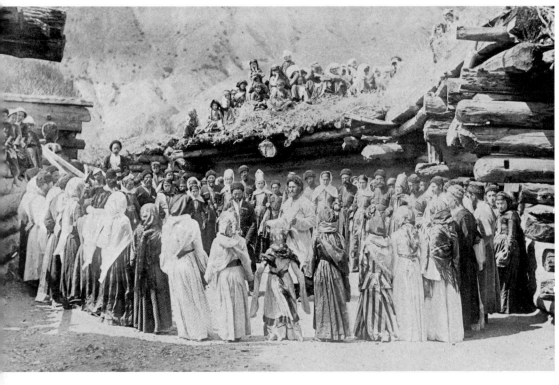

151 Karachaians doing the Uruslich, their national dance, *c.* 1890.

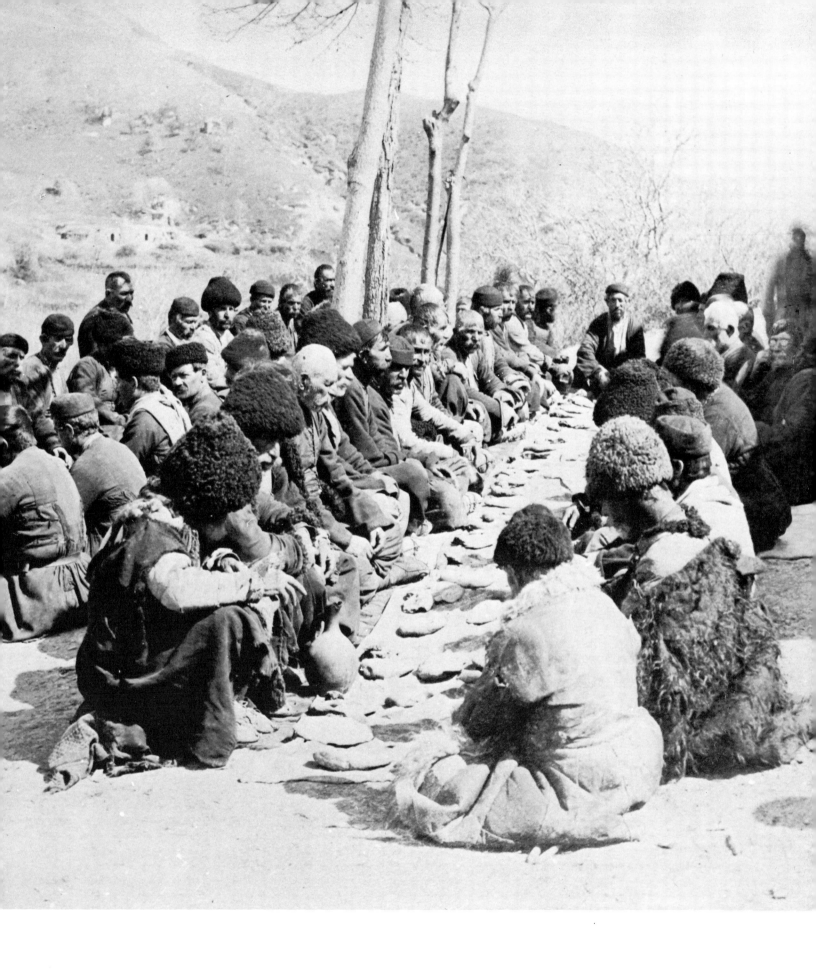

152 Georgians feasting, *c.* 1890.

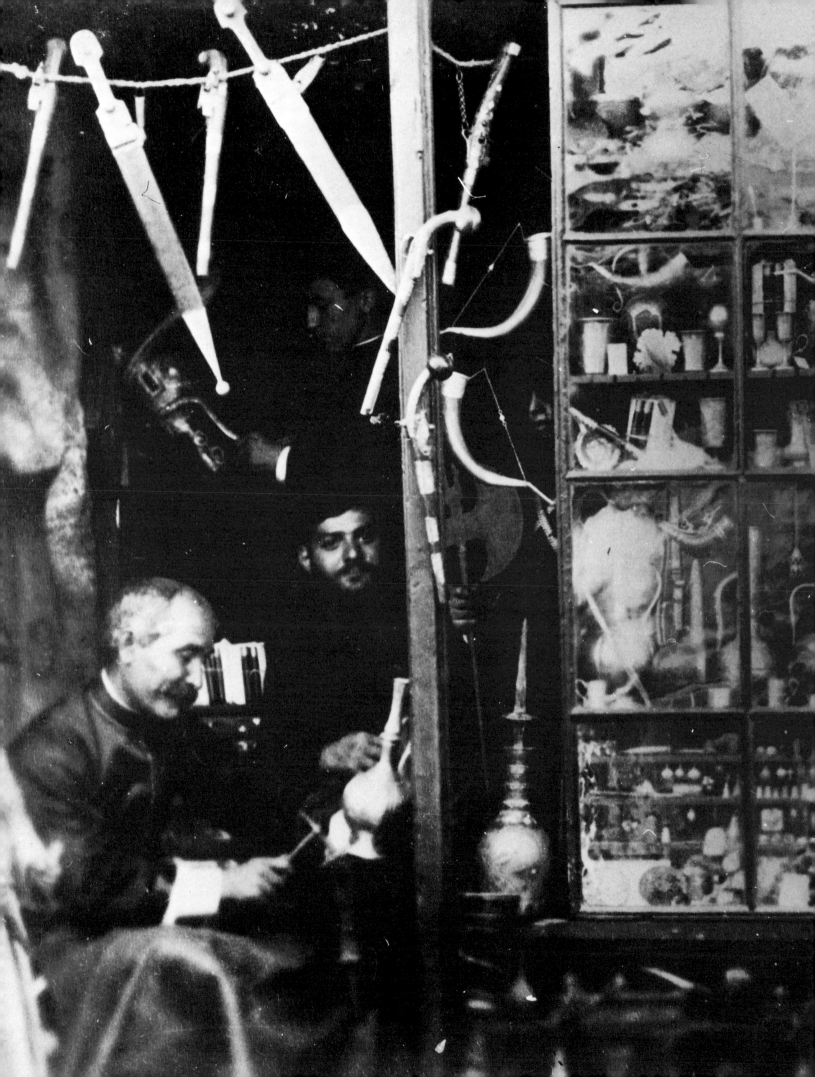

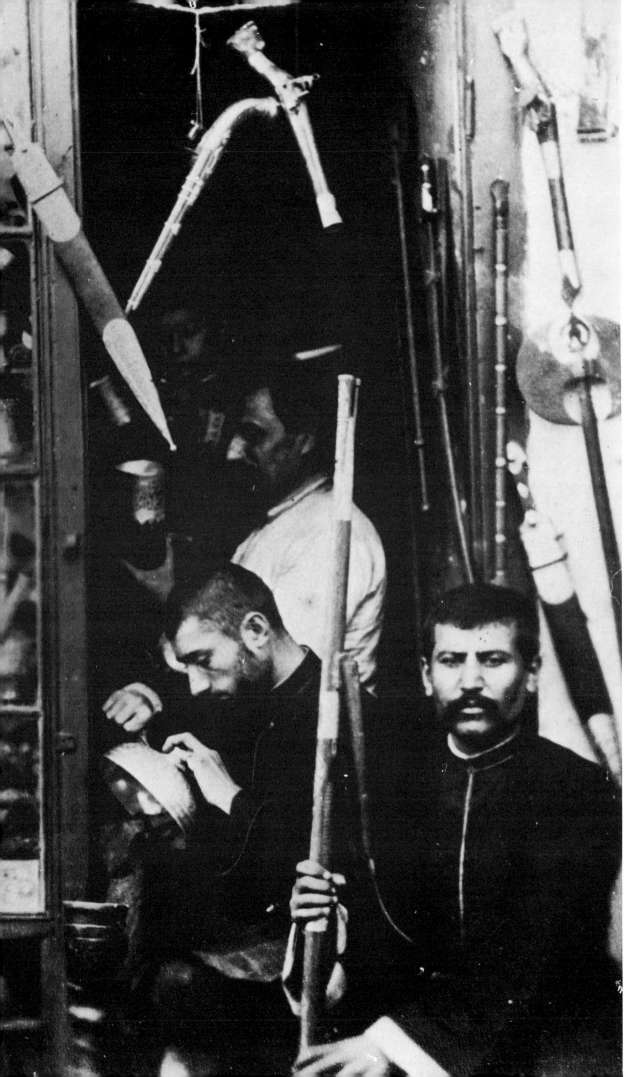

153 Shops on the Maidan, Tiflis, *c.* 1890. A jewellery shop.

155

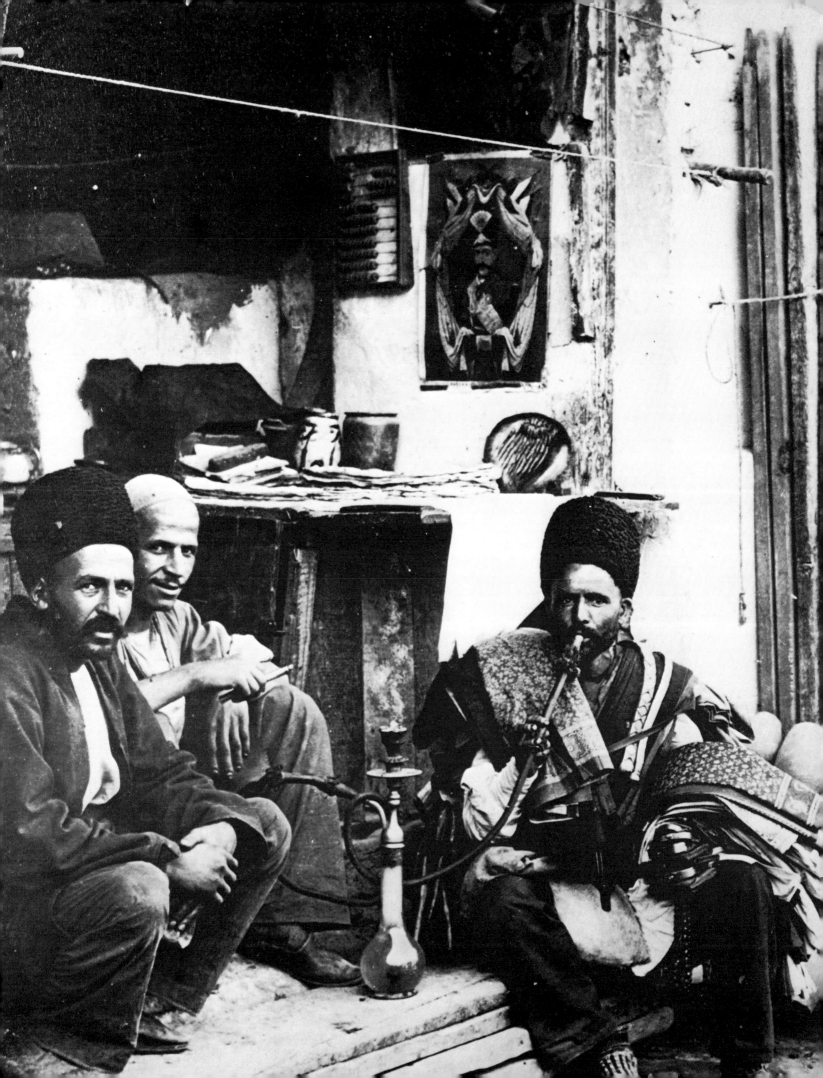

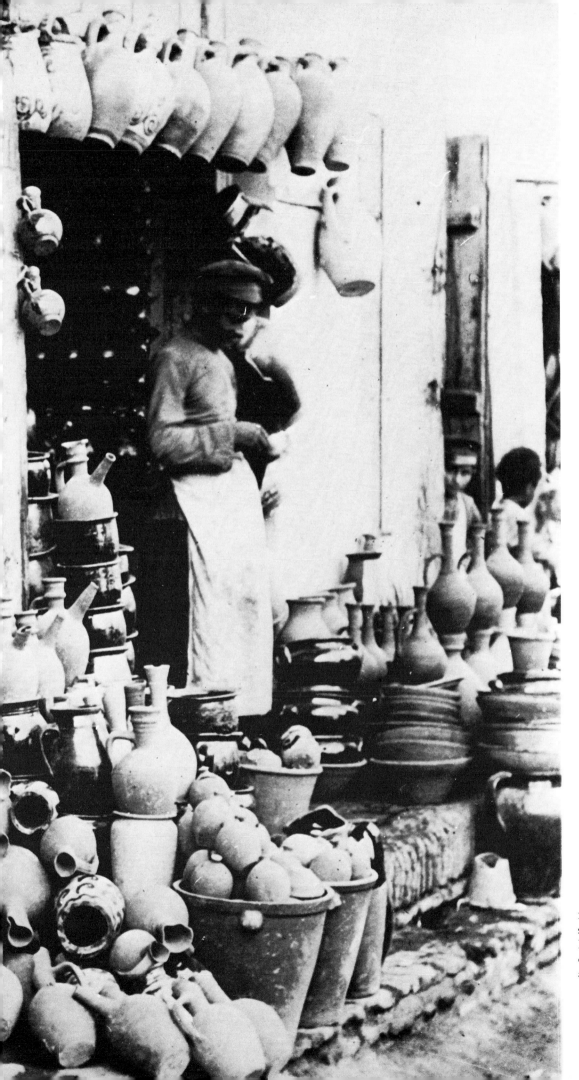

154 A Tiflis market vendor selling crockery and pots. Note the portrait of the Shah of Persia on the wall of the adjoining shop.

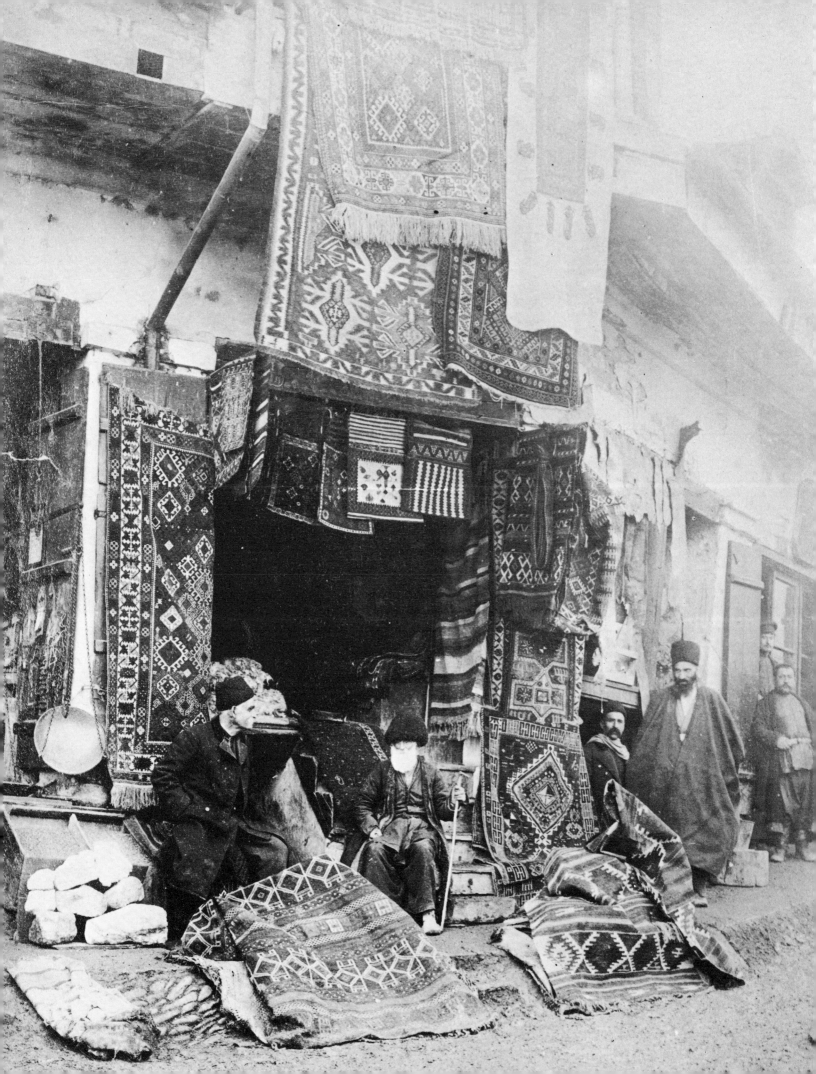

THE GOLDEN ROAD

'Take the golden road to Samarkand . . .' runs the refrain of James Elroy Flecker's poem 'Hassan'; words taken from an old Russian proverb. For Russia's soldiers and statesmen, the east exerted a peculiar fascination: most of Russia's wars in the nineteenth century were fought to extend the Tsar's dominion in the east. The border was always moving forward, Russia always preoccupied in a 'hunt for frontiers', as Prince Gorchakov, her most able statesman, phrased it. This lust for expansion brought Russia into conflict first with the Turks and latterly with the British, as the two nations intrigued against each other for the domination of Afghanistan and the towering peaks of the Himalayas. The conquest of the Caucasus was perhaps the hardest fought of her wars, particularly against the savage tribes so brilliantly led by their iman, Shamyl; Tolstoy served in the wars for the Caucasus and described, in *Hadji Murat* and other works, the extraordinary rigours of the campaign.

In mid-century, Russia began to push forward into the arid wastes of Central Asia, towards the great cities of Samarkand, Bokhara, Tashkent, Khiva and Merv, places which had grown rich on trade, and conjured up in Russian as well as western minds memories of Ghengis Khan or the Golden Horde. In 1864, the conquest of Turkestan was begun; Tashkent was taken in 1865 and a province of Turkestan created two years later. The fabled city of Samarkand was occupied in 1868, and in 1873 the khanates of Bokhara and Kniva accepted the inevitable, submitting to the might of Russia. Reputations were easily made or lost, for the difficulties of campaigning in the atrocious climate, against an enemy who knew every wile of desert warfare, produced many catastrophes for Russian arms. But one of Russia's heroes, the victor of the epic siege of Plevna in 1878, Mikhail Skobolev, 'The White General', smashed the tribes at Geok-Tepe in 1881; thereafter, organised opposition to Russia's march to the Himalayas soon crumbled.

155 Carpets and rugs.

If Russian expansion in Central Asia was the most heroic and dramatic development of her growth, the extension of real control over her possessions in Siberia, and the birth of Russian power in the Pacific, was the more significant. The foundation of Vladivostok, 'The Lord of the East' in 1860, was in earnest of Russia's intention to become a dominant power in the Far East. In 1891, the Trans-Siberian railway was begun, and a line from Moscow to Vladivostok finally opened in 1903. In the ten succeeding years over a million Russians took the slow, jolting train east as voluntary emigrants: the 4,338 mile journey took thirteen days. They were lured by the promise of land and hope of riches; as on the American frontier, few found their dreams. For a million convicts, who over the years were sentenced to exile in Siberia for political or criminal offences, the journey was made on foot. By 1914, nine million people lived in Siberia, a ninth of them convicts or former prisoners: in the prison camps of the east, the political spirit of the revolutionaries was fired and tempered.

156 A Teke family in front of their home, *c.* 1890.

157 *right* Teke elders *c.* 1890.

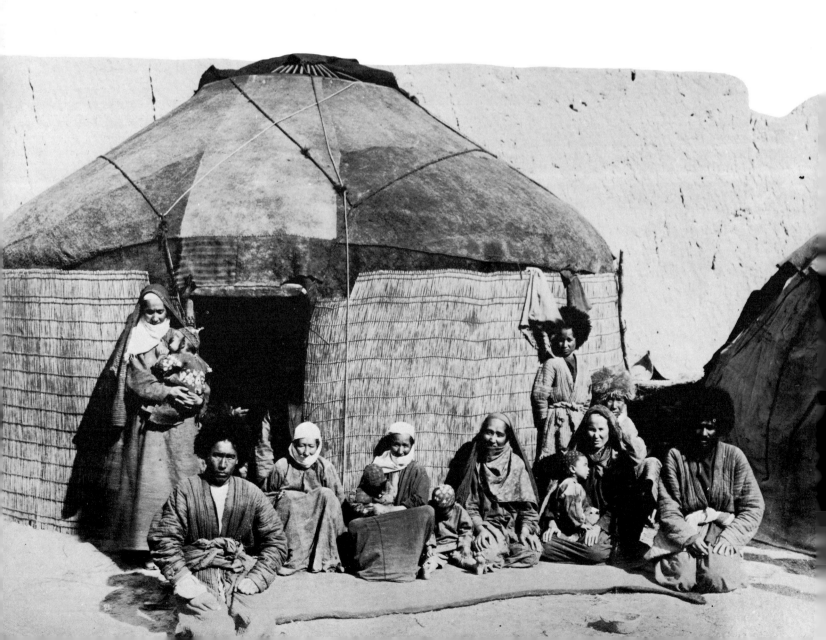

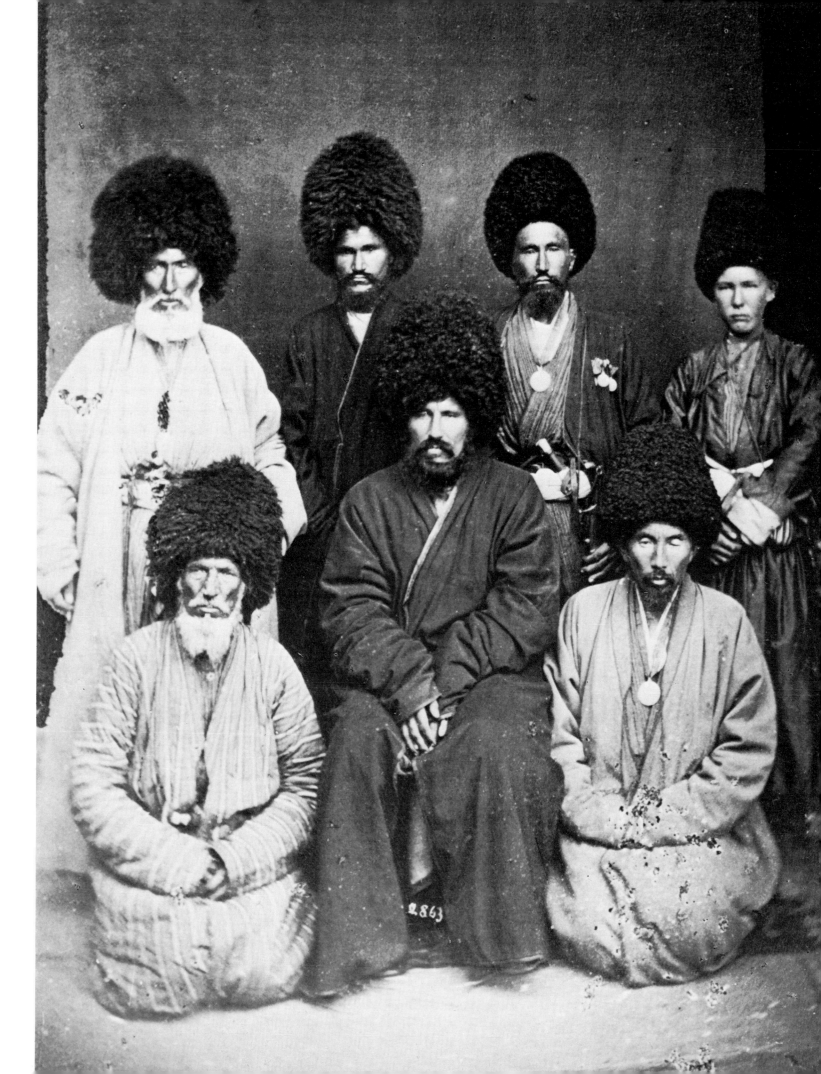

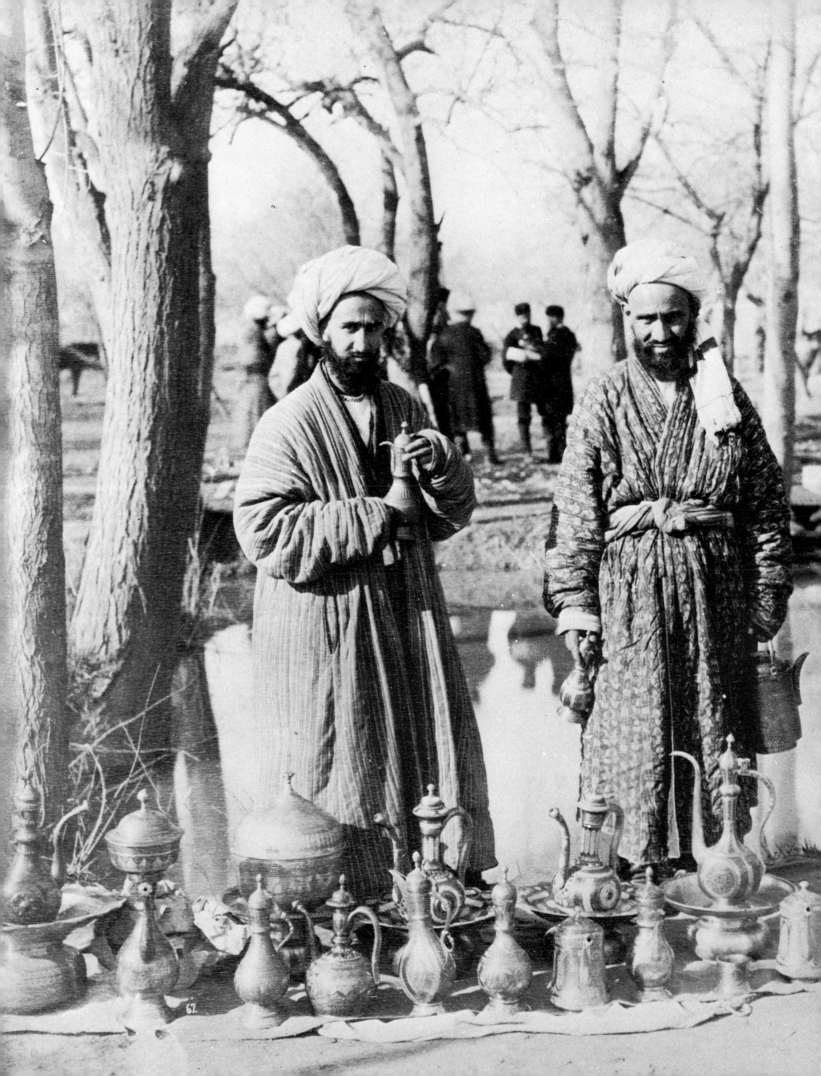

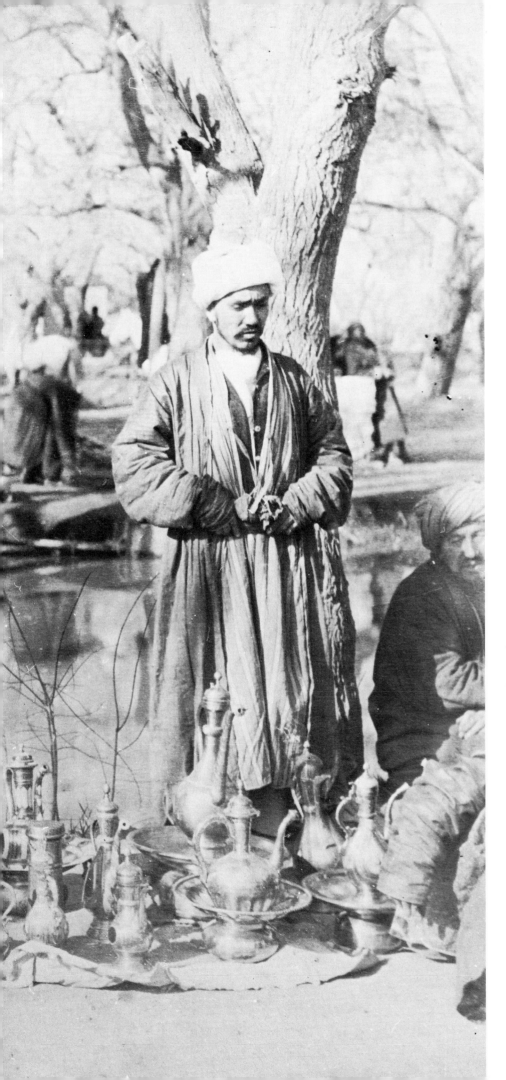

158 An open market at Bokhara, *c.* 1890. (Obviously the prototype for souvenir stands the world over!) Note the two Russian officials on the far bank of the stream.

163

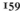

159 The Emir of Bokhara and his Ministers, Bokhara, *c.* 1890.

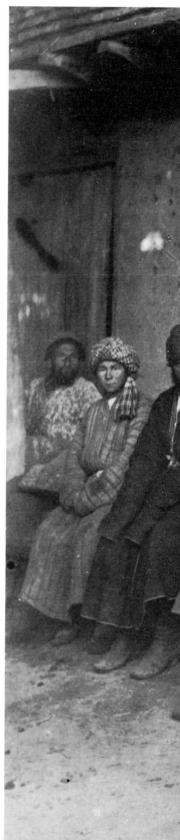

164

Bokhara Jews, *c.* 1890.

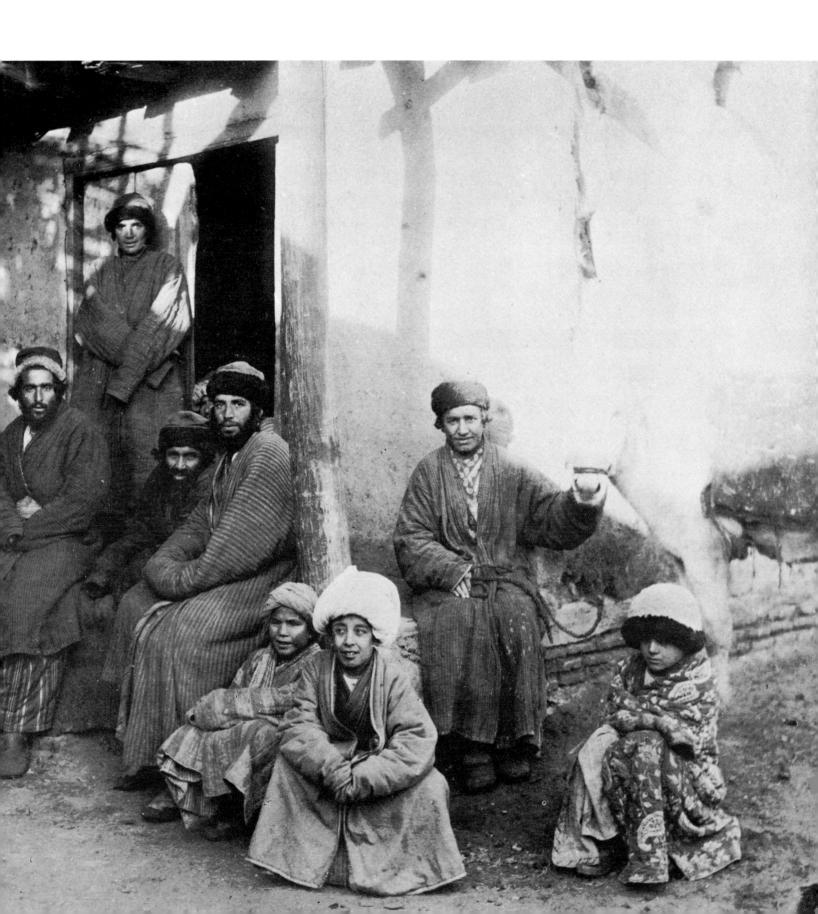

161 A wedding party, Bokhara, *c.* 1890.

162 Tartars from South of the Aral Sea, *c.* 1890.

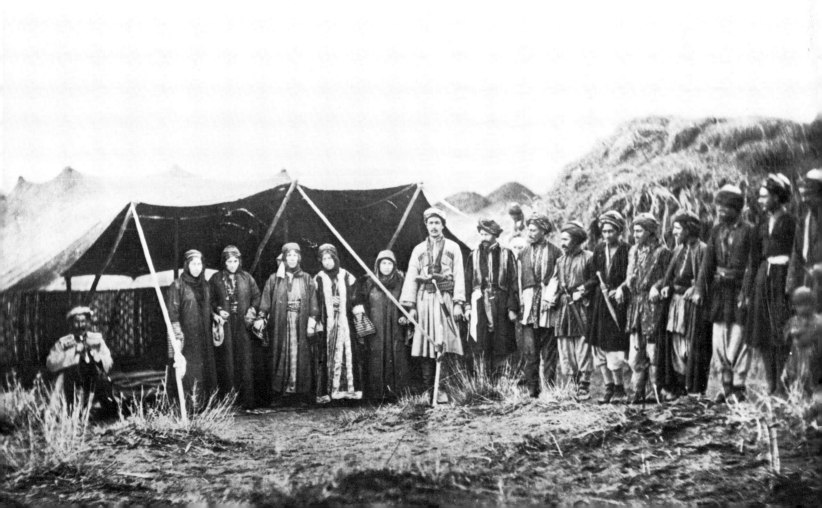

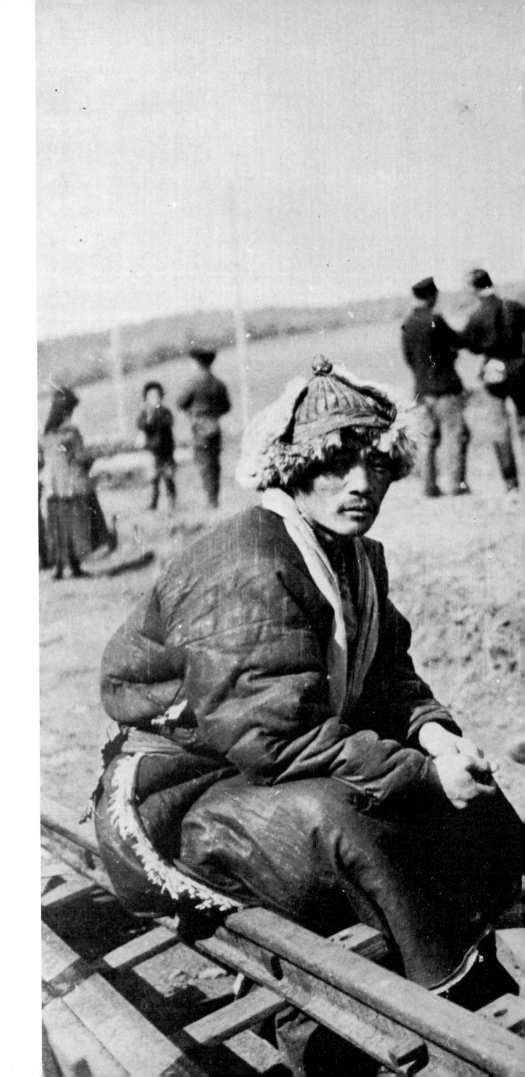

163 Kirgiz, employed as labourers on the railroad, *c.* 1908.

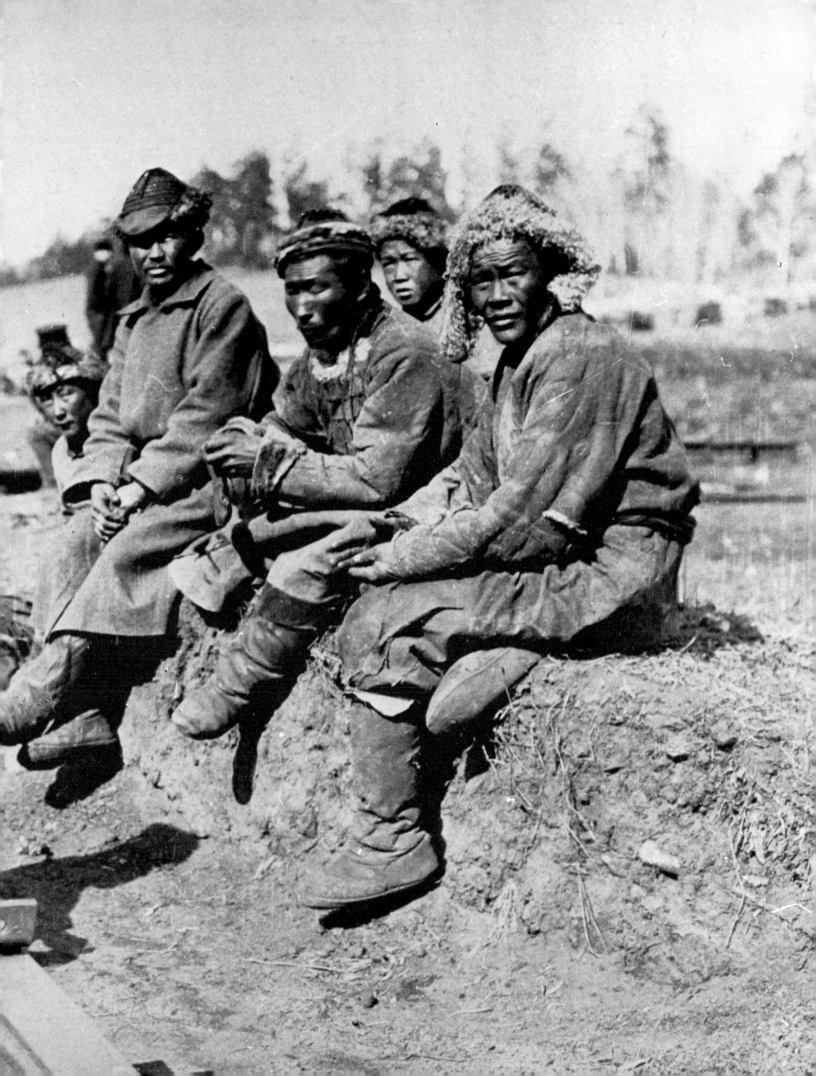

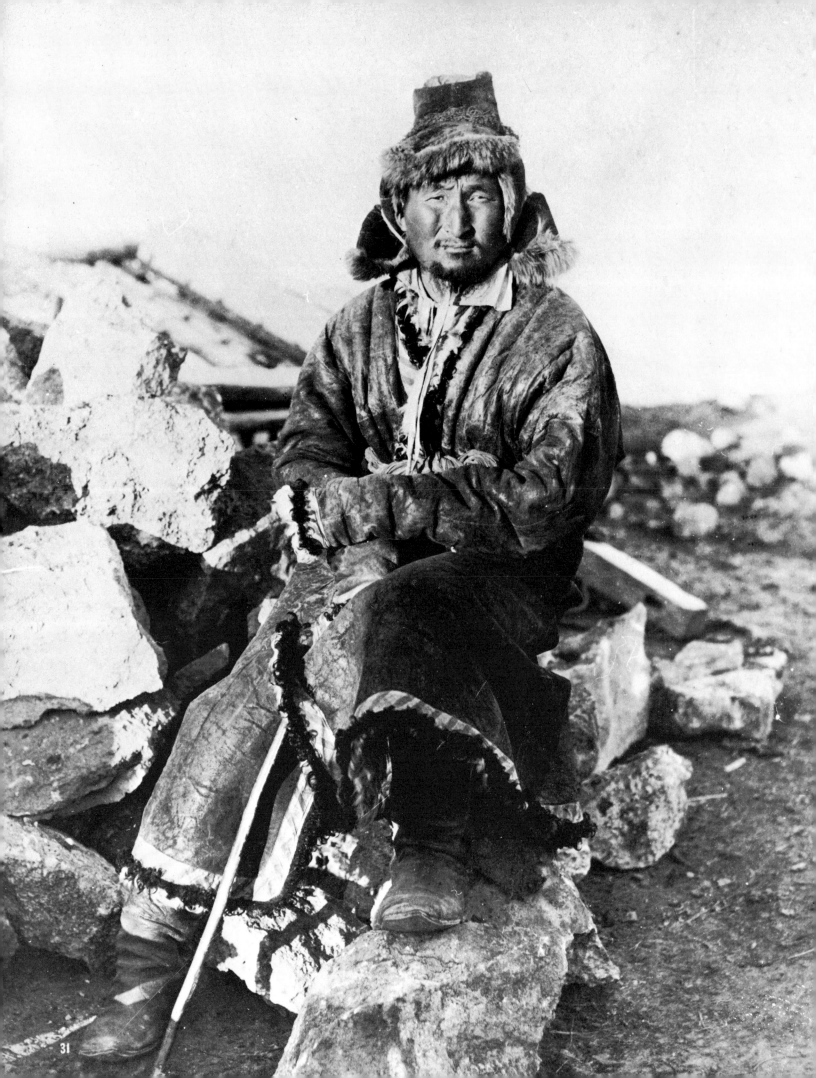

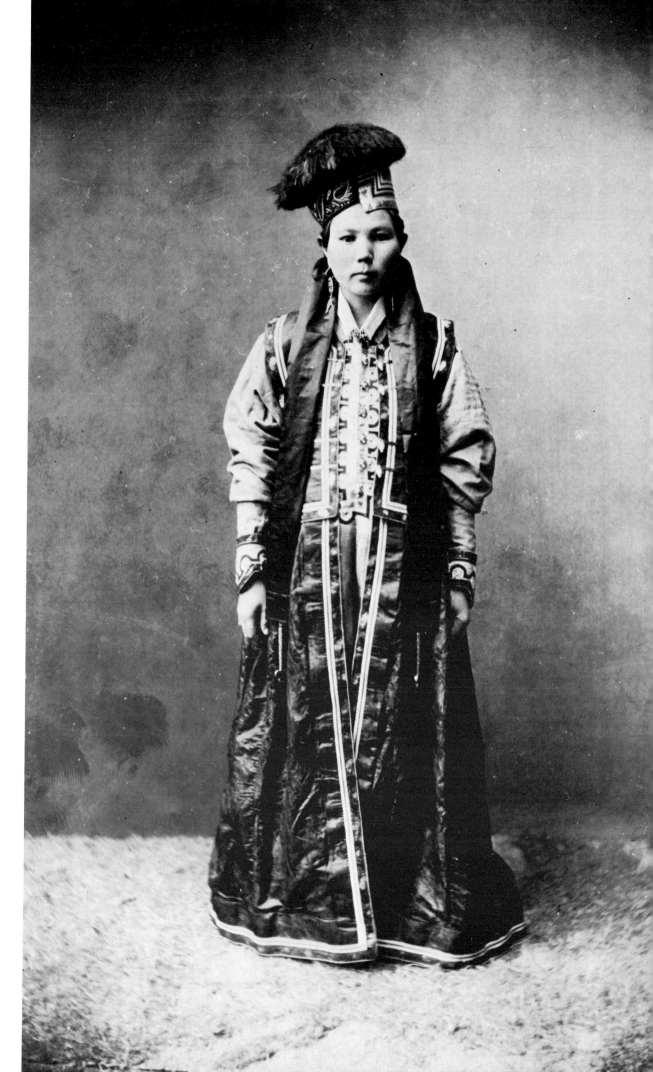

164 *left* A Kirgiz
of Kaonobosk, 1892.

165 A Kalmuk
woman, *c.* 1880.

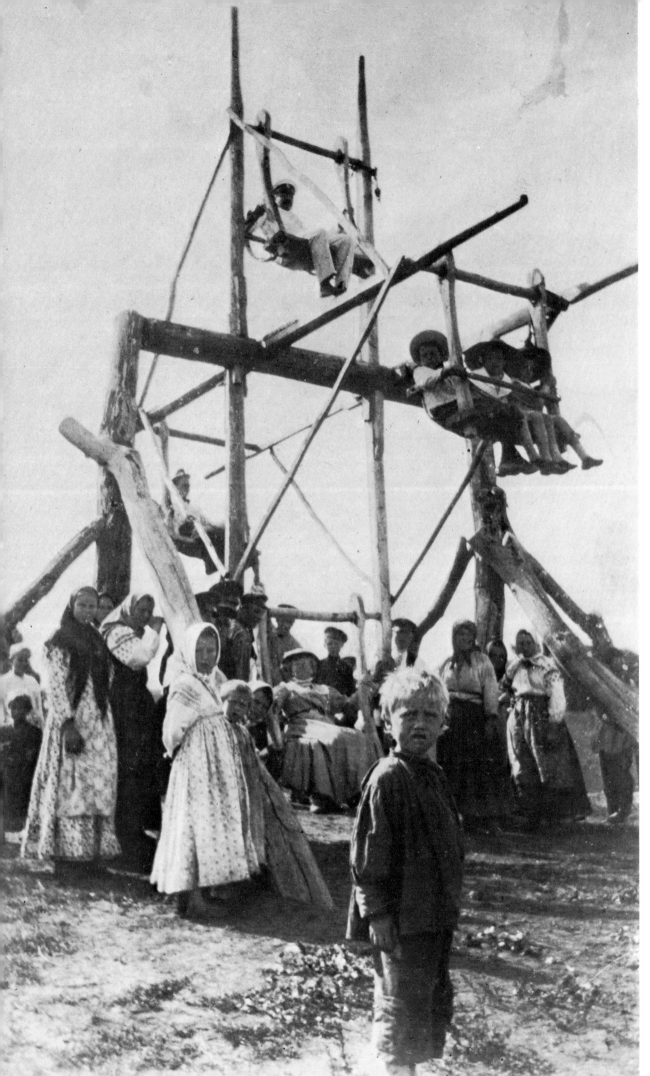

166 A ferris wheel at Anatolovka near Orenburg, 1900.

THE IMPERIAL ARMY

Russia under its last Tsars—Nicholas I, Alexander II and III, and Nicholas II—has been compared to a vast military academy. Certainly no institution had a more pervasive influence than the army or more success in fostering acceptable attitudes among the many disparate elements of Russian society. Before the Crimean war, service in the army was considered a death-sentence by the unlucky conscripts. Sorrowing peasants who delivered up their sons for twenty-five years of service considered them as dead, for half a lifetime would pass before they returned home, if at all. After the Crimean war, the period of service was shortened to fifteen years, but only in 1874 was the army put on a modern footing. Thereafter, much attention was paid to the importance of training conscripts, who now served a maximum of six years, in loyalty and duty, qualities which they were expected to carry back into society.

But if the army in some ways became modern in its structure and equipment, it retained some curious aspects, by comparison with its European competitors. Only the best regiments, the guards and other select formations, were dominated by the nobility; many officers were from peasant backgrounds and ambitious for social advancement. Between 1900 and 1914, the proportion of lower-class officers began to rise; during the war, as the bloody fighting killed off the nobles in substantial numbers, the percentage increased dramatically. Nor was this restricted solely to junior officers, for many sons of former serfs or simple Cossacks, including leading officers such as Generals Denikin, Kornilov and Alexeyev, rose to high command. In Germany and Austria, where the nobility still dominated, or even in England, where lower-class officers were the rare exception, it was believed that this development would weaken the fighting effectiveness of the Russian troops.

Most Army officers were poor, and travelled second class; except for the select regiments stationed in St Petersburg, they lived in provincial centres of the utmost drabness. To compensate, perhaps, Russian uniforms had a style and elegance which quite outshone those of

foreign armies. The relationship between the ruling house and the army was exceedingly close; Nicholas II, in particular, took his duties extremely seriously, and his simple dedication inspired both officers and men. In his cousin, the Grand Duke Nicholas Nikolaevich, the army possessed a commander of real presence. Under the reformers and modernisers, many of the defects revealed by the disastrous war with Japan in 1905 were repaired; the Russian army which went to war in 1914 was a formidable weapon. Its enemies were surprised by its speed of mobilisation, the quality of its equipment, and its tenacity in battle. The catastrophes which dogged the armies were the result of many complex factors. But there was a great quixotic gallantry in the way the last regiments of the old order in Russia went to war.

167 *below* A halt for lunch during the manoeuvres—officers of the Chevalier Gardes enjoy a light repast, 1912.

168 *right* The Grand Duke (later Tsar) Alexander and his Staff, during the Balkan Campaign, spring, 1878.
 Careers often began or received added impetus in the entourage of an Imperial Personage. The young Lieutenant-Colonel seated in the front row wearing the light grey overcoat with the black fur collar would by the end of the century be Minister of War (General Kuropatkin).

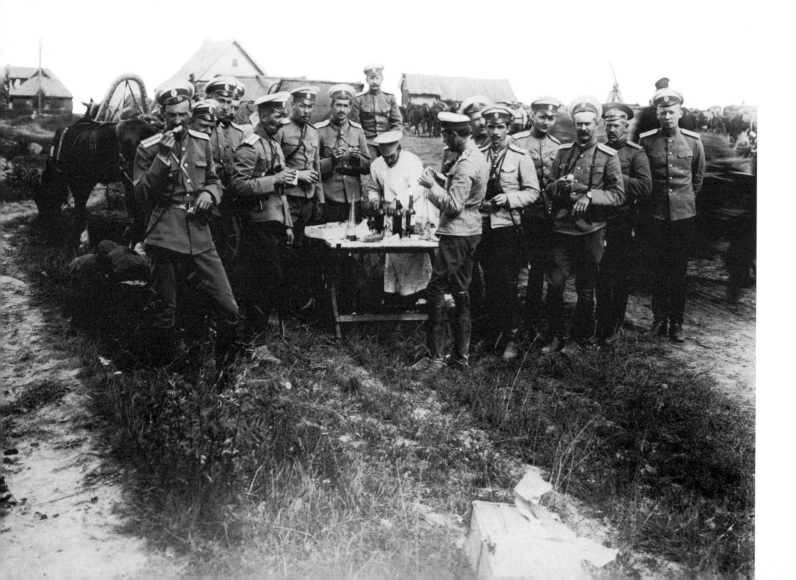

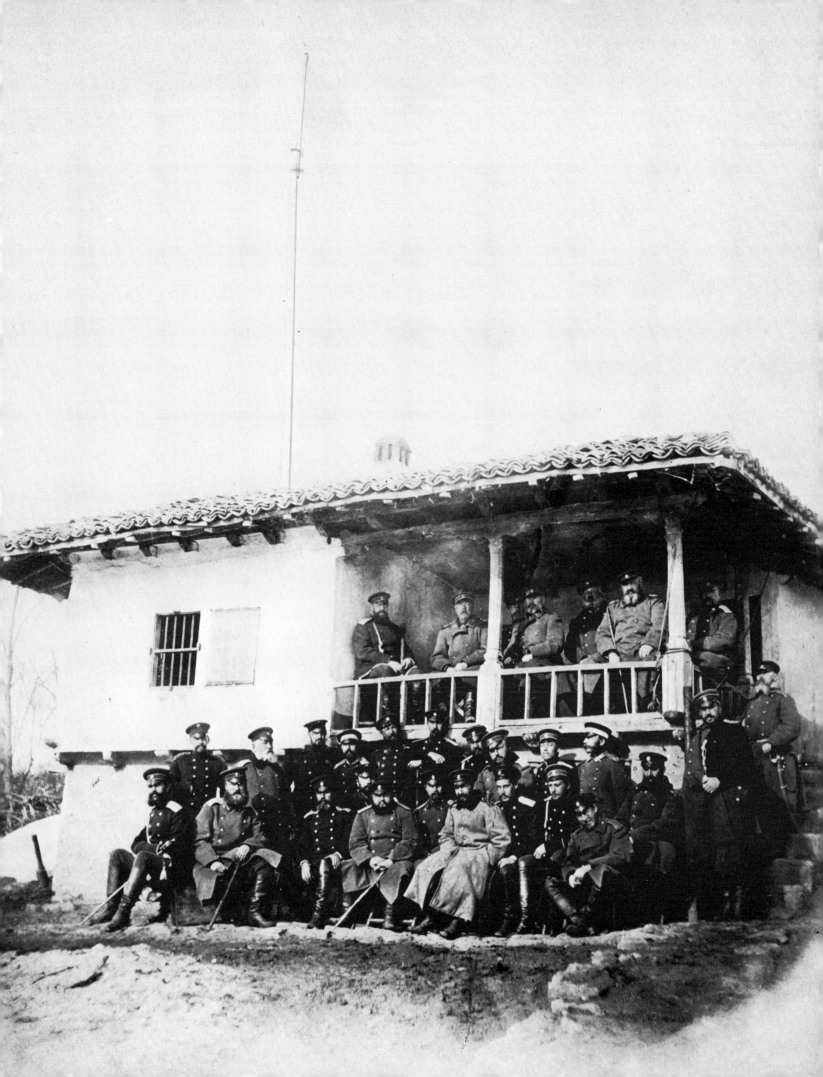

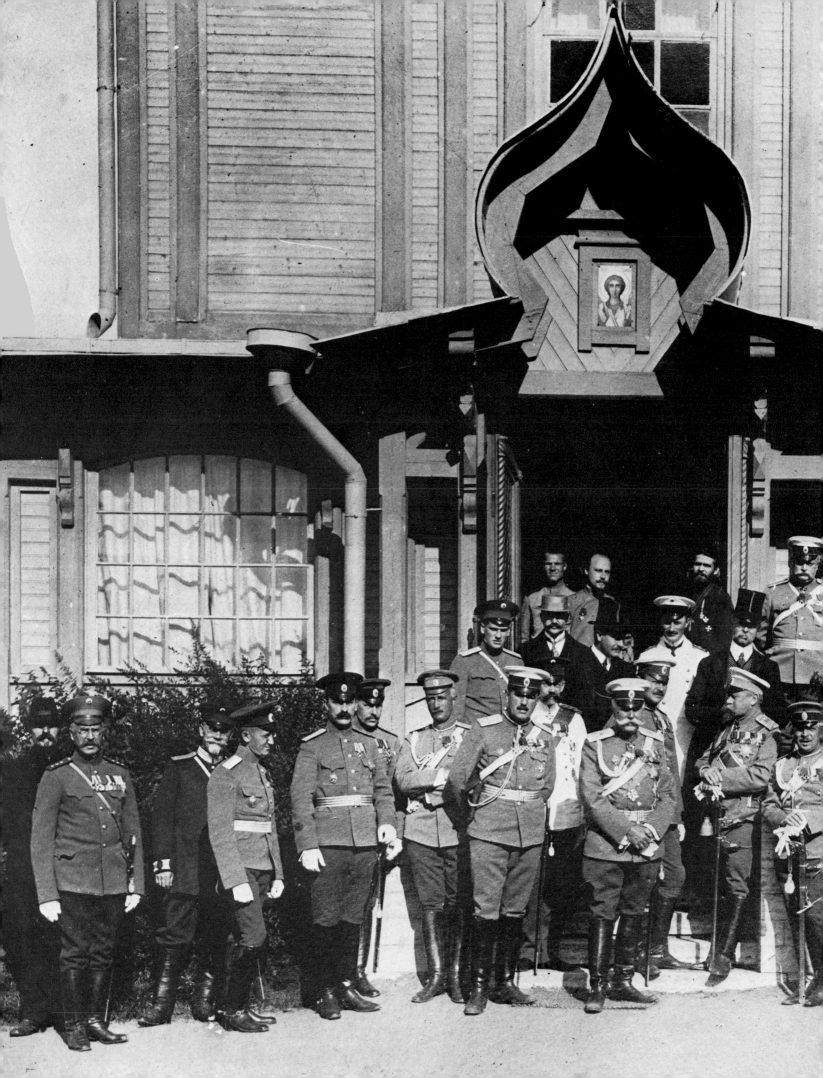

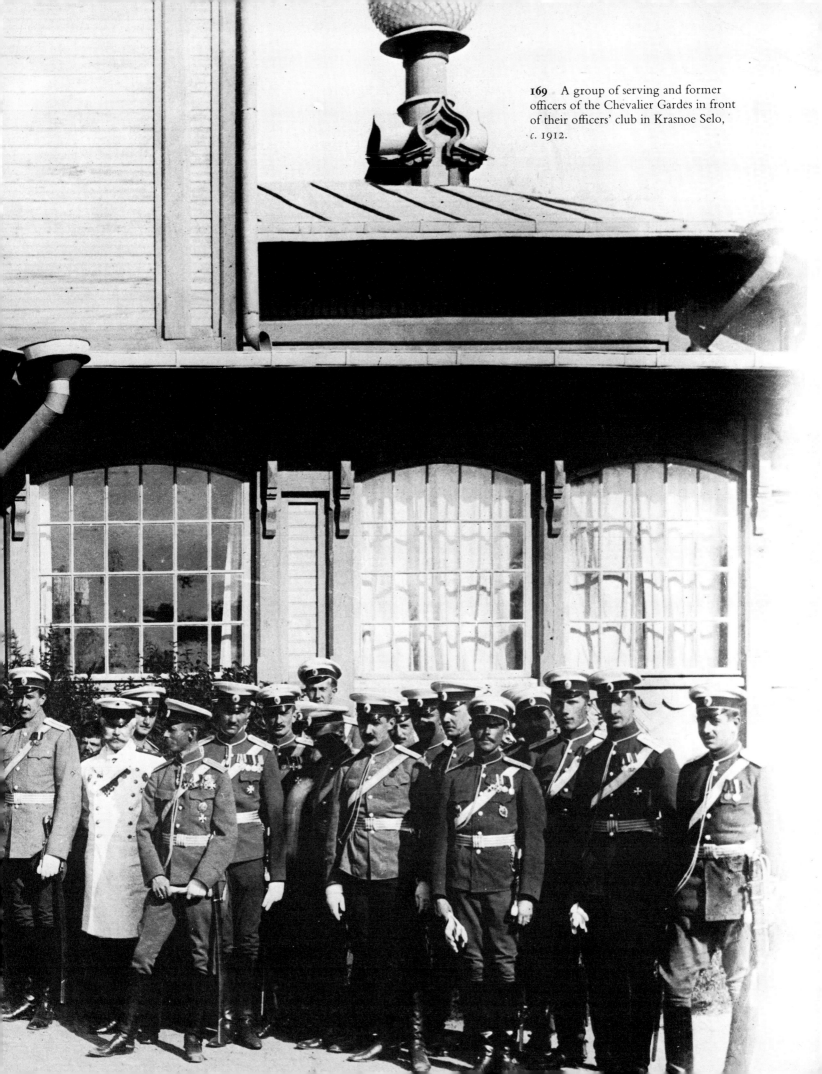

169 A group of serving and former officers of the Chevalier Gardes in front of their officers' club in Krasnoe Selo, *c.* 1912.

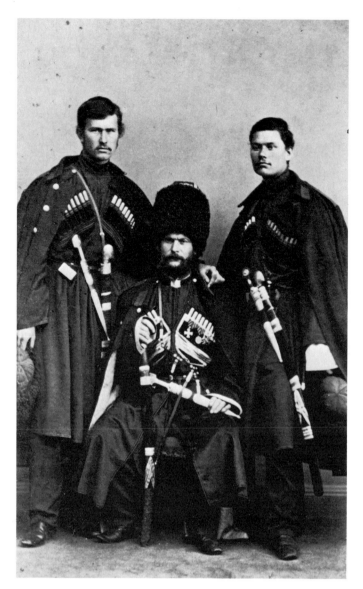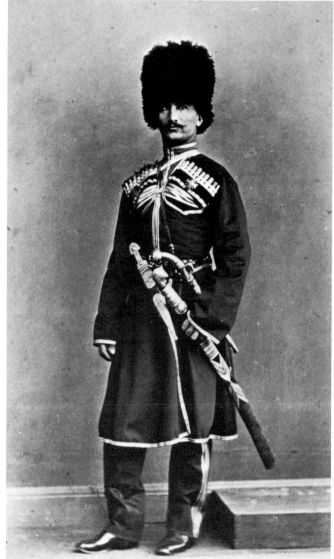

170–1 Some of the types in His Majesty's Personal Escort, St Petersburg, early 1860s. The Escort (*Konvoi*, in Russian) was formed in 1811 as Squadron of Black Sea Cossacks in the Imperial Guard, but in 1855 Emperor Alexander II changed it to a representative Squadron from all the subjugated Caucasian tribes which would form his innermost guard. How better to reconcile the tribes to Russia and the Throne than to make them responsible for guarding the Monarch? It worked well for the tribes never rose and seemed satisfied under the Empire. The Escort remained in existence until well after the revolution, but much of the picturesque variety was lost when—in 1882—the Caucasian Squadron was disbanded, leaving only the Kuban and Terek Cossacks. The Cossacks were originally formed from runaway serfs and robbers and the disbandment of the Caucasian Squadron can only be seen as evidence of Alexander III's 'Russification' policies.

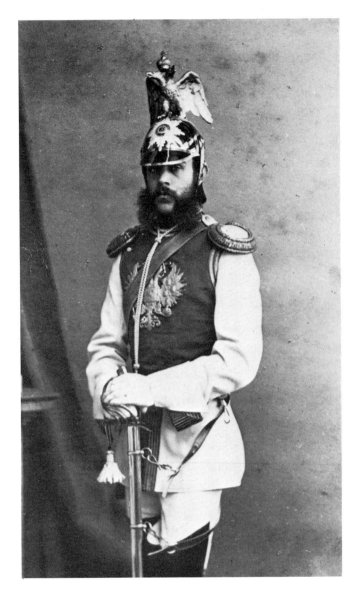

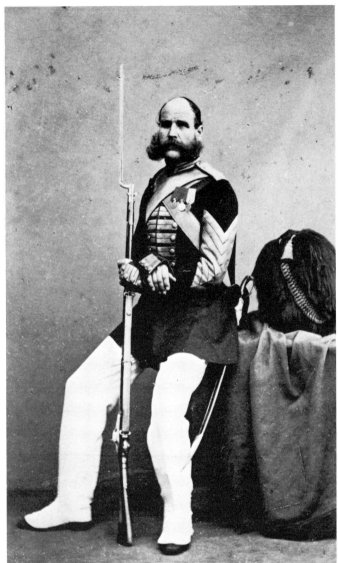

172 Officer of the Horse Guards Regiment in full court uniform.

173 Palace Grenadier in full dress uniform.

174 Officers of the Preobrajenski and Semeonovski Guards Regiments relaxing in their 'summer' quarters at Krasnoe Selo, *c.* 1894.

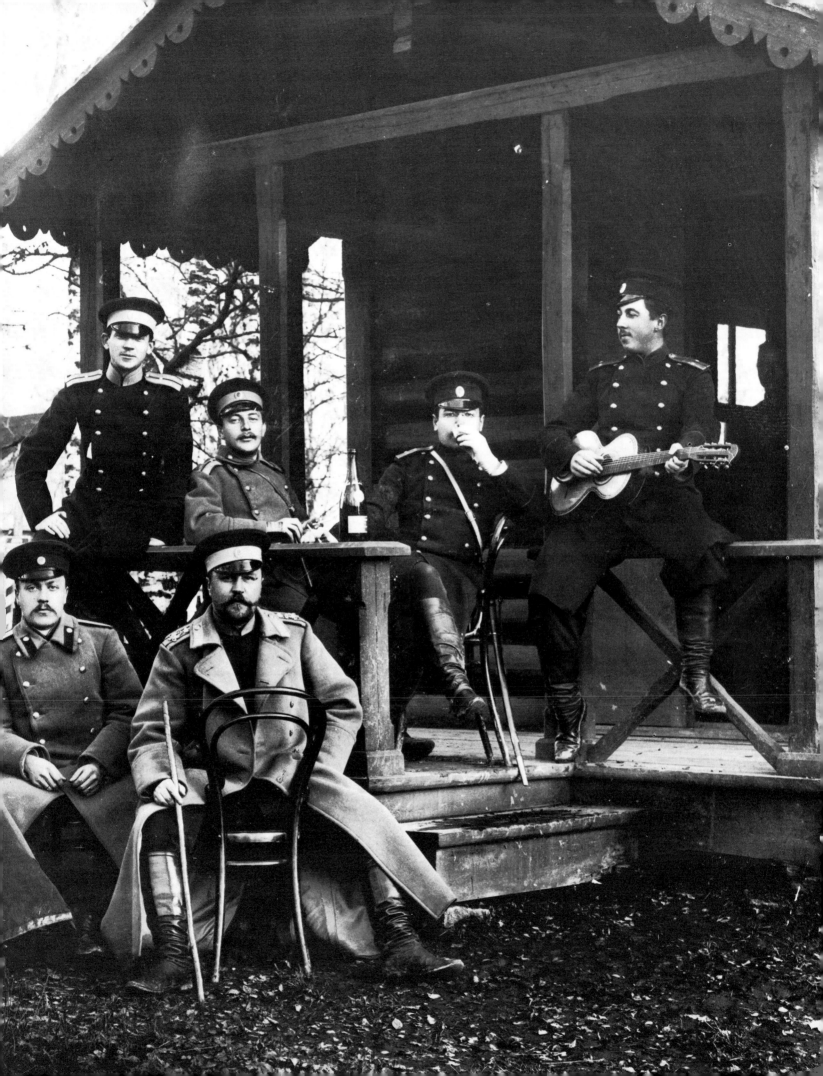

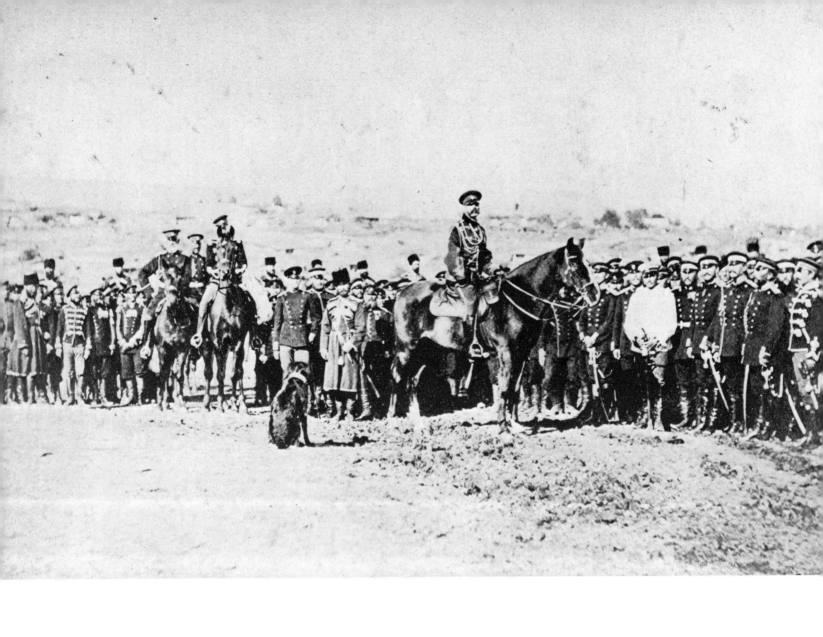

175 The Emperor Alexander II in the bivouac of his Escort at Gornyi Studen, Bulgaria, 3 October 1877 during the Russo-Turkish War. It was the Emperor's headquarters from August to November 1877, allowing him to supervise the campaign at first hand.

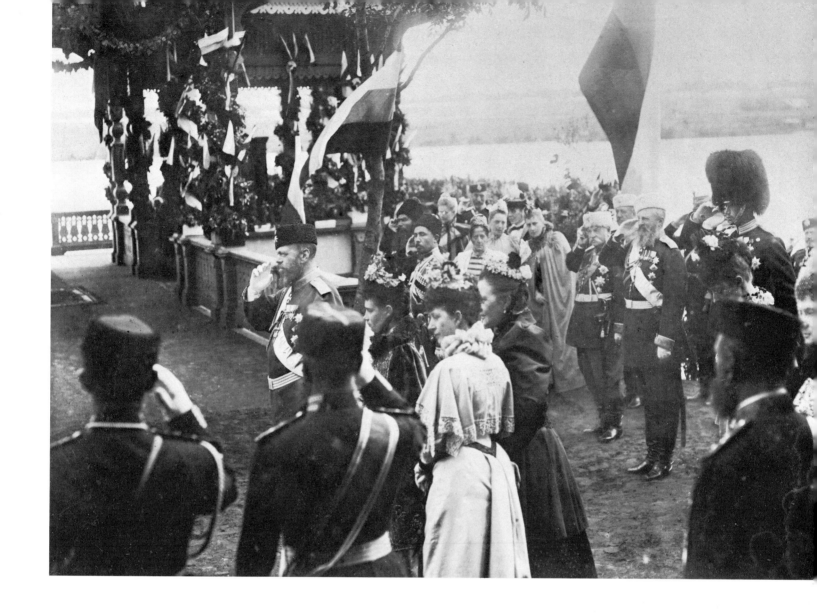

176 The Emperor Alexander III during his last official
public engagement: the visit to the Imperial Guard in the
Camp at Krasnoe Selo, 3–8 August 1894. Accompanied by
the Empress, her sister the Princess of Wales, and Queen Olga
of Greece, the Emperor attends one·of the many functions on
7 August 1894. The officer in the large fur hat is Prince (later
King) Christian of Denmark. The three officers in the white
fur caps and uniforms of the Imperial Suite are (L to R)
General M. I. Dragomirov (?), Minister of the Court Count
I. I. Vorontsov-Dashkov, and the Grand Duke Mikhail
Nikolaevich.

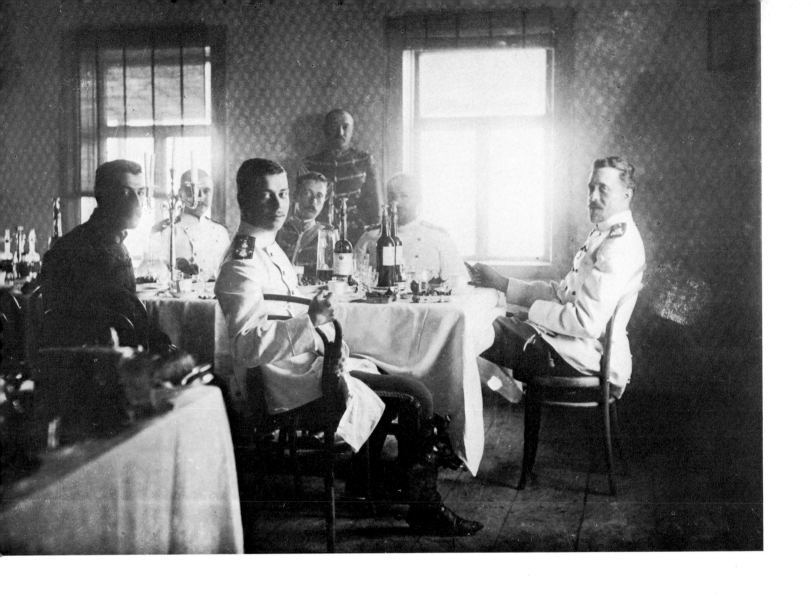

177 Lunch in the old officers' club of His Majesty's Hussar Guards in Russkoe Koperskoe, 1889. (L to R) D. N. Rimski-Korsakov, Prince D. P. 'Mitka' Gagarin 2, The Tsarevich (later Emperor Nicholas II), Solovoi, M. E. Krupenski, S. D. Molchanov, Grand Duke Nikolai Nikolaevich (Regimental Commander).

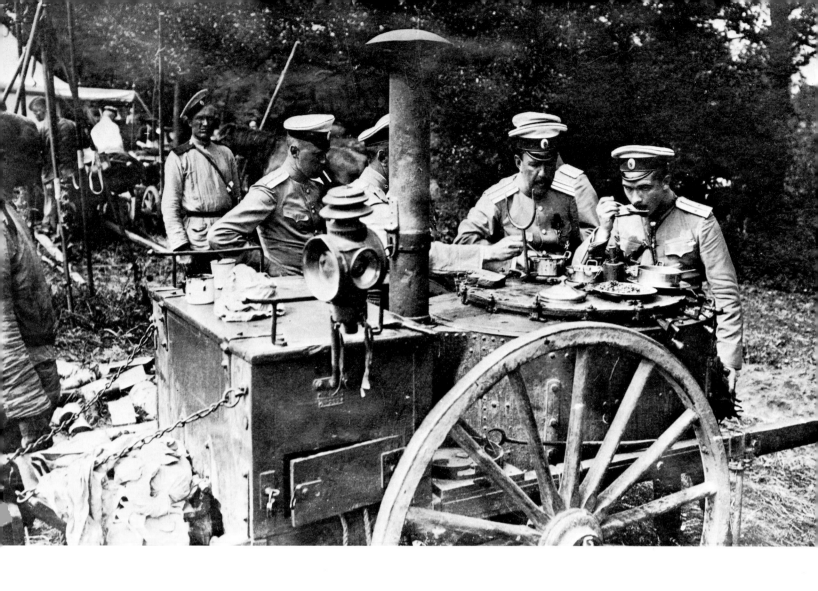

178 Officers of the Chevalier Gardes sample the food of
their men, Krasnoe Selo, 1912.

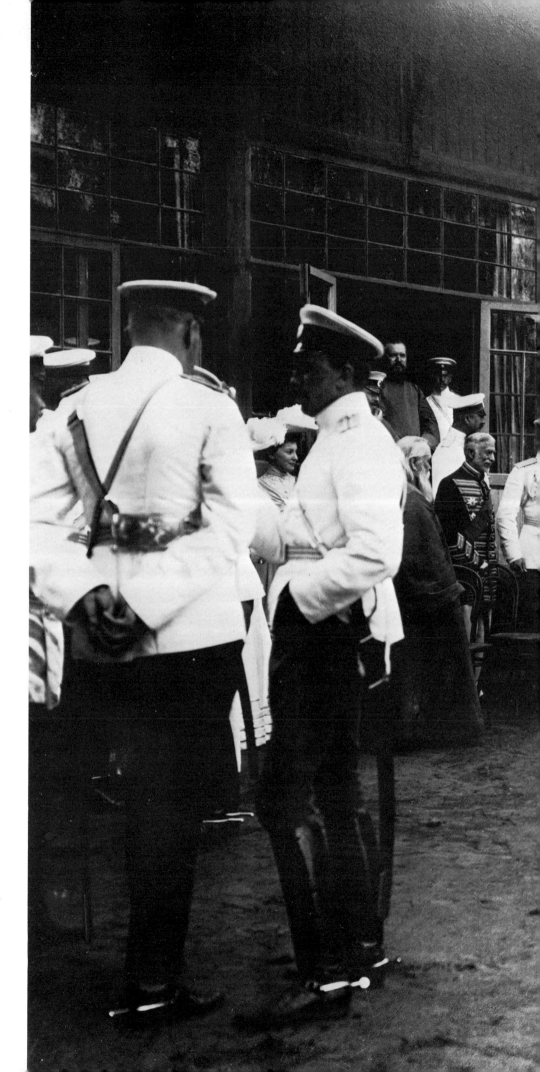

179 The visit of the Dowager
Empress Maria Feodorovna to the
Chevalier Gardes, Krasnoe Selo, 1905.
She is talking to the ample figure of
General Alexei Ignatiev, a former
commander of the regiment. In the
following year he was assassinated in
Tver.

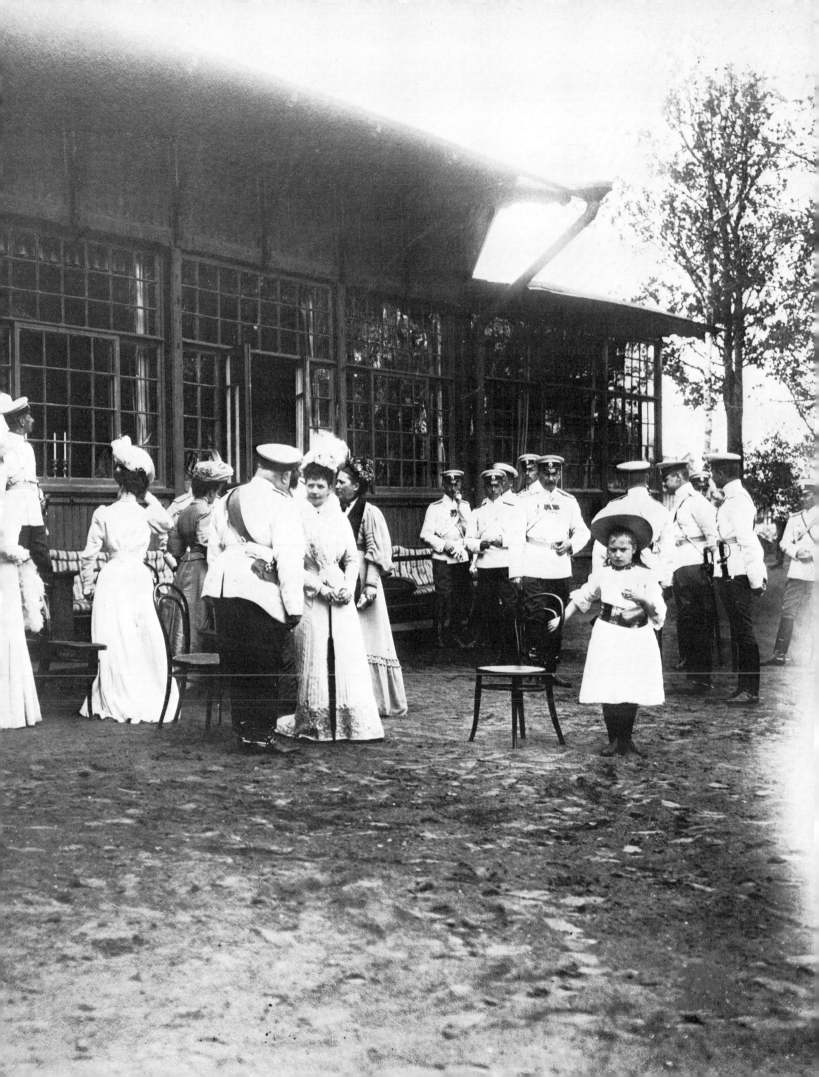

180 A Jewish soldier of the 20th Sapper Battalion, 1918.

188

WAR AND REVOLUTION

If Russia went to war in 1914 in a spirit of patriotic uplift, the elation was not shared by Nicholas II or the more sensitive of his advisers. The Tsar had worked fervently for peace, by direct diplomacy with the Kaiser, and through his emissaries. Russia did mobilize first, and not Germany; but she did so with reluctance. The real enemy was Austria, and the feeling of anger which swept Russia that Austria should seek to humiliate Serbia, a fellow Slav state, was genuine enough. In the three years of appalling warfare, a pattern soon emerged: the Russians could beat the Austrians, whose capacity for ineptitude far exceeded their own, but not the Germans, who approached matters with an unflinching professionalism. What emerged as the war progressed was not the *total* failure of the Russian economy, administration and government, but the lack of cohesion between its various elements. The armies fought well, but as at the battle of Tannenberg (1914), failed to co-operate with each other. Manufacturers worked prodigiously to turn out war material, but produced light shell when heavy shell was required: the profit margins were higher, and the army was contradictory as to its needs. In other countries, the necessary control was provided by national governments: Germany developed an elaborate war economy, Austria a pattern of rigid state control, England a uniquely British amalgam of voluntary and compulsory measures. But in Russia, the central government was unable to bear the burden.

The revolution was born out of the failure of government to govern; in the last analysis, it was realised that the Tsarist autocracy no longer controlled anything. By the time that Nicholas II, with characteristic dignity and patriotic spirit, relinquished his power, all the important decisions were being taken by others. His successors, Alexander Kerensky and the politicians, were able to do little better. Despite all the efforts to rouse the soldiers to rise once more from their lines, and attack in defence of the motherland, the honeyed words of St Petersburg or the

high command were no longer credible. The soldiers at the front voted with their feet: the armies stayed where they were, or came home. In the months after March 1917, Kerensky's Provisional Government revealed itself to be no more in control of events than Nicholas II had been; power was drifting out of the hands of the professional rulers, and into the hands of the governed. More and more, demands were made that no decision should be taken without the approval of the self-appointed popular councils—*soviets*; the demand for 'All power to the Soviets', assiduously fostered by the Bolshevik section of the revolutionary movement, grew in strength.

Out of famine and chaos, and the death throes of the old order, two new forces emerged. The first, clearly, was the revolutionary movement, now guided with demonic energy and implacable determination by Lenin; on the other side, the forces which became known as 'the Whites', to distinguish them from the revolutionary 'Reds'. Led by some of the very best of the Tsarist army's generals—Kornilov, Denikin, Mannerheim, and Wrangel, and Admiral Kolchak—they lacked the singleness of will and purpose which Lenin and his comrades imposed on the Reds. Supported by the allies, who hoped to maintain the Eastern Front against the Germans—and to isolate the bacillus of revolution—the White armies had a considerable material advantage. A war of incredible ferocity was waged on both sides: more than twenty million people are believed to have been murdered, killed in battle, died of starvation, or simply disappeared, in three years of civil war. The territory controlled by White armies steadily shrank, until only the Crimea and the Caucasus remained in their hands. On 15 November 1920 (n.s.), the last of the White armies under General Wrangel embarked at Sevastapol: when the fleet of 126 ships finally left Russian waters, for an unknown destination, they carried 145,693 men, women and children. Behind them they left only desolation and horror; with them they carried few belongings but many memories.

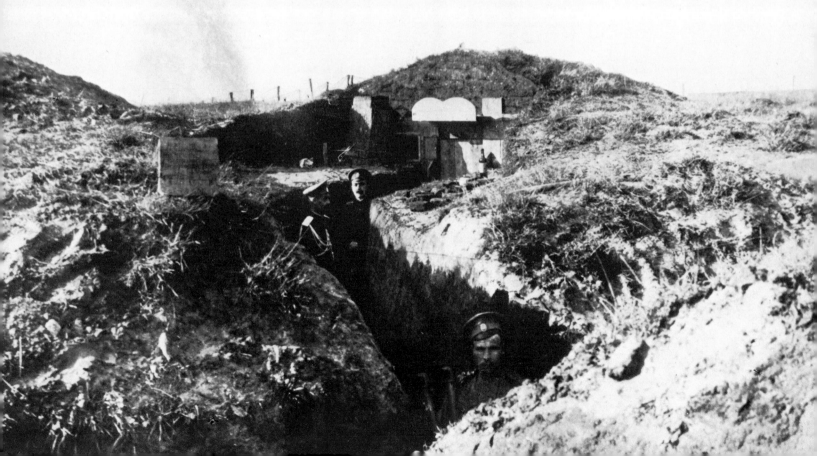

181 *left below* In the trenches of the Guards Horse Artillery (1st His Majesty's Battery) at Pustomyty, 1916. Senior Artilleryman Shaev (in the foreground) and Colonel Linevich (Battery Commander) at the rear seem undisturbed by the huge explosion that has just occurred behind them.

182 *below* In a dugout of the 1st His Majesty's Battery of the Guards Artillery near the village of Pustomyty (Galicia), in October 1916. (L to R) Staff-Captain A. S. Hoerschelmann, Fligel-Adjutant (a.d.c. of the Emperor) Colonel A. N. Linevich, Volunteer B. A. Timashev, Colonel Baron V. I. Velio.

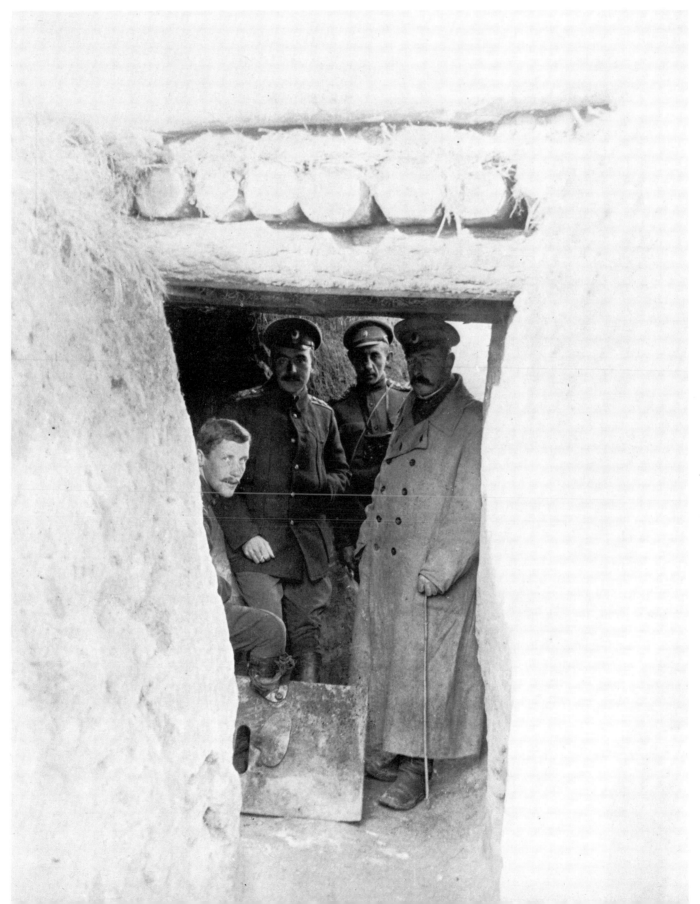

183 'Riders' of the Tartar Horse Regiment of the Caucasian Native Cavalry Division. Formed in 1914 as a six regiment division of Caucasian tribesmen, each regiment in theory consisting of men of one tribal background (Dagestan, Kabardin, Tartar, Chechen, Ingush, Cherkess), but many more were found represented in it.

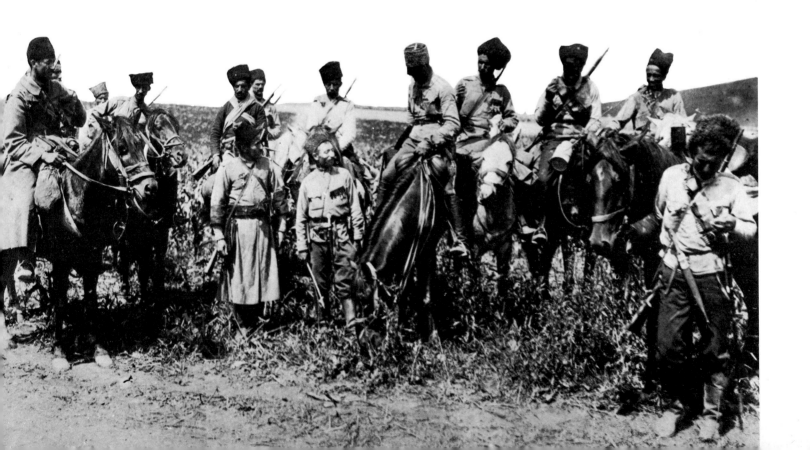

184 The Viceroy of the Caucasus and Commander-in-Chief of Russia's Eastern Front Grand Duke Nikolai Nikolaevich addressing his soldiers, 1916. One of the Grand Duke's Cossack bodyguard holds personal standard (furled) and the Standard of the Viceroy of the Caucasus (unfurled).

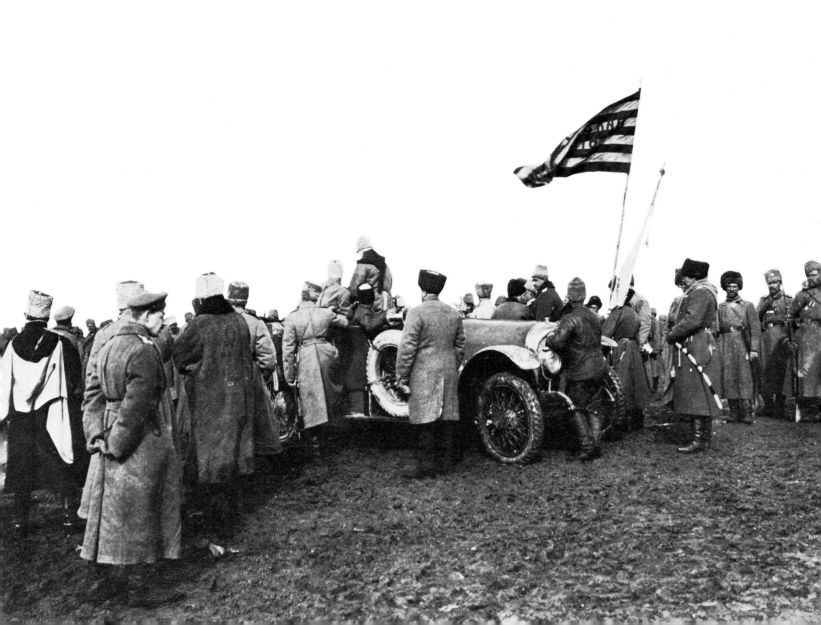

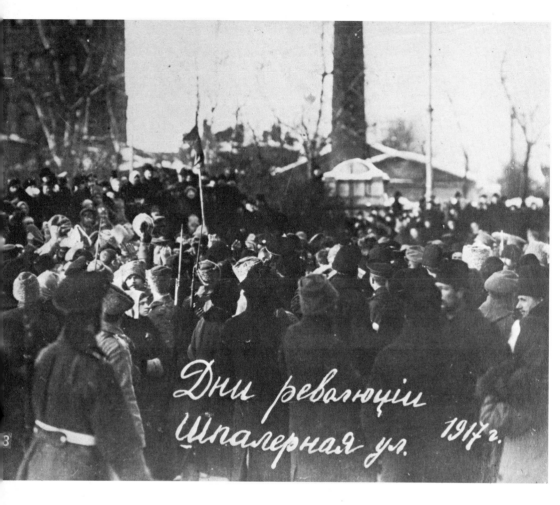

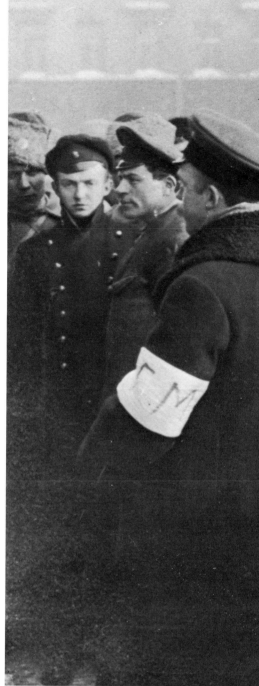

185 Crowds of armed soldiers mix with the civilian population on the Shpalernia,
Petrograd, end of February 1917.

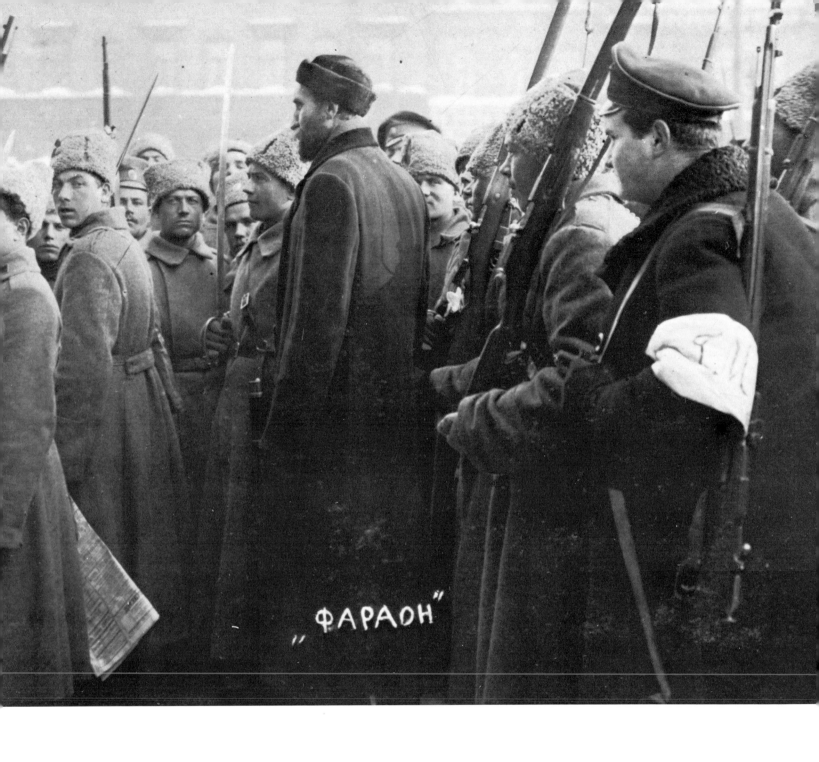

„ФАРАОН"

186 A group of 'militia' (the name given to the new police and still retained by Soviet police) and soldiers with an arrested policeman (he has been identified as a Pharaon which was a slang name for a policeman used by Russian revolutionaries).

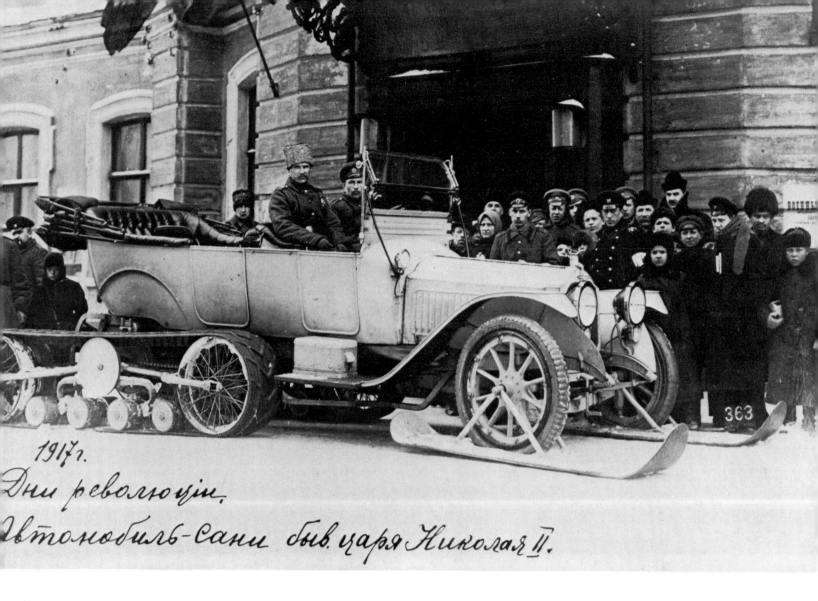

1917 г.
Дни революцiи.
Автомобиль-Сани быв. царя Николая II.

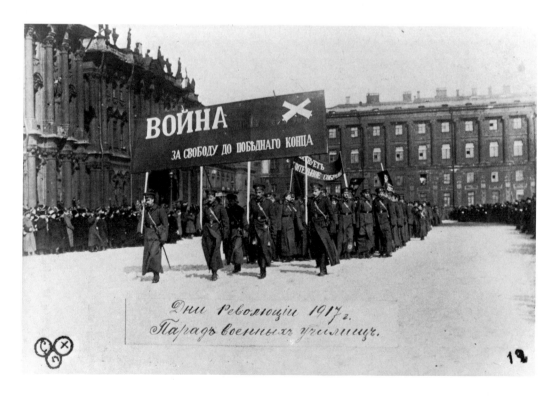

Дни Революцiи 1917 г.
Парадъ военныхъ училищъ.

187 *left* The forces of the revolution quickly seized anything they wanted, including a special automobile equipped for winter driving which was made for the Emperor and delivered to him only a few months before. Both the new Prime Minister Kerensky and Lenin used the car.

188–9 The year 1917 was a time of demonstrations in Petrograd. The Government had theirs (No. 188) to support the regime and the war and the forces opposed to the status quo had theirs such as that on May day on the Field of Mars (No. 189) when the call was for peace and bread.

190 *overleaf* Rushing around the city in impounded automobiles to arrest 'class enemies' and rural political factions became the thing to do for the first few weeks after the revolution. The man standing on the running board is something of a puzzle. Dressed in the leather jacket of a factory worker, he also is wearing spats. He appears third from the left in plate 186 and appears frequently in photographs taken during this period.

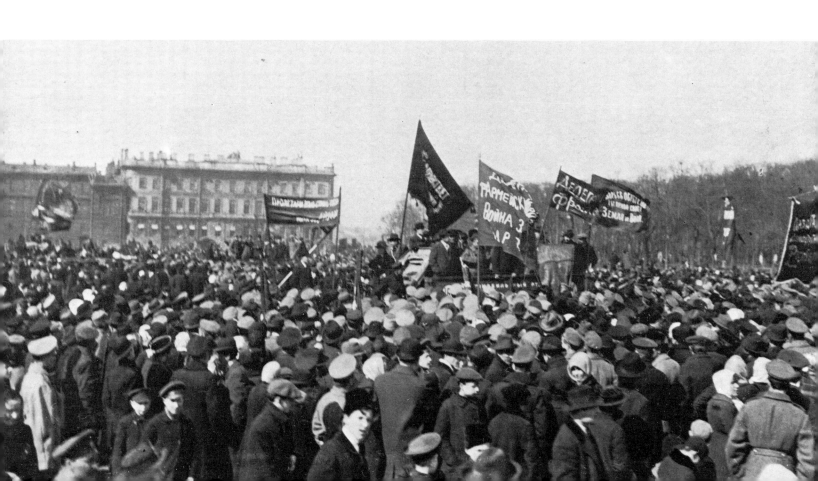

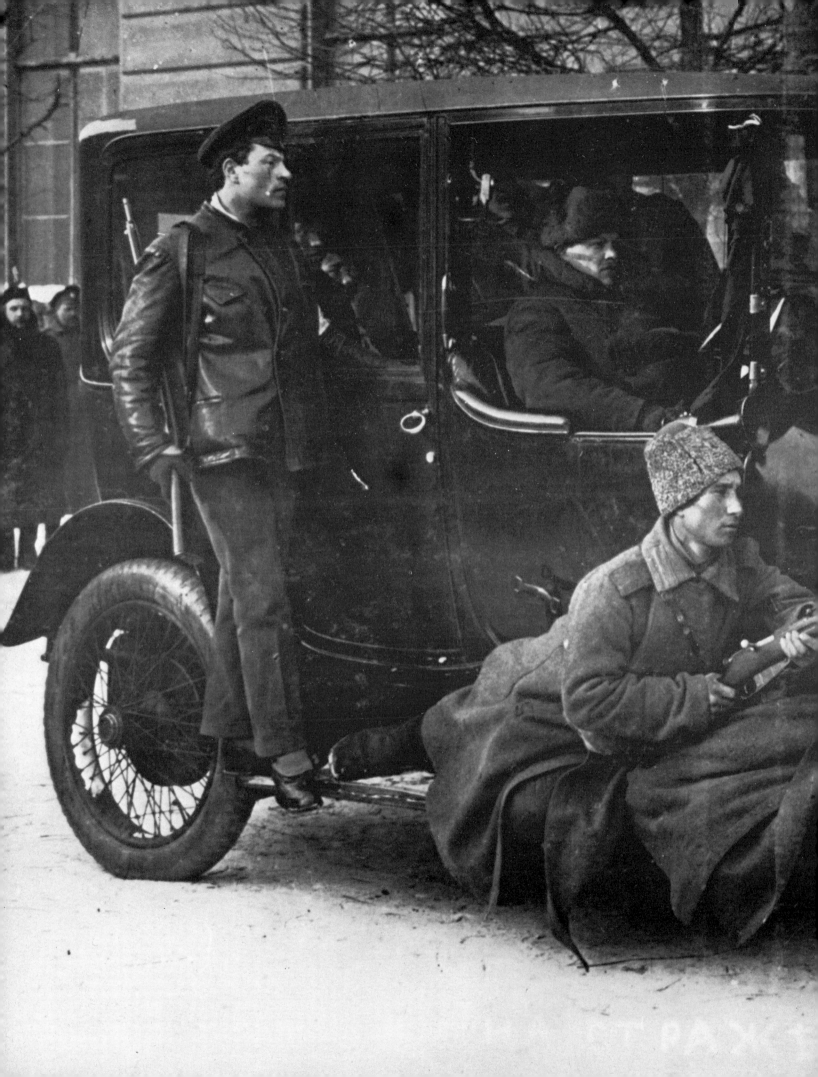

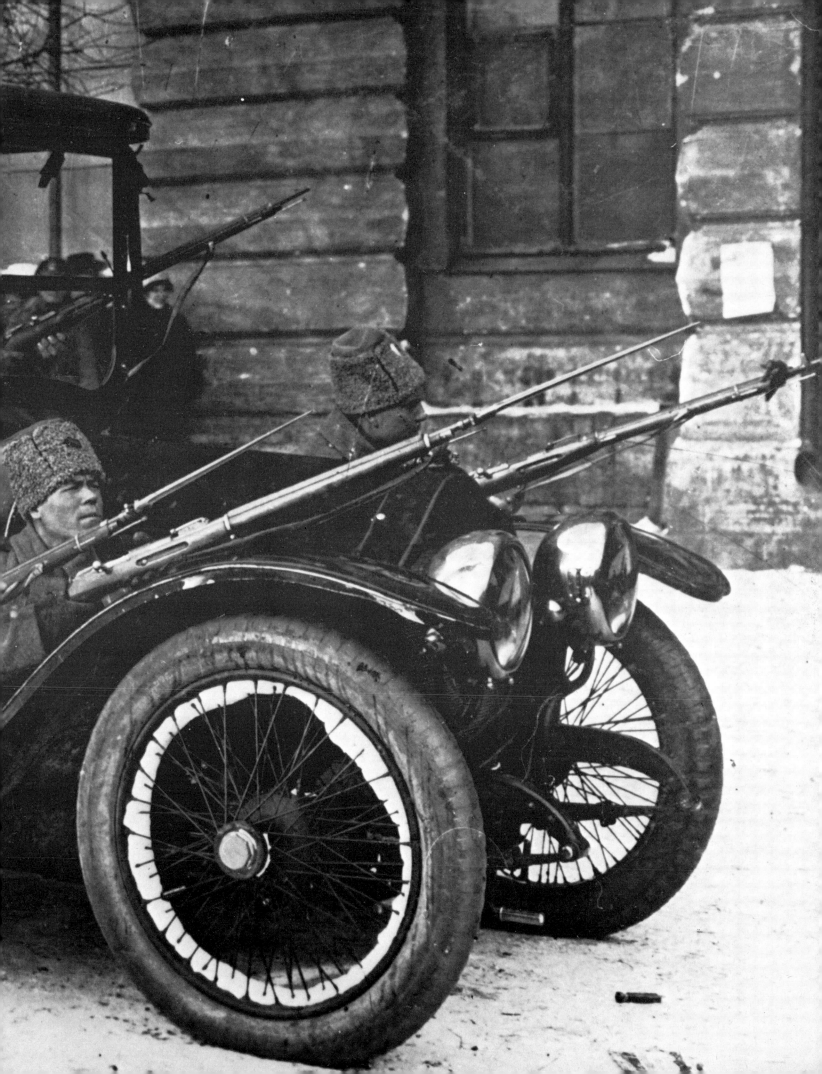

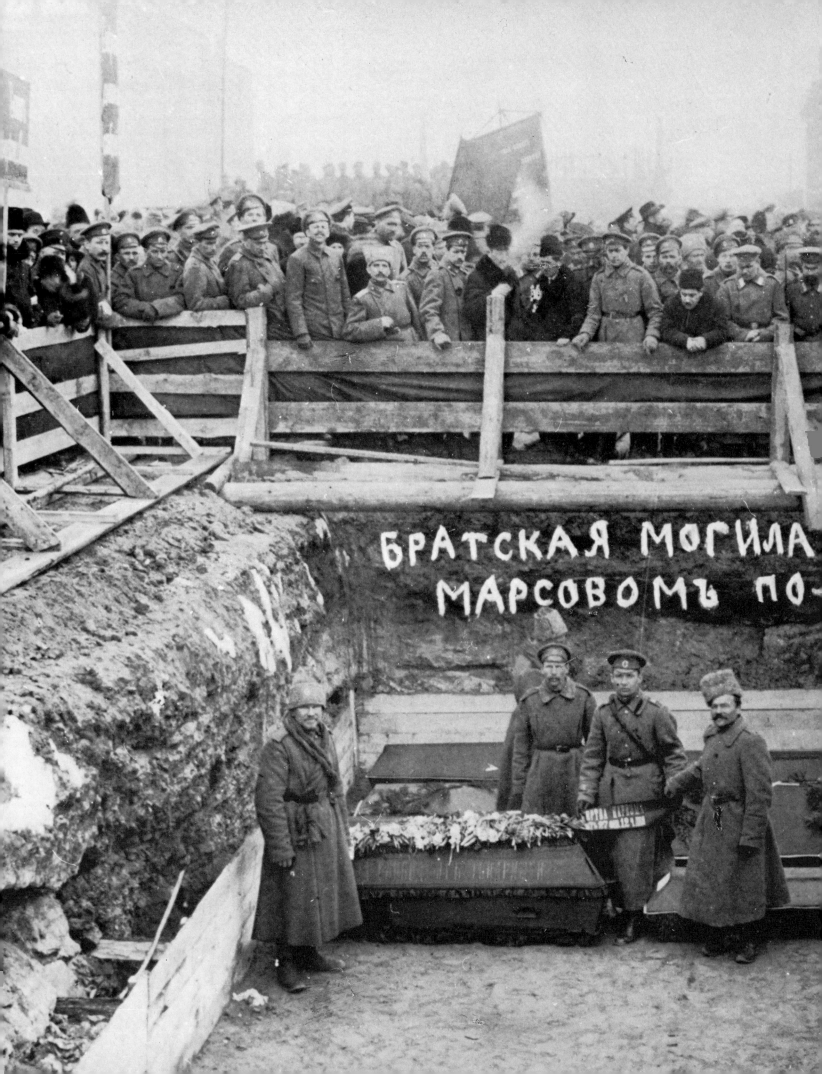

БРАТСКАЯ МОГИЛА
МАРСОВОМЪ ПО-

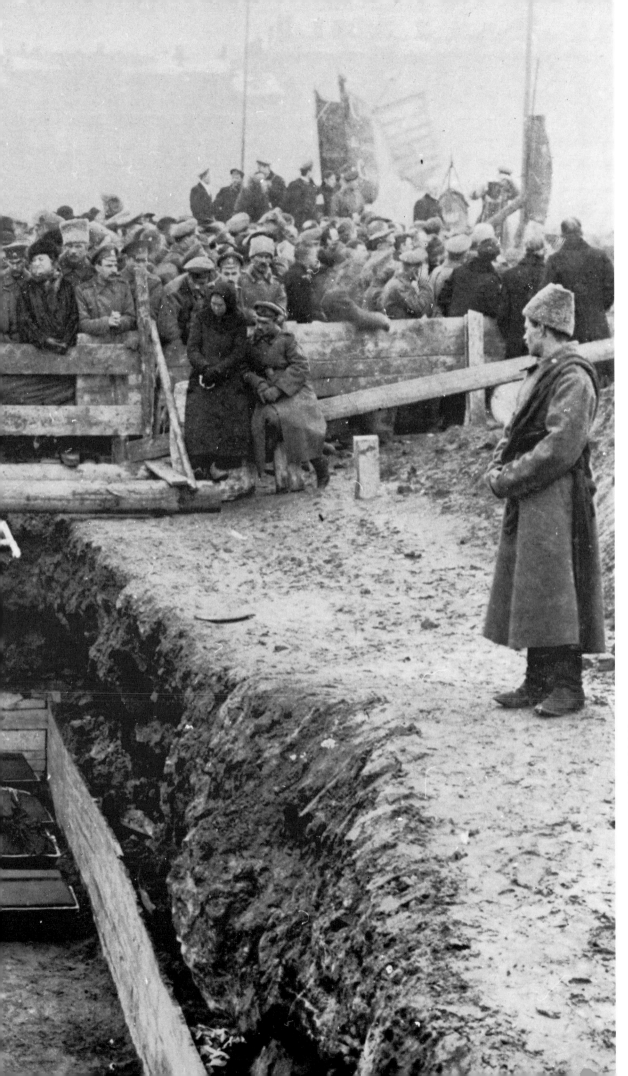

191 Funeral on the Field of Mars of the 'heroes of the revolution', Petrograd 23 March 1917. The brothers' (common) grave on the Field of Mars. According to rumours of the time, most of the 'heroes' buried in the grave were 'left-overs' from the local mortuary and included two or three murdered policemen.

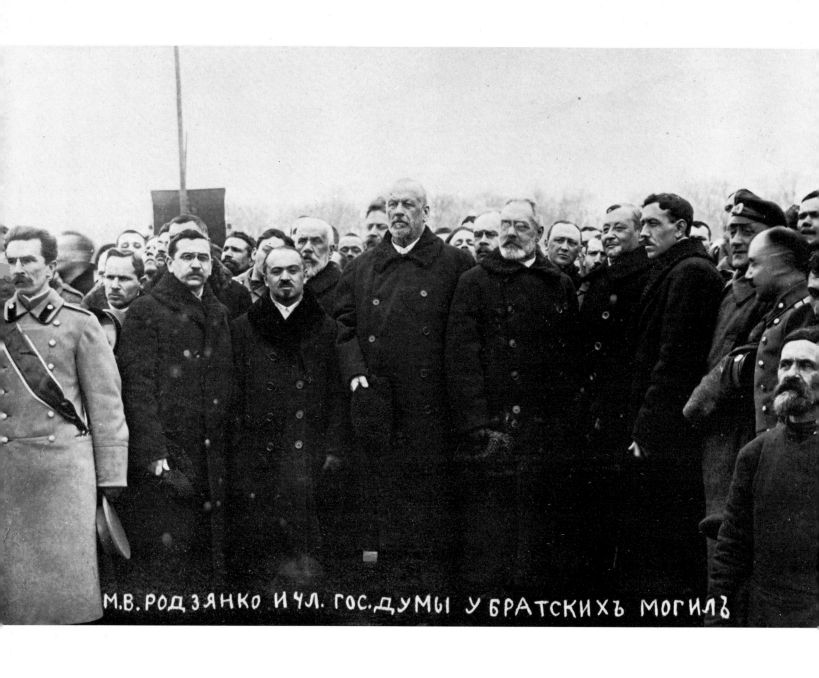

М.В. РОДЗЯНКО И ЧЛ. ГОС. ДУМЫ У БРАТСКИХЪ МОГИЛЪ

192 The President of the Duma Rodzianko (tall figure at centre) and Minister of War Guchkov (at Rodzianko's left) at the ceremonies, which were attended by all members of the Provisional Government and most of the new politically hopeful.

193 Andrei Ivanovich Shingarev (1860 + 1918). Leader of the Constitutional Democratic (Kadet) Party, a man long active in social and political affairs, a leader of the Zemstvo movement, member of the 2nd, 3rd and 4th Dumas, Minister of Finance and then Minister of Agriculture in the Provisional Government, he was arrested by the Bolsheviks after their revolution and murdered by them on 7 January 1918.

194 Alexander Kerensky. Educated as a lawyer and prominent as a defence counsel, he was elected to the Duma in 1912, as a candidate of the Social Revolutionary party. He forced through the destruction of monarchist state in 1917 and, supremely confident in his own abilities, believed that he could turn the tide of war. But fresh disasters on the battlefield undermined his position; the growth of soldiers' councils, 'soviets', and the growing demand for 'all power to the Soviets' weakened central authority to the point where the Bolsheviks, a small grouping, could seize control of the state. Fleeing abroad after the October Revolution, Kerensky devoted the remainder of his long life (he died in 1973) to an exculpation of his own position, and bitter attacks on all his enemies, real or imagined.

195 The German 'watch' parades through Melitopol in Tauride Province, 1918. After months of anarchism and murderous Bolshevik rule, the German advance in 1918 and occupation of much of Southern Russia and the Crimea was greeted by most with relief if not open enthusiasm. They at least brought with them order, organisation and law. Feeling sympathetic to the newly forming Volunteer Army, they offered arms and encouragement. Except in rare instances, the former were refused and the latter ignored. If the officers of the Imperial Russian Army were in no position to offer them combat, at least they could ignore the enemy.

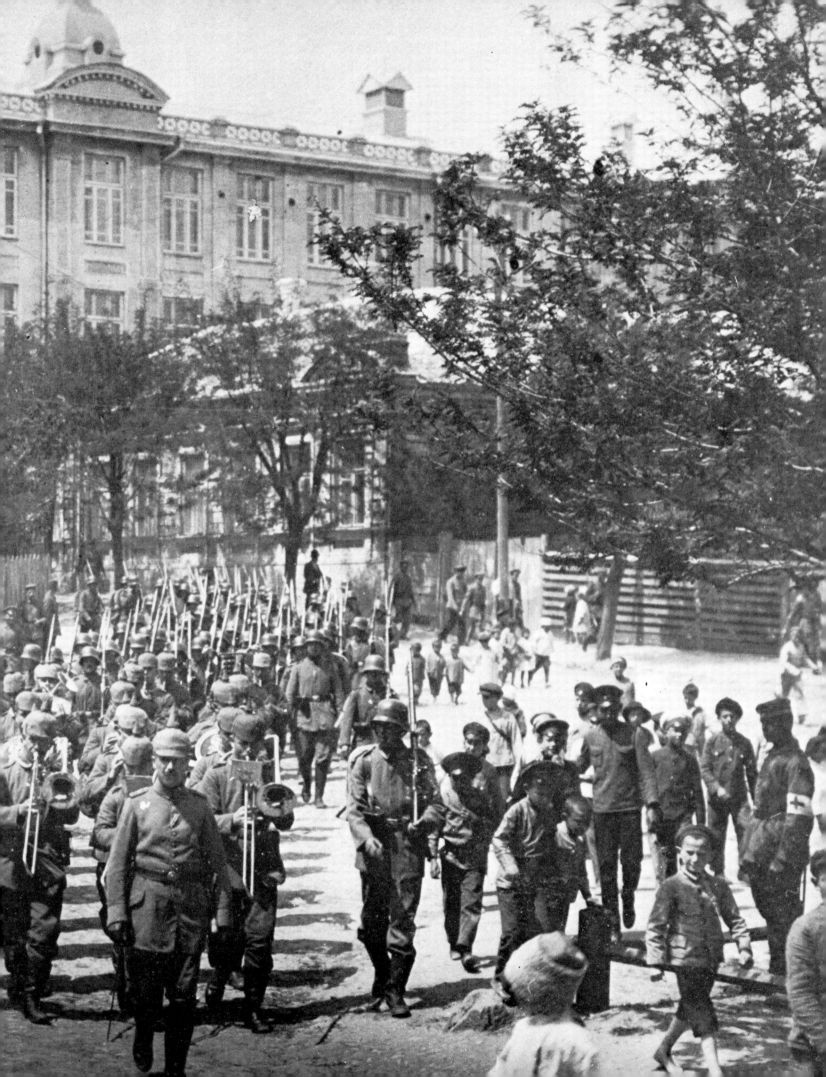

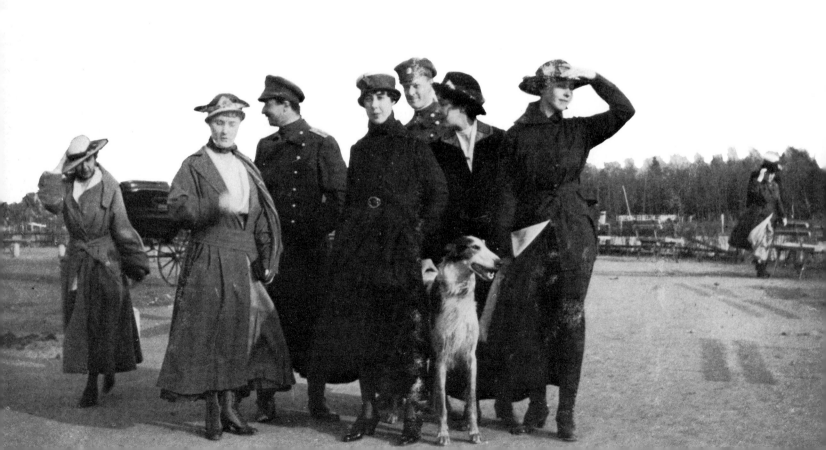

196 *left* A group of young aristocrats in Petrograd, spring 1917. Their world is about to vanish, although they show no signs of understanding this. (L to R) Countess T. P. Kotzebue, Prince N. L. Barclay de Tolly Weymarn, Miss M. V. Okhotnikov, Count M. V. Murav'ev-Amurski, Miss Olekhin, Miss E. Maksimovski.

197 *below* A group of 'captives' at the Grand Duke Alexander Mikhailovich's estate Ai-Todor in the Crimea, 1918.

From the time members of the Imperial Family and aristocracy started to arrive in the Crimea in the late spring of 1917 until the evacuation in the spring of 1919, their lives were frequently in danger. Murder was constantly occurring outside the parks, but usually the normal standards of life were observed. The children seem to have enjoyed the excitement. The hand-lettered sign on the painting reads 'Jolly Arnol'f'. 'Arnol'f' means absolutely nothing and was a nonsense game in which the participants made or drew caricatures or other silly things; all having a good time in the process. (L to R) Baroness M. A. Stael von Holstein, Princess F. F. Yusupov, Princess Irina Alexandrovna/Princess Yusupov, Miss O. K. Vasil'ev, Miss V. S. Somov.

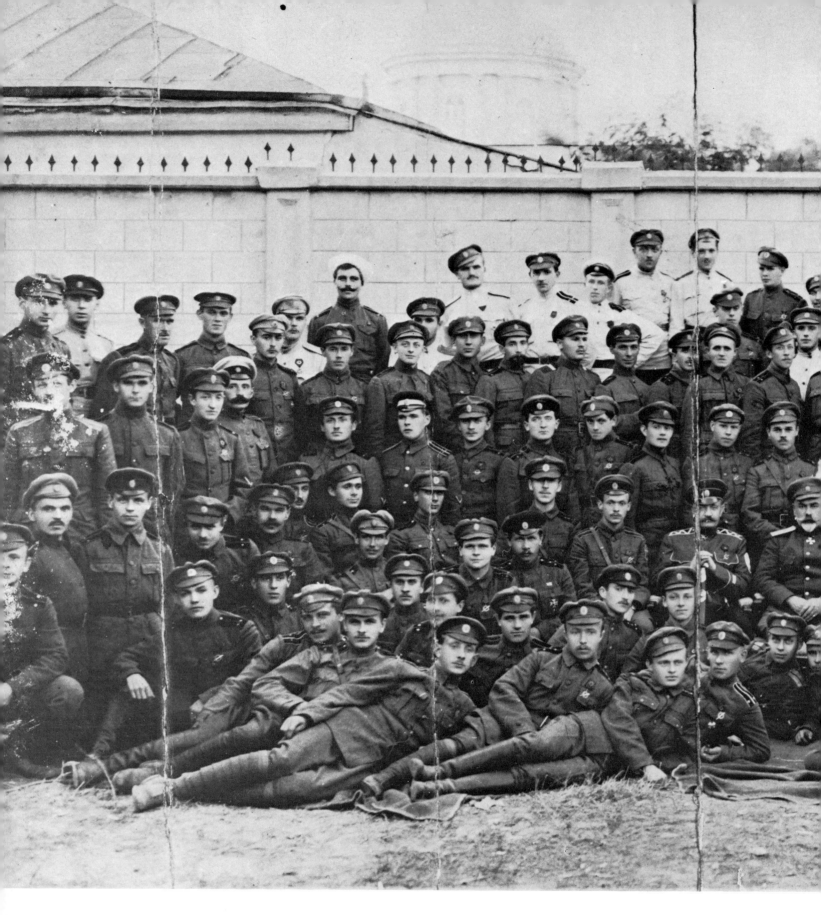

198 The Commander of the Volunteer Army in South Russia General A. I. Denikin (white beard, seated in centre) with a group of his young officers. Most of them wear the medal for the Kuban Campaign of 1918 (a sword piercing a crown of thorns) which was the beginning of the Russian Civil War, and thus must be considered as among the greatest opponents of bolshevism. Most are very young and lack pre-revolutionary decorations or regimental insignia: an almost certain sign that their military careers began after 1917.

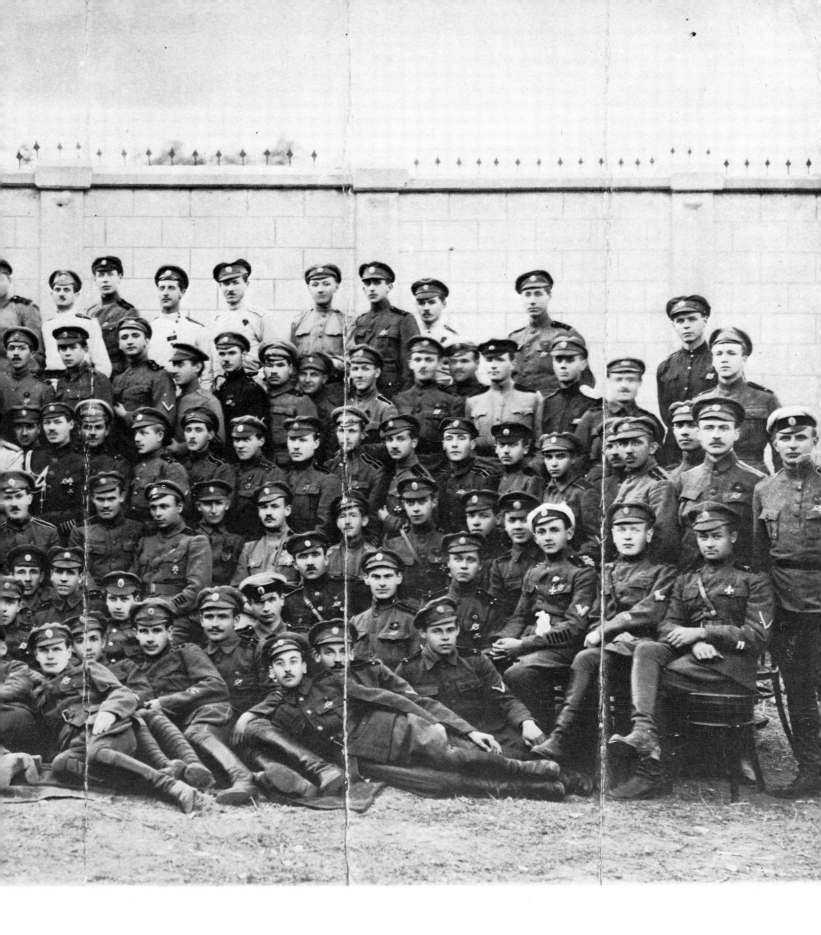

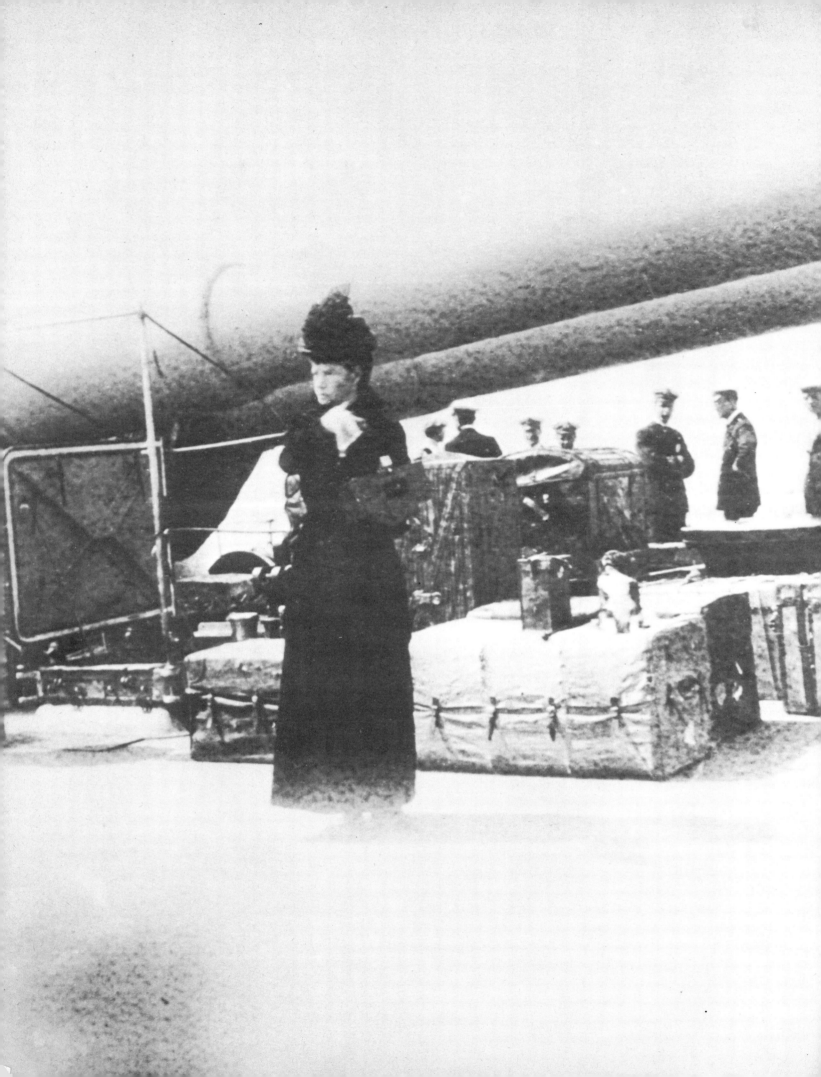

199 Waiting for HMS *Marlborough* to sail, the Empress Maria Feodorovna looks back towards the Crimean landscape she has just left, to the world that once was hers—11 April 1919 n.s.

PICTURE SOURCES